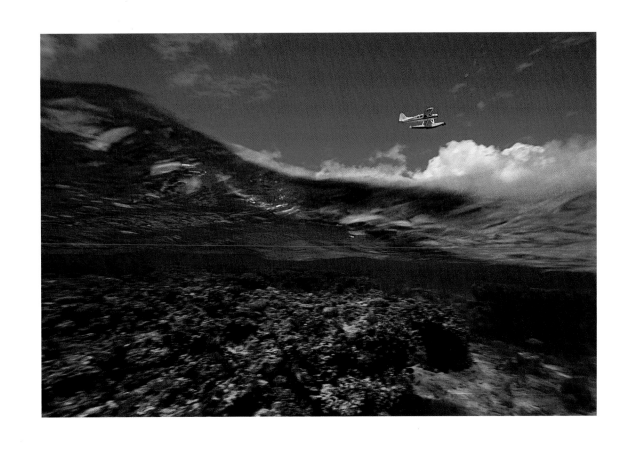

GREAT BARRIER REEF

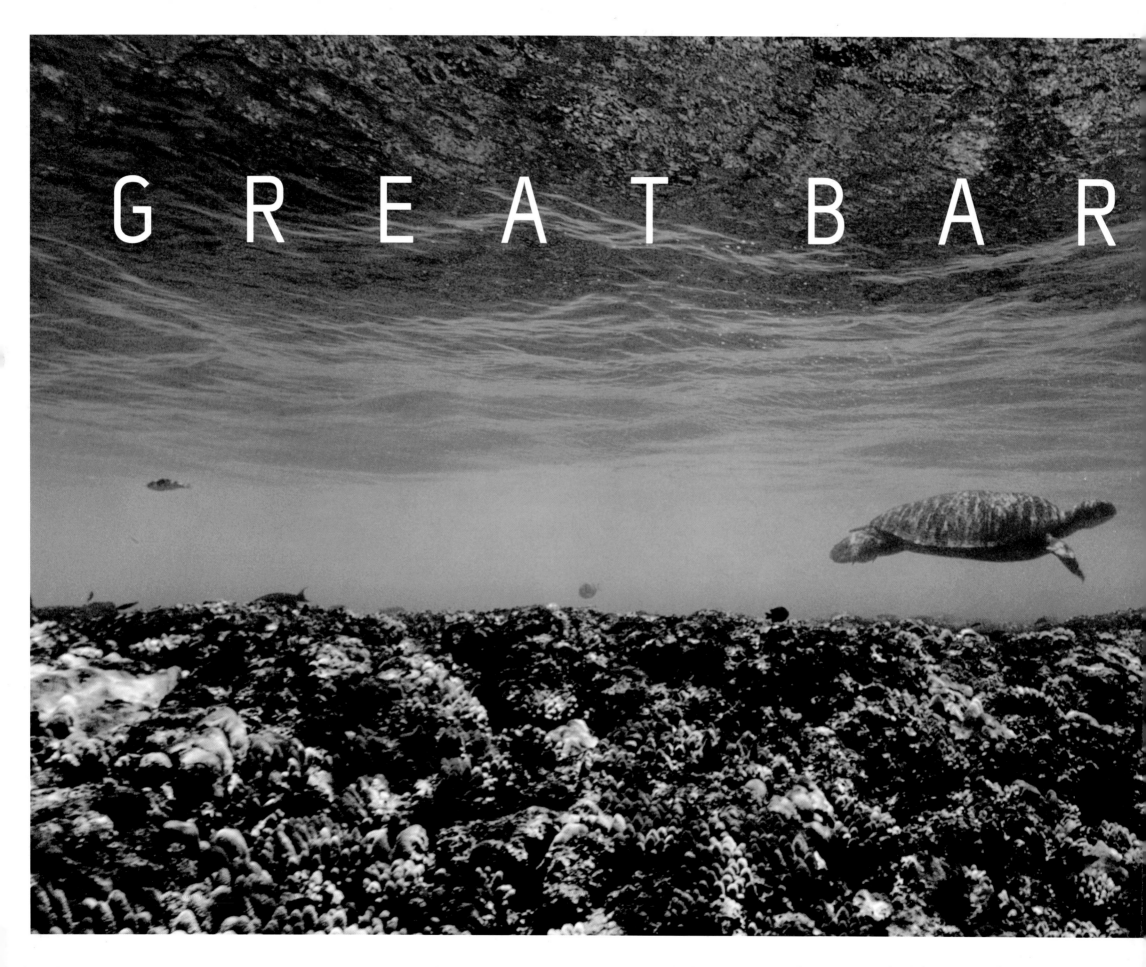

G R E A T B A R

RIER REEF

DAVID DOUBILET

NATIONAL GEOGRAPHIC INSIGHT

NATIONAL GEOGRAPHIC

WASHINGTON, D.C.

PAGE ONE: De Havilland Beaver aircraft in flight

PREVIOUS PAGES: Green turtle and blacktip shark, Raine Island

INTRODUCTION

SMALLER THAN AN INFANT'S FINGERNAIL, an extraordinary animal, the coral polyp, has transformed our planet. With its tentacles it feeds on plankton, the living broth of the sea. At the same time, algae living in the creature's tissues absorb sunlight, then produce oxygen and nutrients. With this food source the polyp has the energy to build a surrounding "house" of calcium carbonate. The polyp lives, reproduces, then dies, and the next generation builds on the skeletal foundation of its ancestors. Billions of tiny creatures living in billions of tiny calcium carbonate houses—this is a city in the sea, a coral reef.

The greatest coral reef system in the world is Australia's Great Barrier Reef. It stands alone, far offshore, and meanders a third of the way down Australia's eastern coastline. It is a vast, self-contained coral universe that does not touch land. In the last 25 years I have made multiple journeys to the Great Barrier Reef. I have photographed not just the reef, but all of the surrounding ocean neighborhoods. To the north, the giant island of New Guinea is home to the richest, most diverse coral growth on the planet. Nearly 700 miles south of the Great Barrier Reef, tiny Lord Howe Island, bathed in warm currents, is ringed by the south-ernmost coral reef in the world. To the east are the reefs of the Coral Sea, isolated oases in empty, clear water. And to the west, the green-brown water between the barrier reef and the mainland is a sea of mangroves, crocodiles, and deadly jellyfish. These places frame the Great Barrier Reef.

The reef is not a single homogeneous coral jungle. It is a series of countries that range

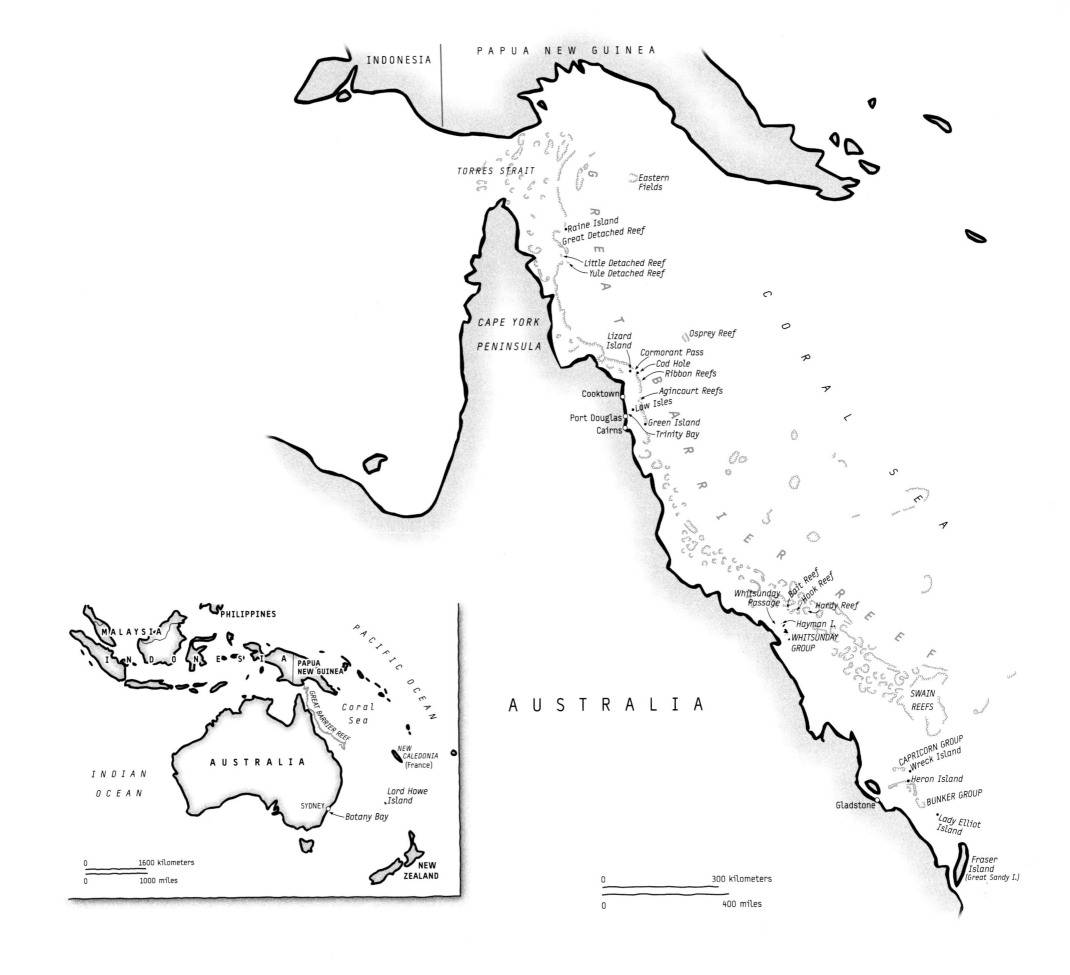

INDONESIA

PAPUA NEW GUINEA

TORRES STRAIT

Eastern Fields

•Raine Island
Great Detached Reef

Little Detached Reef
Yule Detached Reef

CAPE YORK

PENINSULA

Osprey Reef

Lizard Island

Cormorant Pass
Cod Hole
Ribbon Reefs

Agincourt Reefs
Cooktown •Low Isles

Port Douglas •Green Island
Cairns Trinity Bay

CORAL SEA

GREAT BARRIER REEF

AUSTRALIA

Bait Reef
Whitsunday Hook Reef
Passage Hardy Reef
 Hayman I.
 WHITSUNDAY
 GROUP

SWAIN REEFS

CAPRICORN GROUP
 Wreck Island
 •Heron Island
Gladstone •BUNKER GROUP

 Lady Elliot Island

Fraser Island
(Great Sandy I.)

PACIFIC OCEAN

PHILIPPINES

MALAYSIA
 INDONESIA
 PAPUA NEW GUINEA
 Coral Sea
GREAT BARRIER REEF
 NEW CALEDONIA
 (France)

INDIAN OCEAN

AUSTRALIA

Lord Howe Island

SYDNEY
 Botany Bay

NEW ZEALAND

0 1600 kilometers
0 1000 miles

0 300 kilometers

0 400 miles

from a tropical north to a temperate south. Every one is a bizarre visual challenge.

The images in this book, which I have made over the last 25 years, paint a personal portrait of the Great Barrier Reef. A new diver here is overwhelmed. An old diver begins to take the confusion for granted, and then at some point on every dive there will be something new and perfectly wonderful. The rules of the surface world are transcended. There is, as Shakespeare wrote in *The Tempest*, "a sea-change into something rich and strange."

Photographing the Great Barrier Reef is exceedingly difficult. It is a reef in the open sea, totally exposed to wind and waves, without the sheltering arms of land. It is so far offshore that in 1770 Capt. James Cook sailed more than a thousand miles up the eastern coast of this newly discovered continent before he even suspected there was a reef system—let alone a great barrier system. His discovery of the Great Barrier Reef is a story of extraordinary bravery—a quality once defined as unalterable calm in the face of unfathomable adversity. Here is the tale.

Mid-April 1770: The bark *Endeavour* was caught in a vicious gale blowing across the Tasman Sea. Cook was on an epic voyage of discovery. It was a scientific journey with high political goals for England. *Endeavour* carried a party of scientists led by naturalist Sir Joseph Banks. *Endeavour* had circumnavigated New Zealand, and Capt. Cook was running down the latitude, sailing westward across a vaguely known sea. The gale roaring in from the southeast pushed *Endeavour* north. At first light on April 19, 1770, the crew saw land, a low, blue landscape etched with white beaches that stretched across the horizon and slowly edged northward—*terra australis incognita*—the unknown southern land.

Endeavour crept northward hugging the coastline, surveying, plotting, and mapping. By the end of April they reached a large bay where Joseph Banks went ashore and began collecting or "botanizing." Cook named this place Botany Bay. They sailed past another huge bay to the north, which he named Port Jackson, later known as Sydney Harbour. Some 700 miles to the north, off the port of Gladstone, the barrier reef begins. The shoreline is flat and featureless, and the water is avocado colored. The *Endeavour*, keeping close to the coast, had no idea that there was an inner reef (the Capricorn and Bunker Groups) nearly 40 miles offshore. The beginning of this vast reef system is like the mouth of a funnel, a wide ocean highway. As the reefs march north the distance between mainland and reef narrows.

On Whitsunday, the *Endeavour* ghosted past a series of high islands. Cook named this, not so surprisingly, the Whitsunday Passage. Farther north, the coastline became a series of mangroves punctuated by river mouths and high, rain-forested hills. Here the barrier reef came close to the shore as the ocean road narrowed, and murky water cloaked the inner reefs.

On the night of June 11th, the moon rose over a calm sea as light winds pushed the *Endeavour* northward. Cook retired to his quarters. With a sickening suddenness the ship ground upon a reef. The coral ripped into her bottom. The sounds of breaking timbers, groaning and splintering, reverberated through the ship. She struck and struck fast. The waters around the Great Barrier Reef poured into her. It was sheer terror. The word "reef" could mean a drowning death or, worse, slow starvation about as far from home as humans could be—beyond the far side of the world.

It was a fight for survival. The guns and ballast were thrown overboard as the water rose within the *Endeavour*'s hold. At ten o'clock the following night, the ship floated free. Water now poured in as fast as it could be pumped out. Land was several miles distant against the tide and the wind. A sail covered with oakum (fuzzy strips of caulking material) and wool was slid under the ship like a giant bandage. The *Endeavour* limped toward shore, was beached, then careened—turned on her side—as carpenters began repairs. They found a large chunk of coral embedded in her timbers. Ironically, this piece of barrier reef had acted like a plug and saved their ship. Cook named this place the Endeavour River, just south of present-day Cooktown. They patched the ship, refloated her, and after weeks of waiting for fair wind resumed their journey in a creeping progress, the pinnace slowly going ahead, and emergency anchors at the ready. The *Endeavour* did have one piece of technology that rivals what we have today. From her mainmast, which towered more than a hundred feet above the deck, a lookout had a superb view of the coral maze and could see reefs farther away than any modern ship could hope to spot. But *Endeavour* was a prisoner of the wind, and James Cook was caught up in a world of coral greater than mariners had ever encountered or even imagined.

Off to the east the crew spotted a high island (Lizard Island). From its granite summit 1,178 feet above sea level, Cook finally began to understand the deadly coral geography that had trapped his ship. To the east was a long line of coral reefs. Breakers pounded against the seaward side of the reefs, but to the north he saw a passage—an escape. Finally, after weeks in the reef, the *Endeavour* felt rolling blue water swell beneath her hull. The crew's incredible relief lasted a mere day, then, unbelievably, their wind died. The tide changed, and the swells began to push the ship inexorably back toward the reef. The endless swell of the Coral Sea smashed against the outer reef, forming enormous breakers. They could not throw an anchor, for the outer parapets of the barrier reef drop down precipitously, forming the edge of the continental shelf.

The ship was within a half mile of the reef when a puff of air from nowhere filled the sails and gave the crew some control over their destiny. As *Endeavour* crept away from the reef their

mysterious wind disappeared, and the calm prevented them from escaping to the safety of the open ocean. The longboat was put over, and the crew pulled at the oars, trying desperately to haul their ponderous ship out of harm's way. But once again the tide turned and began to pull the ship back toward the reef. Then, as if by magic, a passage through the reef appeared in front of them—a tight squeeze, but with the tide the *Endeavour* slipped through.

Of the ordeal, Joseph Banks wrote "Two days [ago] our utmost wishes were crowned by getting without the reef and today we were made happy by getting within." So Cook sailed north, and the ship's scientists, led by Banks, turned their attention to the reef, not the land. They actually had a tool; "a curious contrivance of a telescope, by which, put into the water, you can see the bottom at great depth, when it is clear."

Artist Sydney Parkinson described the reef: "The reefs were covered with numberless variety of beautiful corallines of all colours and figures.... These made a pleasing appearance underwater, which was smooth on the inside of the reef, while it broke all along the outside, and may be aptly compared to a grove of shrubs growing underwater. Numbers of beautiful coloured fishes make their residence amongst the rocks.... There are also crabs, molusca of various sorts and a great variety of curious shellfish which adhere to the old dead coral that forms the reef."

The Great Barrier Reef, one of James Cook's greatest discoveries, languished, nearly forgotten by the West. For more than 120 years no one really looked at the reef system. There were but a few descriptions, many from commercial helmet divers who peered at it through their tiny glass windows. It took a simple invention, the rubber face mask (a vast improvement over goggles), developed in the 1930s, to allow divers to understand and appreciate what an extraordinary discovery Capt. James Cook had made in 1770.

The faceplate of a mask is a magical window opening onto a secret garden. It gives vision to Cook's extraordinary discovery. The simple fact is that a coral reef is the richest, most complex visual environment in the world. A rain forest may support more species than a coral reef, but to the untrained eye the forest is a mysterious, dark place among shadows cast by a towering canopy. A coral reef glows. A simple sweep—a glance—and I see blue and green parrotfish, yellow sweetlips, orange clownfish, emerald chromis, blue-green humphead wrasses, and crimson squirrelfish. And this is without looking at the invertebrates—clown-colored nudibranchs, pink soft corals, giant red sea fans. The coral polyp produces living architecture in a seemingly weightless environment. For a 21st-century diver it remains constantly astounding.

Scientists began to look at the barrier reef system at Heron Island in the 1930s. In the

early 1950s Austrian divers-scientists Hans and Lotte Hass visited the reef. The Australian press warned them: You will be devoured by sharks, poisoned by sea snakes and scorpion fish, shredded by coral and caught by giant sea clams. The Hasses returned to describe a vision of sheer beauty. Even though it was a difficult place to visit, it was an Eden.

The more than 1,250-mile-long Great Barrier Reef is composed of at least 2,800 individual reefs. There are more than 900 islands, islets, and cays, but few islands on the reef have places to stay. You can live on Lady Elliott Island and Heron Island in the south or on Lizard Island to the north. Some reefs are 160 miles offshore, while others are within 20 miles of the coast. Some reefs fringe the mainland. Nothing is easy to get to, and the wind blows….

There are about 400 species of coral and around 2,000 species of fish, and then there are the invertebrates: worms, sea cucumbers, anemones, nudibranchs, crabs, clams, and on and on. The reef is not one continuous coral kingdom, but a collection of smaller countries. The change is subtle from warm to cool waters. From the air, however, the difference is apparent. The northern reefs are delicate lines and traceries. The central reefs are great raised platforms, while the southern reefs are green sandy islets with wide, coral footprint-like reefs surrounding them.

The ocean side has the clearest water and the wildest reefs. The goal of most divers is to see these outer edges—the front of the reefs that are the ramparts against the Coral Sea—even though they are not necessarily the most beautiful parts of the reef. But throughout the reef there are constant surprises, from the schools of sweetlips to mating sea cucumbers. The tides on the reef are enormous, up to 20 feet. The wind can blow for days and quit suddenly, turning the sea to glass. The reef seems to whisper the familiar mantra of frustration: "You should have been here when…."

The barrier reef is a coral nation offshore, and, like all coral communities worldwide, it is threatened by overexploitation by fishermen and tourists, as well as by environmental factors such as global climate change, which can lead to coral bleaching. I have seen changes on the reef over the years. Simply put, there are fewer fish and more people.

There are journeys in this book from the bommies of Heron Island to the green turtle-choked beaches of Raine Island in the far north. To photograph the reef is a subjective task, very much like three blind men trying to describe an elephant by touch: it's long, it's thin, it's fat. It is 1,250 miles of coral dreams, of giant groupers and soft coral trees. The coral polyp has indeed changed our planet. Its biological process makes geologic facts. Add all of the world's coral reefs together, and the sum is equal to another continent—a continent bathed in blue light, a coral continent best represented by Australia's Great Barrier Reef. ✦

"The faceplate of a mask is a magical window

opening onto a secret garden." DAVID DOUBILET

De Havilland Beaver aircraft over Hook and Hardy Reefs, Whitsundays

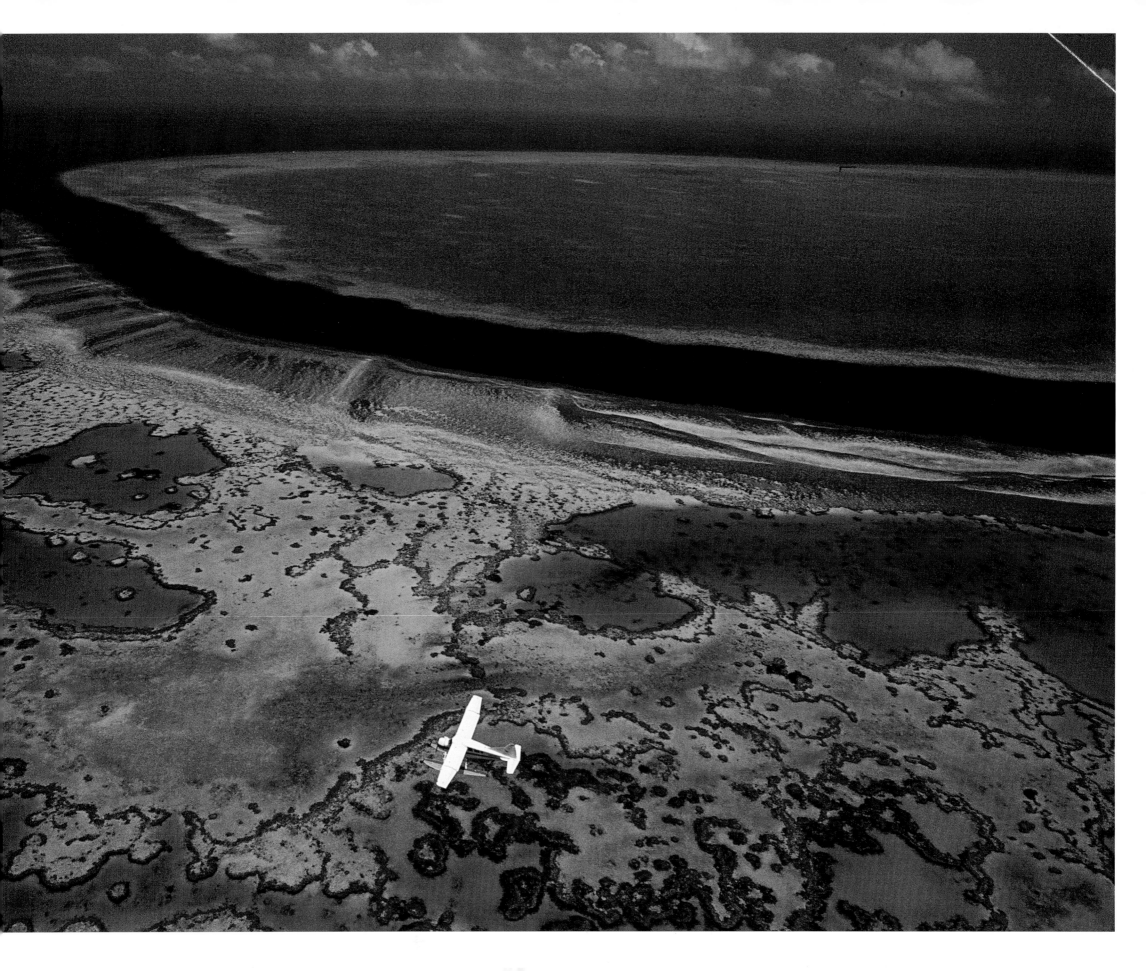

Percula clownfish and anemone, Great Detached Reef

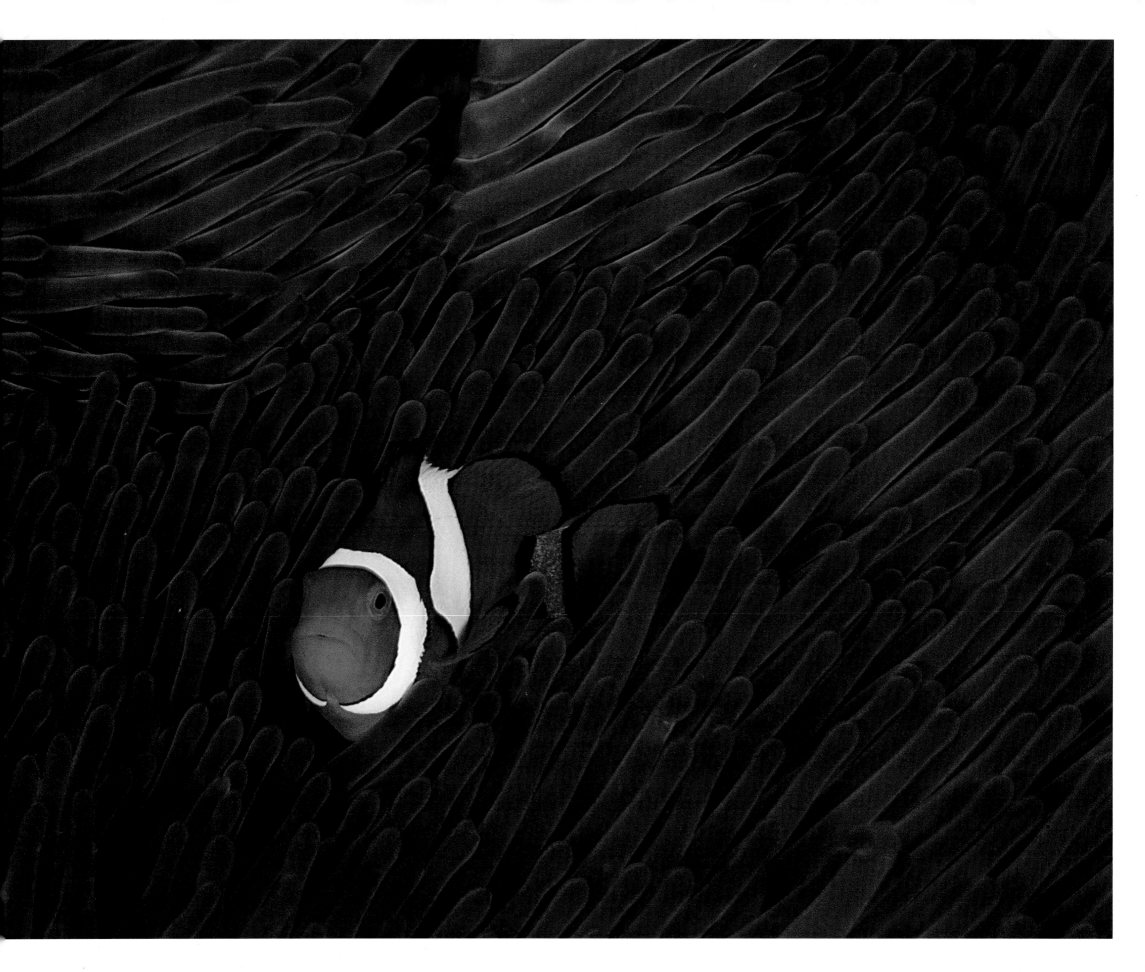

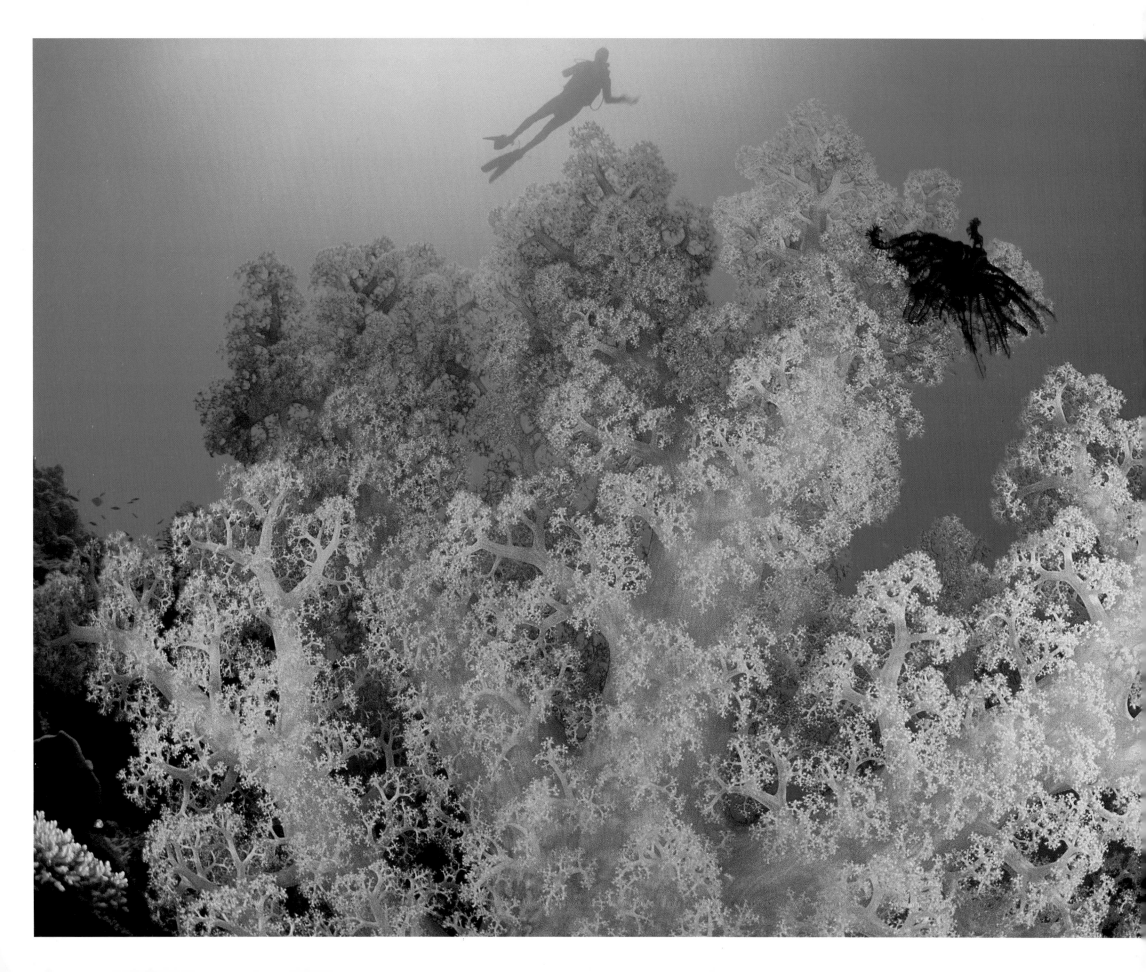

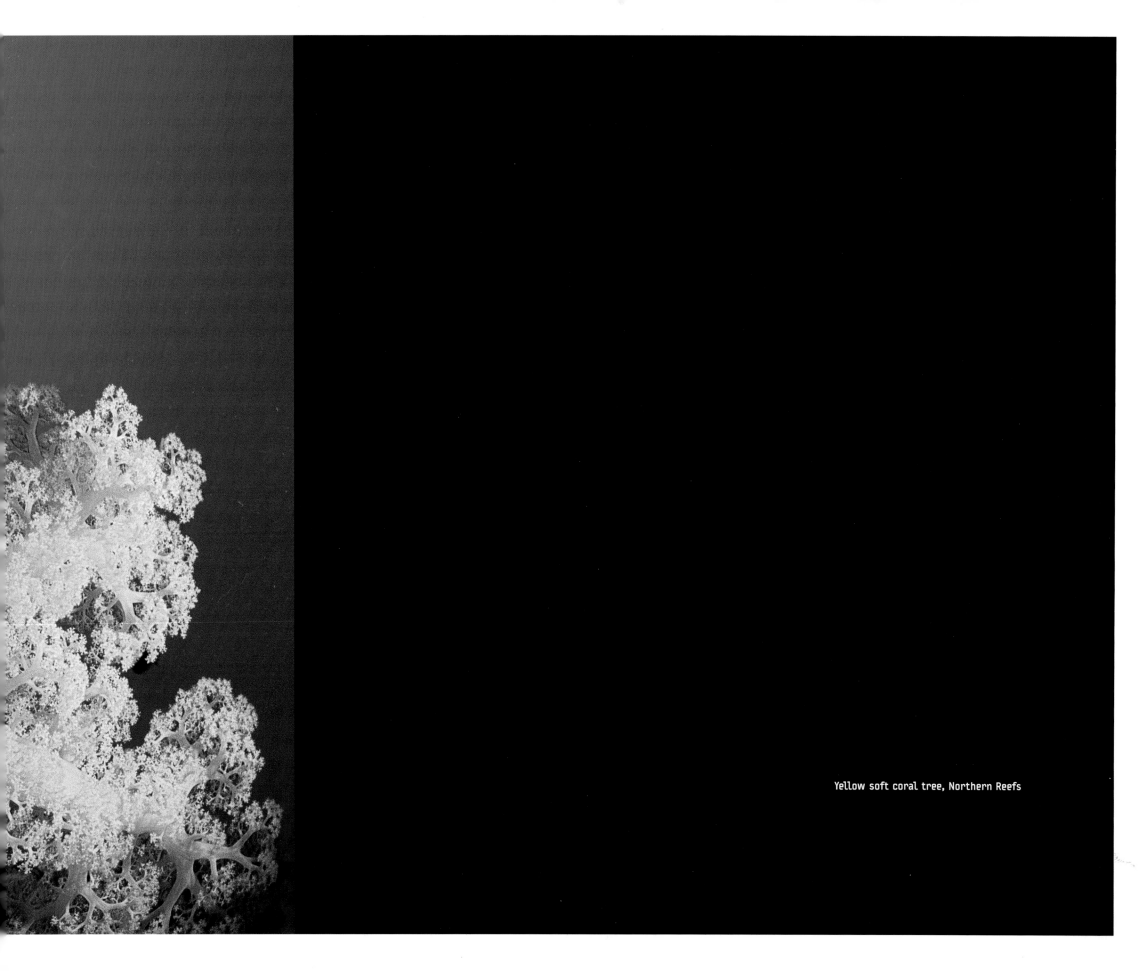

Yellow soft coral tree, Northern Reefs

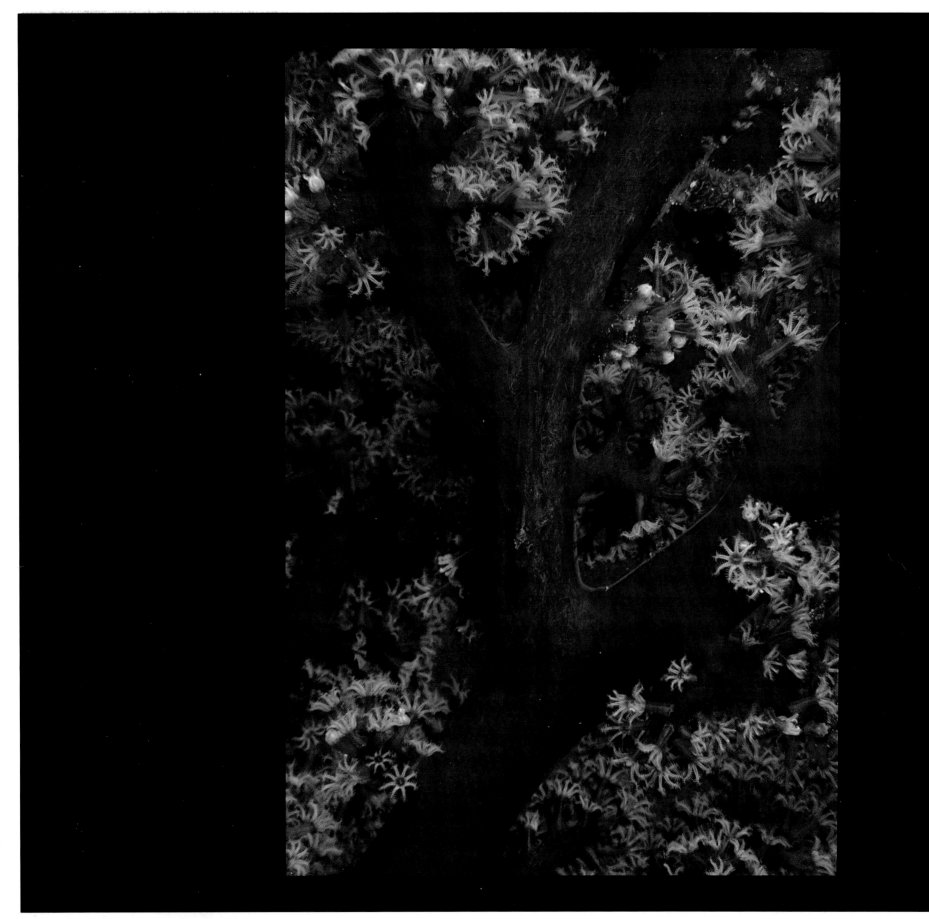

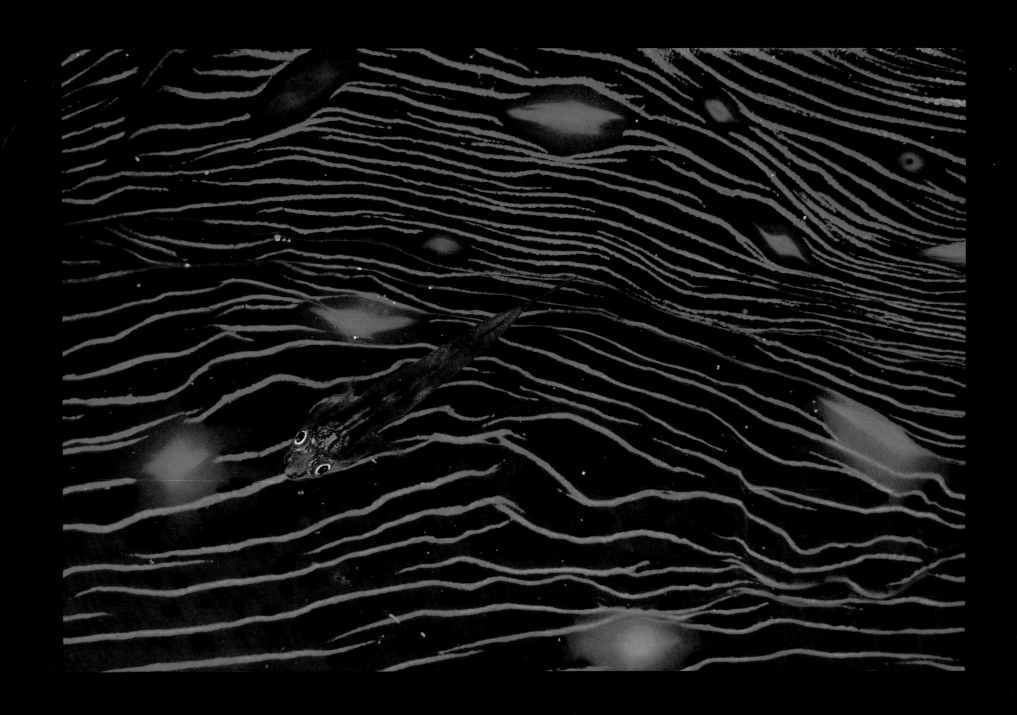

Goby on gorgonian coral, Number 6 Sand Cay

OPPOSITE: Goby on giant clam mantle, Great Detached Reef

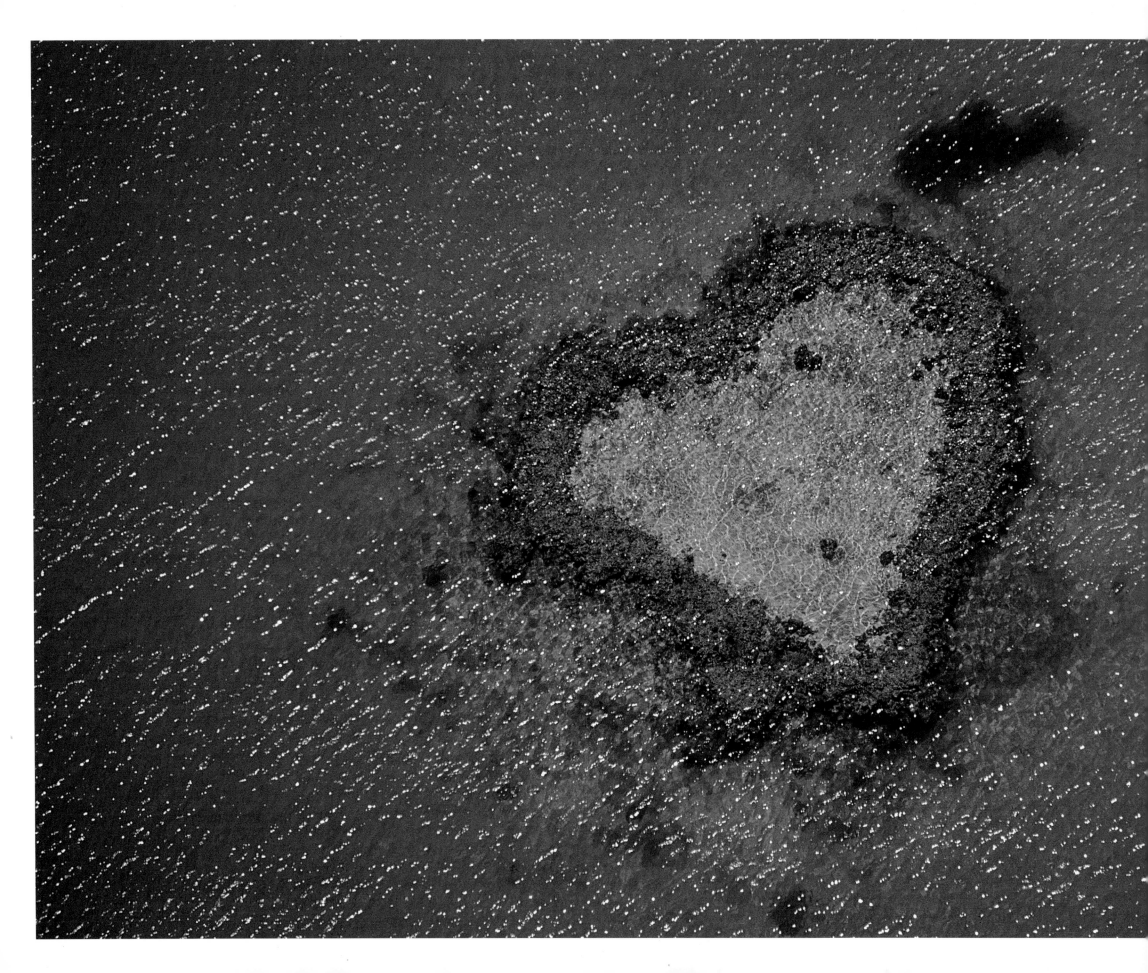

Heart Reef, Hook and Hardy Reefs

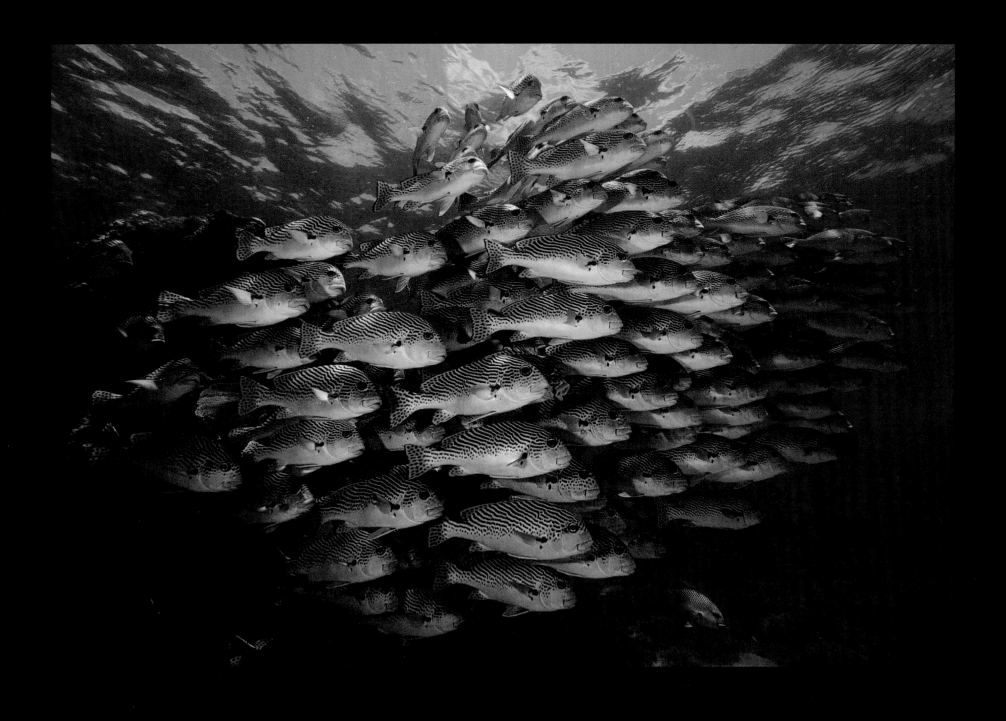

School of sweetlips

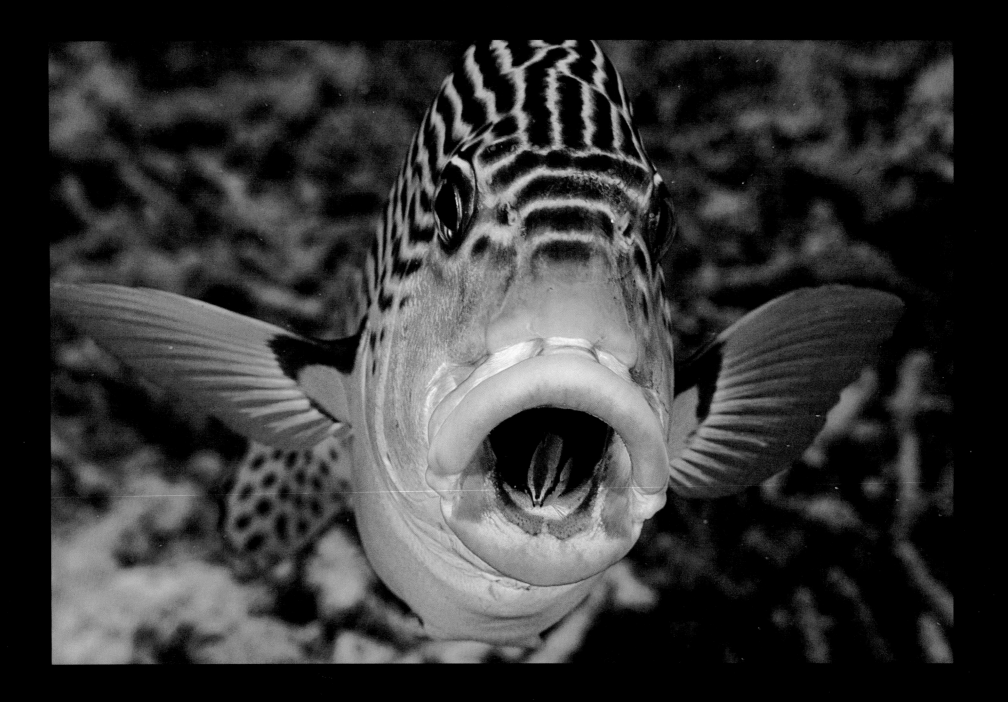

Sweetlips being cleaned by a blue-striped wrasse, Cod Hole, Number 10 Ribbon Reef

Crown-of-thorns starfish feeding on brain coral, Swain Reefs

FOLLOWING PAGES: *Endeavour* replica in the Whitsunday Passage

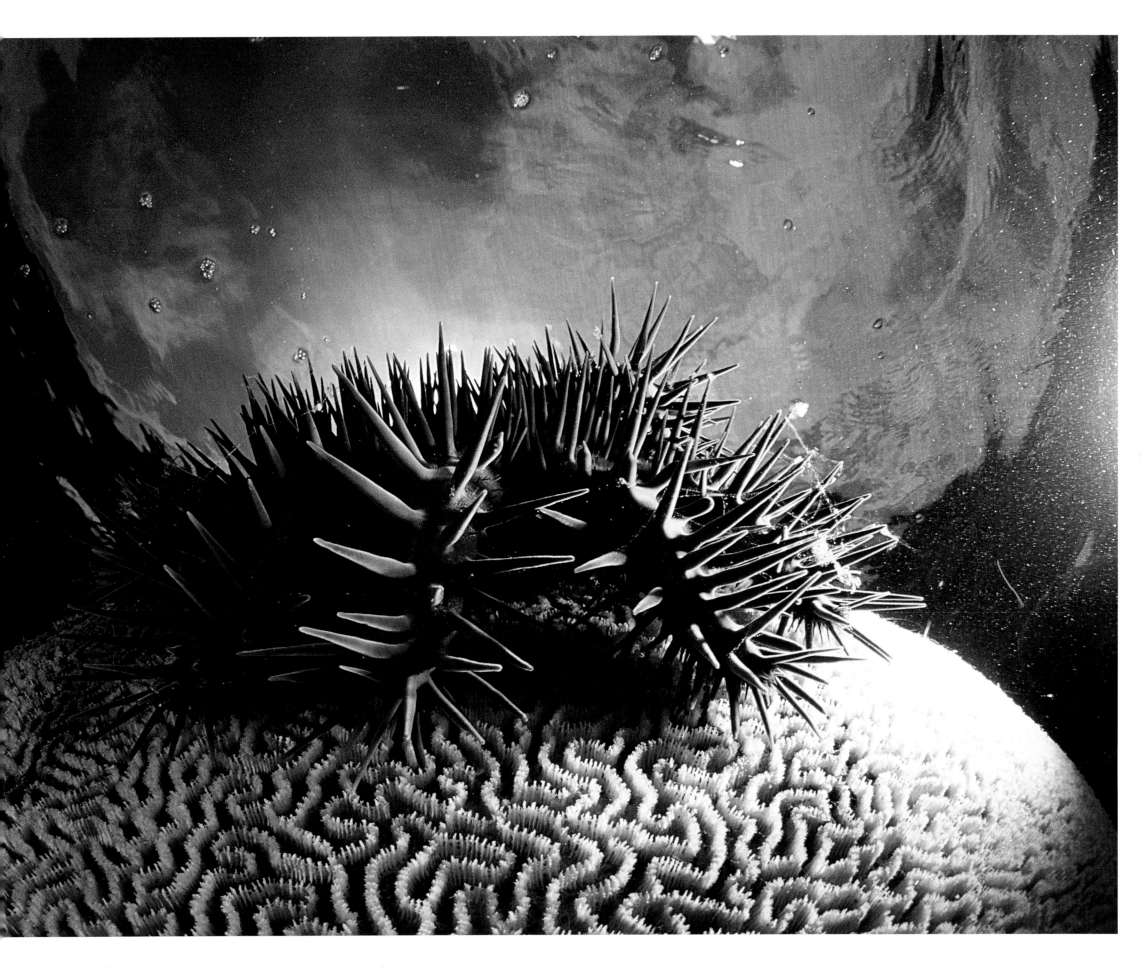

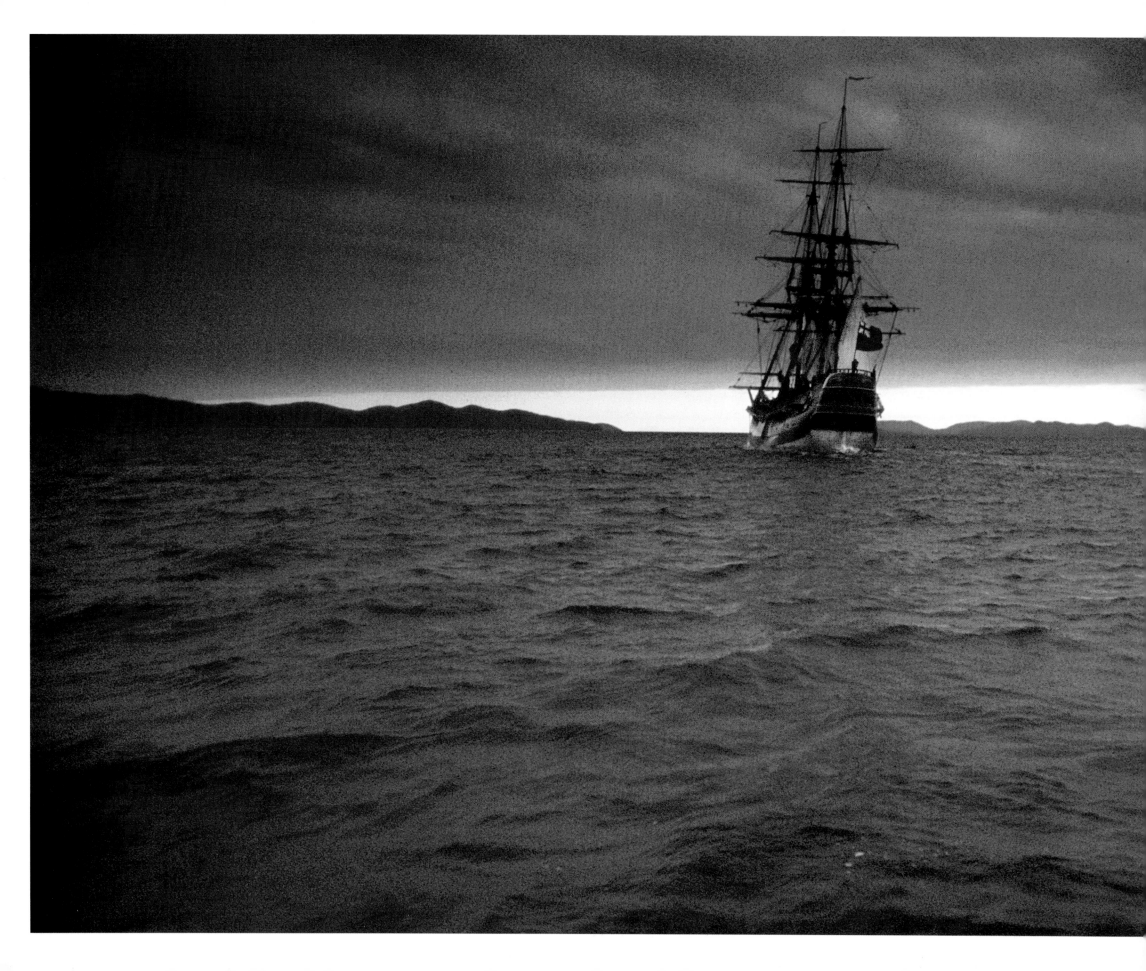

FOLLOWING PAGES: Gary Bell in a sea cave, Northern Ribbon Reefs

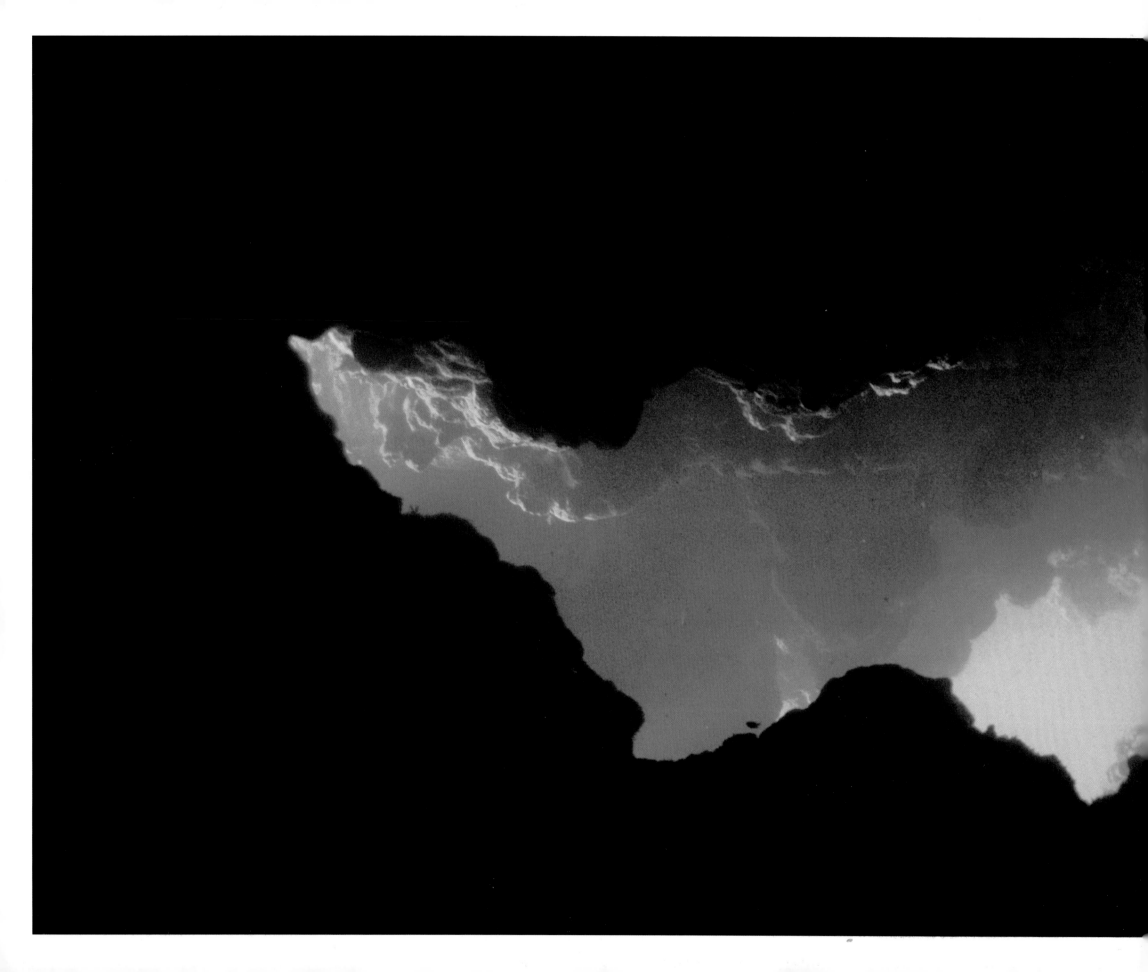

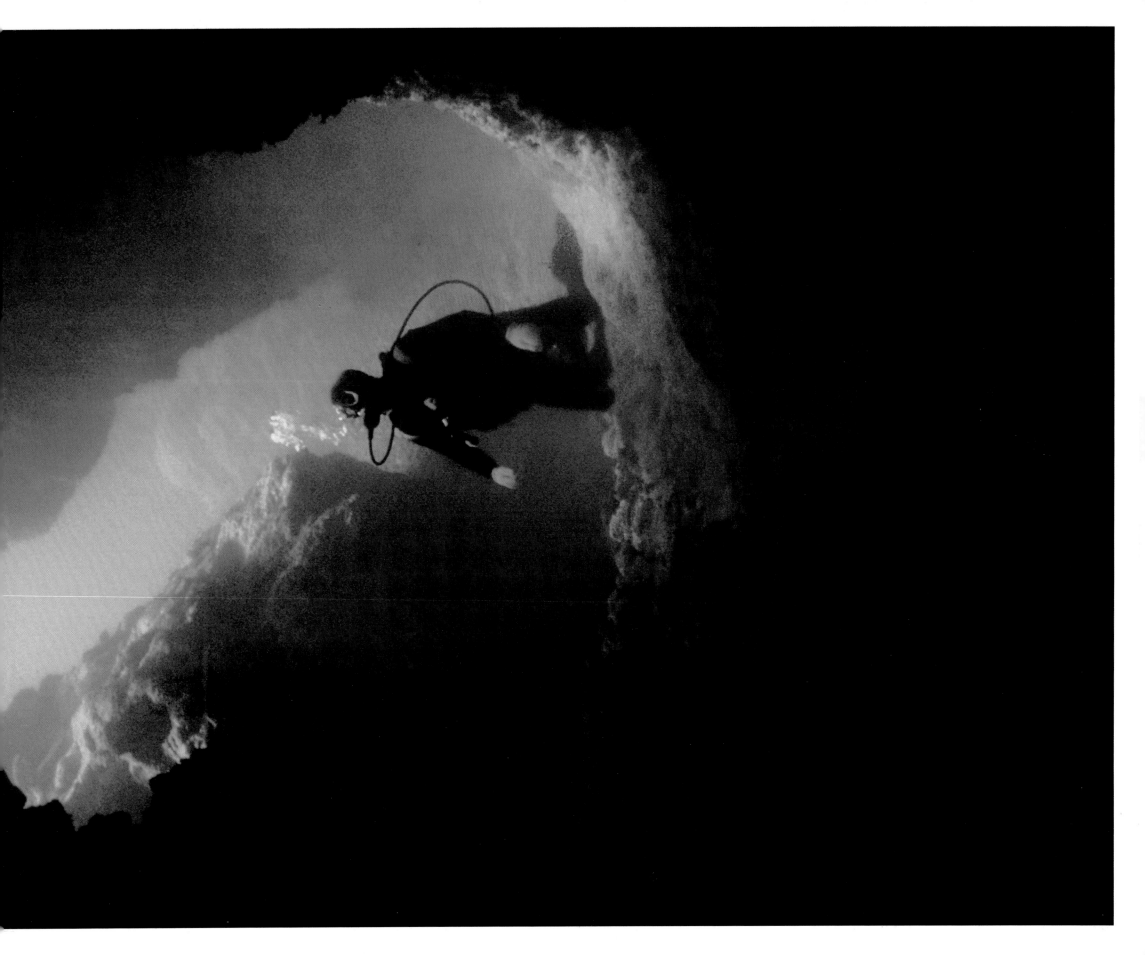

AUSTRALIA IS A CONTINENT DESCRIBED BY A REEF. This bastion of coral is more famous than kangaroos, koalas, leathery crocodile hunters, the outback, and the Sydney Opera House. The Great Barrier Reef *is* Australia. It dominates most visitors' conception of Australian geography.

"I'll just fly to Sydney, go to the beach, put on flippers, and go diving on the Great Barrier Reef." Well, no. The northern gateway to the heart of the reef is the city of Cairns, far to the north, in the enormous state of Queensland. It is as far from Sydney as New York is from Miami.

"Okay, then," says the eager tourist, "I'll fly to Cairns, put on my flippers, and go diving on the Great Barrier Reef." Again, not so fast—Cairns is a city of 130,000 people and 40 dive shops, built on the shores of a great tidal flat bordered by brown rivers and mangroves. Ten-foot tides turn the flats to seas of mud, where flocks of black-and-white Australian pelicans patrol. And the bright blue waters choked with coral, where a myriad of brightly colored tropical fish dart hither and yon? Well, that's still way over the horizon.

The Cape York Peninsula stretches nearly 500 miles to the north of Cairns. The Great Barrier Reef here is far closer to land than it is in the south, yet it is still an average of 20 to 35 miles offshore. The reefs here have a richer and more diverse coral and fish life than the reefs farther south. Even though this area is not the central part of the reef, I consider it to be the reef's very heart.

The road to Port Douglas, about 40 miles north of Cairns, winds past golden beaches edged with palm trees and Australian pines. A calm green sea laps at the shore. It is magnificent

real estate except for one small thing: For about half the year you cannot set foot in the sea except in areas protected by nets. This is no exaggeration. The creature responsible for the terror is the box jellyfish (*Chironex fleckeri*), also known as the sea wasp or, with typical Australian understatement, marine stingers. Creatures of the tidal rivers and the massive dense mangrove systems that punctuate the coast, they are the sea's most venomous creatures.

A fully grown box jellyfish may have tentacles 15 feet long attached to its transparent, box-shaped head, which is about the size of a diving helmet. Their tentacles are basically thin strings of nematocysts, roughly the diameter of angel-hair pasta, and there are 60 tentacles. A brush with a 10-foot section of one tentacle can kill a human. The jellyfish have four eye groups, not eyespots, but actual eyes with tiny lenses. They can sense potential threats, such as pier pilings and mangrove roots, and avoid them. How they do this is a great mystery, for they have no discernible brain.

The jellyfish hunt very close to shore, where they feed on small shrimps, using their powerful venom to kill their prey instantly. And, in turn, sea turtles—especially hawksbill turtles, if presented the chance—will eat these deadly creatures like popcorn. But this is not surprising since turtles eat sponges, which for a human would be a little bit like eating glass. The jellyfish are delicate creatures whose tentacles and bell can be easily torn. They cannot afford to fight; it is no accident that they have the most powerful venom in the marine world.

There is a wonderfully simple defense against the stinging tentacles of this jellyfish: pantyhose. The nematocysts cannot penetrate a sheer nylon layer. Of course, this is definitely function over fashion. Surf lifeguards have been known to wear them because even in these days of modern Lycra suits it is still easier to swim in a suit of pantyhose. The tops of the suits are fashioned out of a second pair of pantyhose, with the crotch section removed.

But box jellyfish are an integral part of this green-brown inshore sea that lies between the Australian continent and the reef. It is a sea bordered by vast mangrove forests, saltpans, and wide beaches. Fed by wide brown rivers, it is a nutrient-rich place—sometimes too rich. Fertilizer from the sugarcane fields washes into the sea during the wet season, and some inshore corals die as a result of the excess nitrogen.

One gray late afternoon, I flew over the cane fields in an antique Tiger Moth biplane. It was an afternoon full of clouds that threatened rain. Even in the low light it was a world of absolute greens. The light greens of the cane field blended with the dark greens of the gum trees. What was apparent from the air was the lack of trees lining the banks of the creeks and rivers. What should have been a 20- or maybe 30-yard buffer was a mere 5 yards in many

places. In some places there were no tree zones because farmers had cut down trees and planted cane all the way to the riverbanks. In the monstrous rains of the wet season, fertilizers from the cane fields are washed into the rivers that run to the sea. The sun managed to squeeze through as we left the coast and hopped along a peninsula that leads to Green Island and the reef.

There are places in the nearby green sea that have a rare beauty. The brown water gives way to green water farther offshore. A special environment in the sea—a mangrove forest in clear water—surrounds the Low Isles, about ten miles from Port Douglas. Above the water the mangroves are dense and impenetrable. Below is a sunken forest of dappled light and shadows. Schools of snappers swim beneath the brown roots. Cassiopeia (upside-down jellyfish) pulsate on the bottom, and little barracudas hunt baitfish while triggerfish swim over hidden meadows of sea grass. Schools of silver hardyheads flow through the hidden pathways in the mangrove forest. The barrier reef's tides create a sunken underwater forest. Then, within a few hours, when the tide changes, the forest will go dry.

From Port Douglas it is possible to visit the reef in one day. So, ironically, the eager tourist diver can experience his dream. It's all accomplished with a high degree of organization and a higher degree of technology. The Quicksilver Connections company pioneered the use of long, wave-piercing, jet-powered catamarans. They can easily achieve 30 knots and accommodate up to 450 passengers in aircraft-like seats. Making huge rooster tails, they can accomplish the almost 40-mile trip to Agincourt Reefs in little more than an hour.

At Agincourt Reefs the catamaran ties up to its "pontoon." The pontoon is an aluminum raft about half the size of a football field. The passengers can snorkel off the platform, take rides on an aluminum, semisubmersible glass-sided boat, or take a helicopter ride. There are snorkel expeditions led by marine biologists, and novice divers learn to dive under the pontoon. Certified scuba divers take off in aluminum dive boats for distant reefs. Lunch—chicken, shrimp, fruit, and salad—is served on aluminum picnic tables. Everything is aluminum.

At 3:00 o'clock it is time to leave. The passengers board the catamaran and are counted and then recounted before the high-speed journey back to Port Douglas. The Quicksilver catamarans enable all sorts of tourists to view the reef. But because the tourists are contained, their impact is minimal. This little piece of Agincourt Reefs is like a city park, controlled, contained, yet full of life.

The pointed finger of the Cape York Peninsula almost touches the island of New Guinea. The richest coral seas are in a corner of the world that stretches from the the eastern tip of Papua New Guinea across Indonesia, touching Malaysia in the west and the Philippines in the

north. These waters are among the warmest in the world. It is a place of deep basins and volcanic islands. Dozens of isolated mini-seas were formed during the ice ages. When the water receded, each sea found its own evolutionary pathway. When the water levels rose once again, more species of coral, fish, and invertebrates existed there than in any other coral region of the world. It is the core of the world's greatest coral-reef diversity, an evolutionary epicenter. The farther away you get from it, the fewer species of marine organisms. Even the northern barrier reef has fewer species.

Eastern Fields is one of the northernmost outposts of the Great Barrier Reef. I dove with longtime colleagues Gary and Merri Bell on a corner of an inside passage. Pairs of red-and-white checkerboard longnose hawkfish hunted in a forest of yellow sea fans. Near Great Detached Reef we found a clam with a midnight blue-and-silver mantle—a tiny red-eyed goby lived there. The outer ramparts of the narrow ribbon reefs were built of thousands of plate corals up to five feet in diameter, with towers and castles of plate corals at the corners. It was a land of coral dreams.

Number 6 Sand Cay was one such dream, with magically pure white sand. Like coral, sand is formed by a biological, not geologic, process. Some sand is a product of the breakdown of coral by algae, but sand is also a by-product of parrotfish. Parrotfish graze on coral, gnawing at it with their beaks, ingesting worms, tiny crustaceans, and live tissue. They excrete white clouds of dead coral also known as "sand." The biggest parrotfish, the bumpheaded parrotfish (*Bolbometopon*), whose huge, protruding moss-covered beaks are as hard as Krupp steel, can consume a ton of coral in a few weeks. Schools of these fish, with their bulbous heads and dark-green bodies, look like buffalo grazing on the stone pastures of the reefs. The sand produced by the parrotfish drifts over the reef and begins to form a cay that attracts birds, and turtles crawl onto the beaches to lay their eggs. All of this happens because of the sand.

By midday at Number 6 Sand Cay, the light was fierce. The sand was so white that it looked like snow. The little cay was like the top of a mountain, where a crown of sand rose above the tree line of coral. Sand fields covered the bottom, and surgeonfish traversed the sand like black shadows. A garden eel colony stretched toward the blue underwater horizon. Fields of half-inch-thick, two-foot-long eels fed in the current, swaying back and forth. A whitetip reef shark cruised in the distance. I swam up the slope to where the sand met the coral. Here was a world of simple elements: water, sand, and coral illuminated by light that came from a blue tropical sky. Above, the sun silhouetted the seabirds and cast fleeting underwater shadows that flew across the fields of sand. ✦

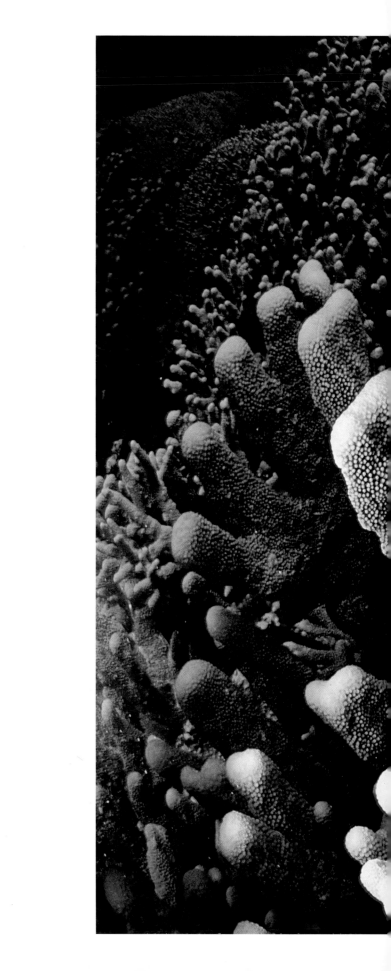

Clownfish and anemone in pillar coral, Eastern Fields

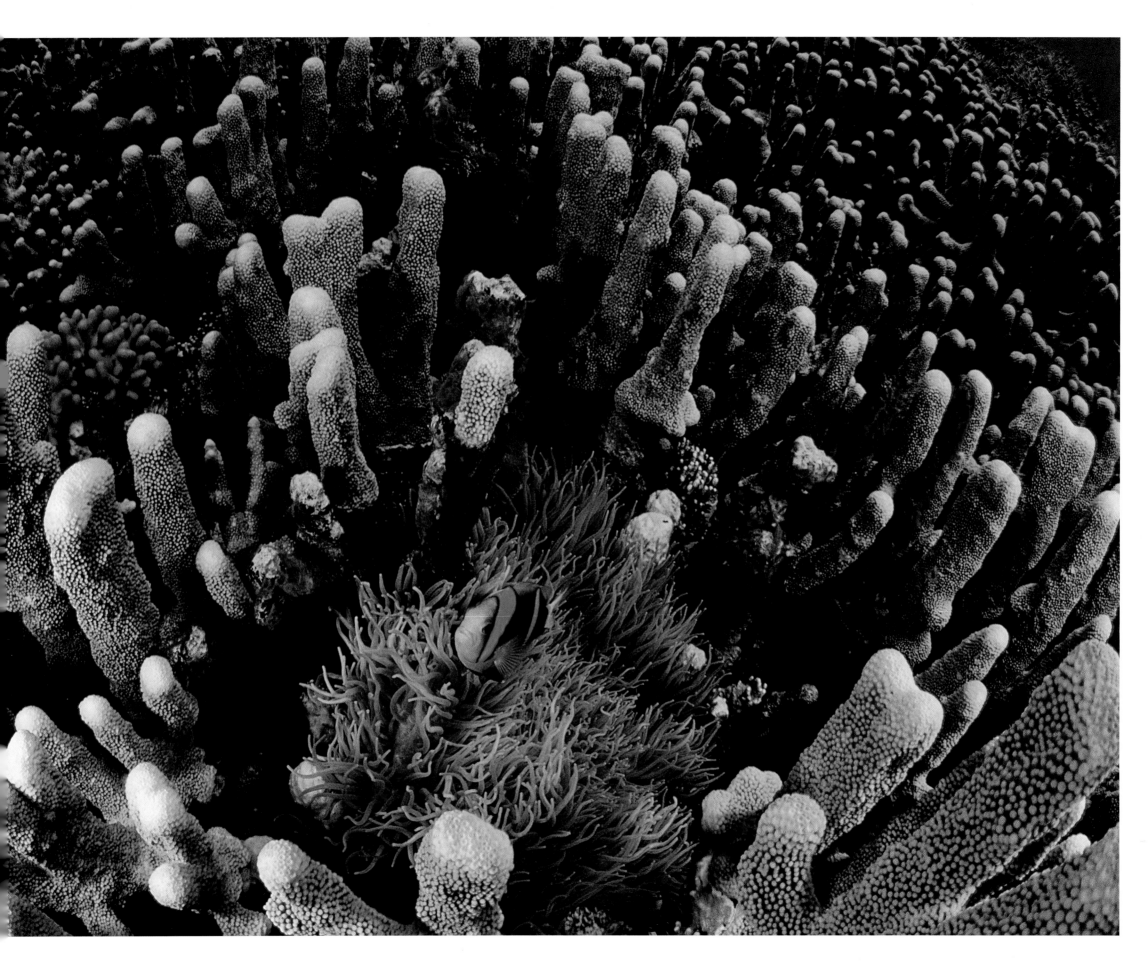

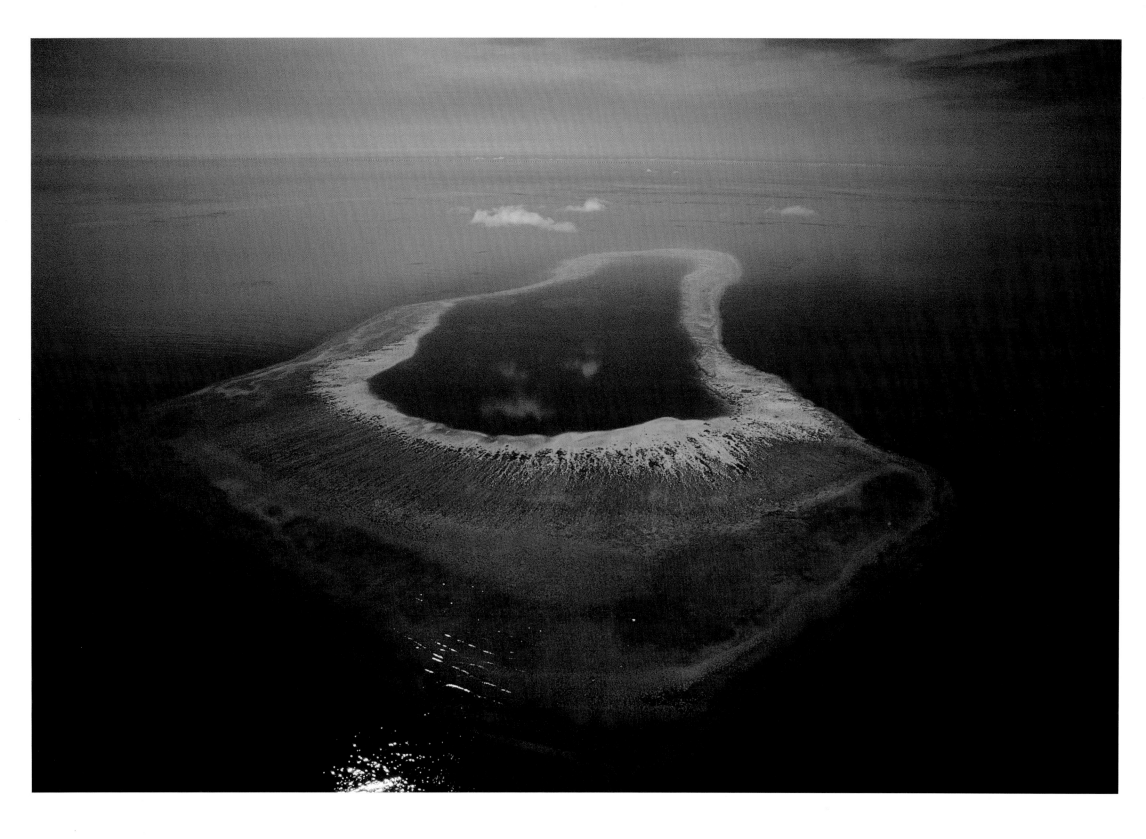

Yule Detached Reef

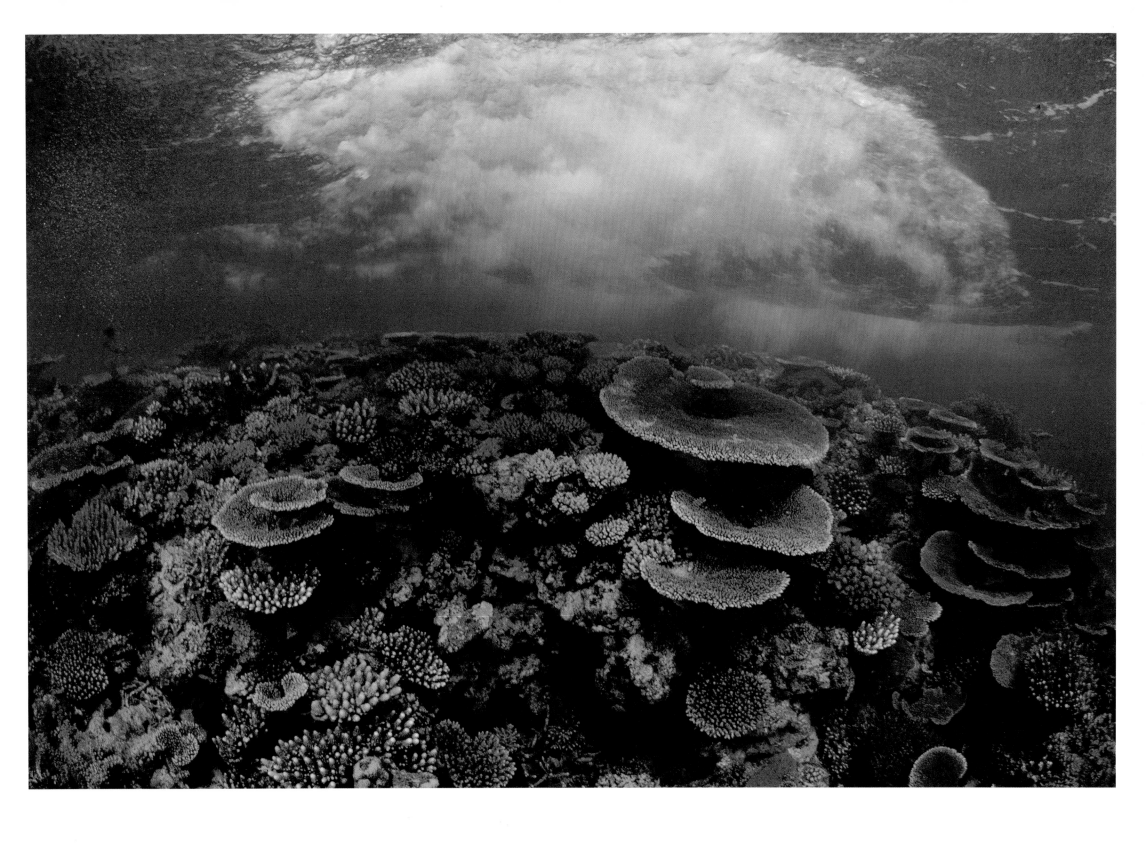

Plate corals, Number 10 Ribbon Reef

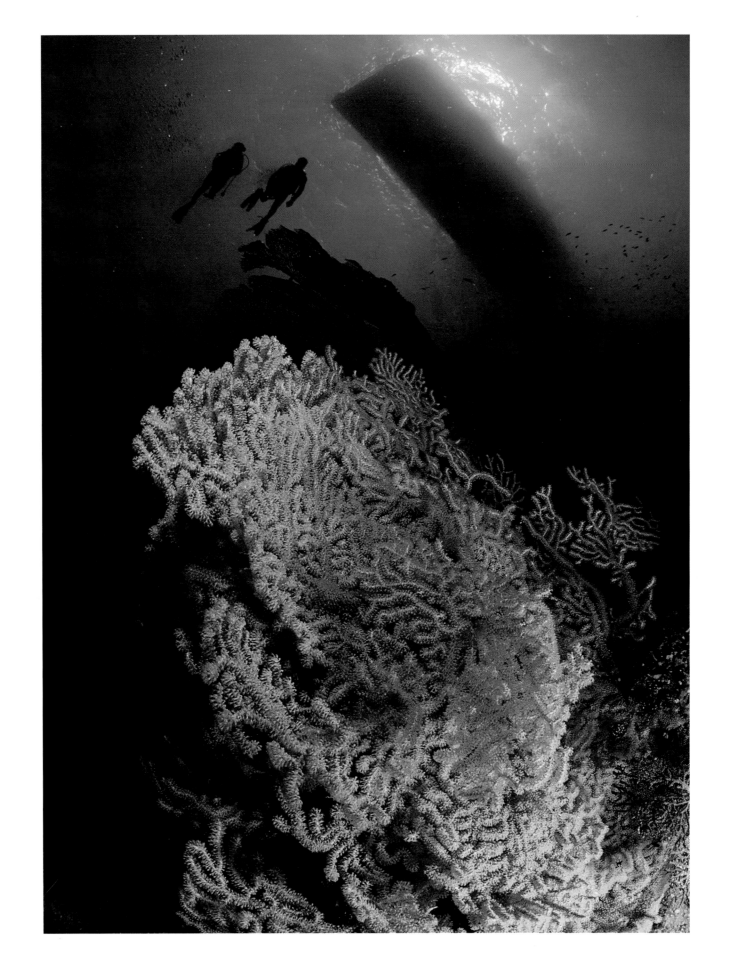

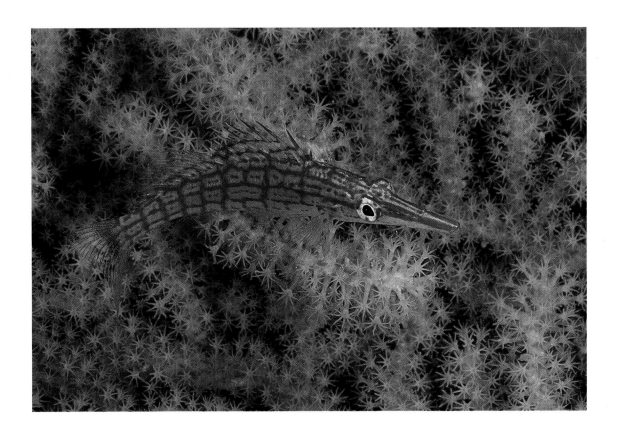

Longnose hawkfish in yellow gorgonian coral, Eastern Fields

OPPOSITE: Yellow gorgonian coral, Eastern Fields

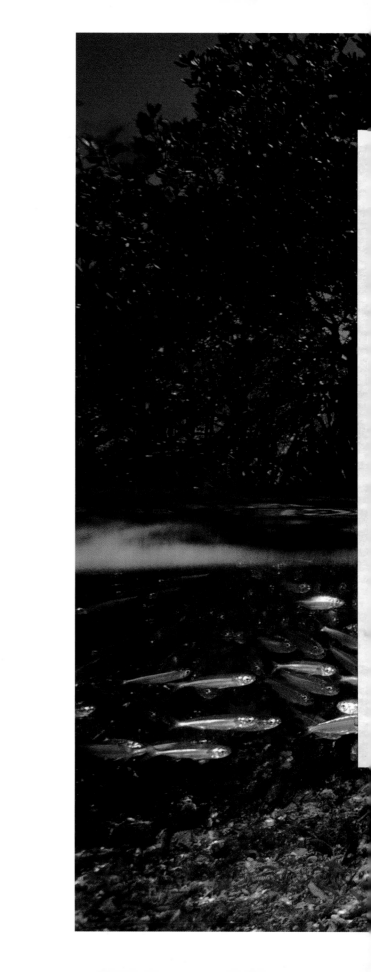

Mangroves and hardyheads, Low Isles

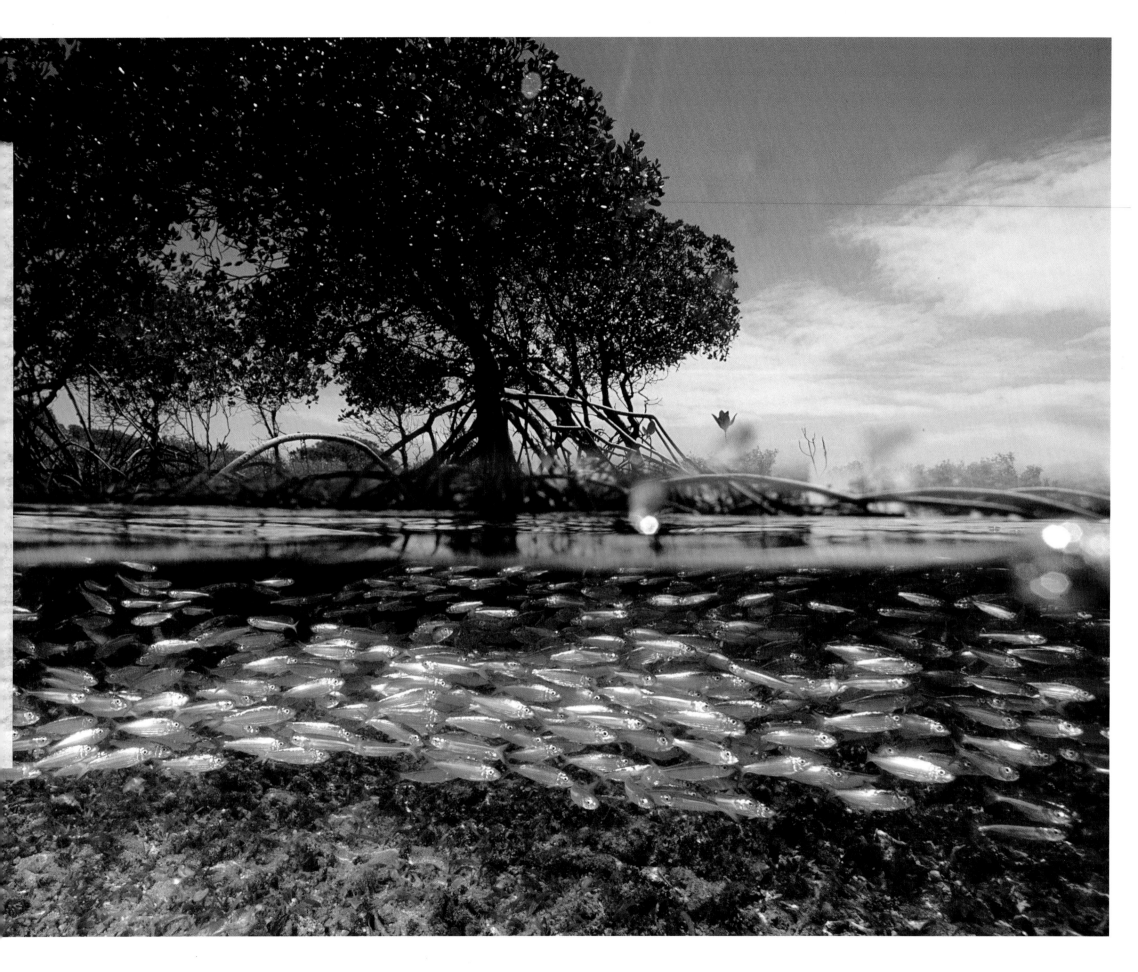

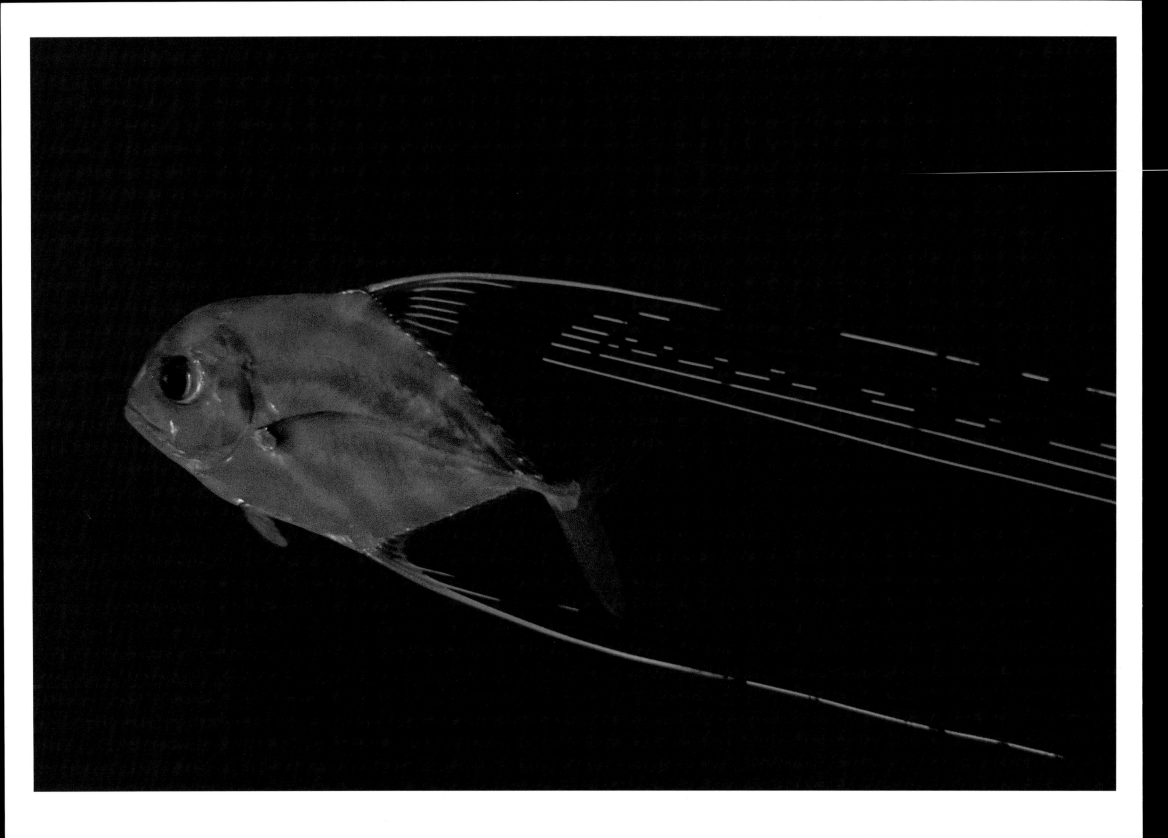

Filament fin jack, Raine Island

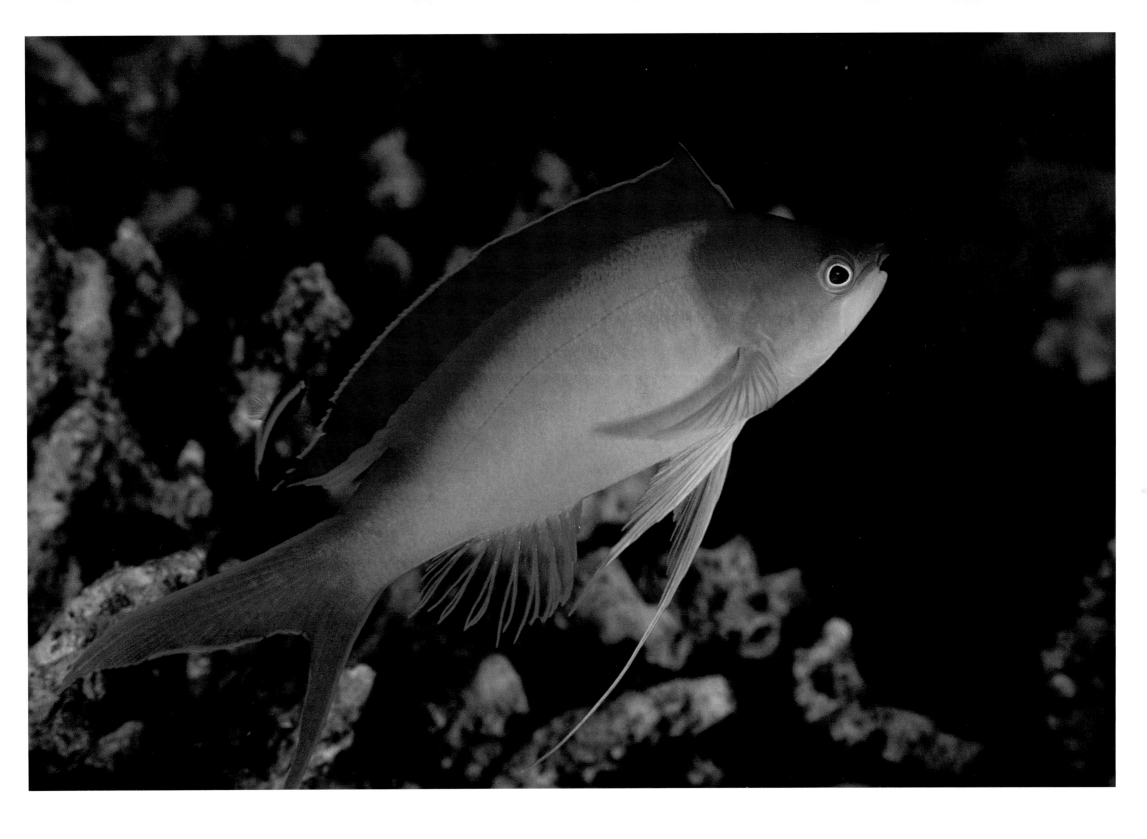

Male anthias displays, Pixie Pinnacle, Number 9 Ribbon Reef

OF BOMMIES AND PINNACLES

Bommies (from an Aboriginal word "bombora") are coral heads or coral towers that rise from deep water to within inches of the surface. They are biological, geological, diabolical structures designed to tear the bottoms out of ships. Coral pinnacles are, of course, large, stiletto-like mountains that also soar to within inches of the surface and naturally tear the bottoms out of ships.

This is the traditional view.

They are, however, absolutely the best places to dive along the Great Barrier Reef. Bordering the ends of reef systems, bommies are bathed in the currents driven by sometimes massive tides yet are protected from the destructive swells of the open ocean. The currents bring plankton and nutrients, and the ocean floods the bommies and pinnacles with clear water.

There is little space for the corals to grow, so the competition is fierce. The coral growth is magnificent. It reminds me of a wild, yet totally planned, English garden. The swirling currents also bring plankton to the open water surrounding the bommies and pinnacles. This attracts schooling fish. In essence, bommies and pinnacles become vertical coral malls or, better yet, department stores.

Pixie Pinnacle, at the southern end of Number 9 Ribbon Reef, is a perfect example of this coral department store. Instead of taking the elevator to the top floor and walking down, I jump in, swim to the first floor, then work upward. There is a small forest of elephant ear sponges that actually look elephant gray or gray-brown and have a velvet texture. On the underside of one, I find half a dozen inch-long gobies with orange-red eyes and flattened heads. They move along the soft surface folds of the sponge, eating the plankton that lands there.

The elephant ear sponges, like all sponges, are filter feeders. They are porous and are translucent when I look up at them silhouetted against the surface sun. Holding my breath so the bubbles will not disturb the gobies, I watch the little fish swim across the lace curtain of the sponge.

Farther up the pinnacle there is a belt of gorgonians (sea fans). I find a lionfish partly obscured, wings folded back, waiting for an orange anthias or blue chromis to swim by.

A pair of reef cuttlefish are courting. A rival male hangs in the distance. When they mate, cuttlefish softly mash into each other, head-to-head, arms entwined. Their round eyes become slit-like, and they both blush a grayish white. Later, the female will take her eggs in her arms and place them carefully in a branching tree coral or other object on the ocean bottom.

The skin of a cuttlefish has chromatophores, cells that can change color. Its complex skin can go from a dull brown to a gold, black, or red color, but when it is disturbed the animal can develop vibrant zebra stripes. The cuttlefish elongates its arms and puffs its body up with water in an attempt to terrorize its foe: a rival cuttlefish or, worse yet, an underwater

Bommie, Outer Reef, Cairns

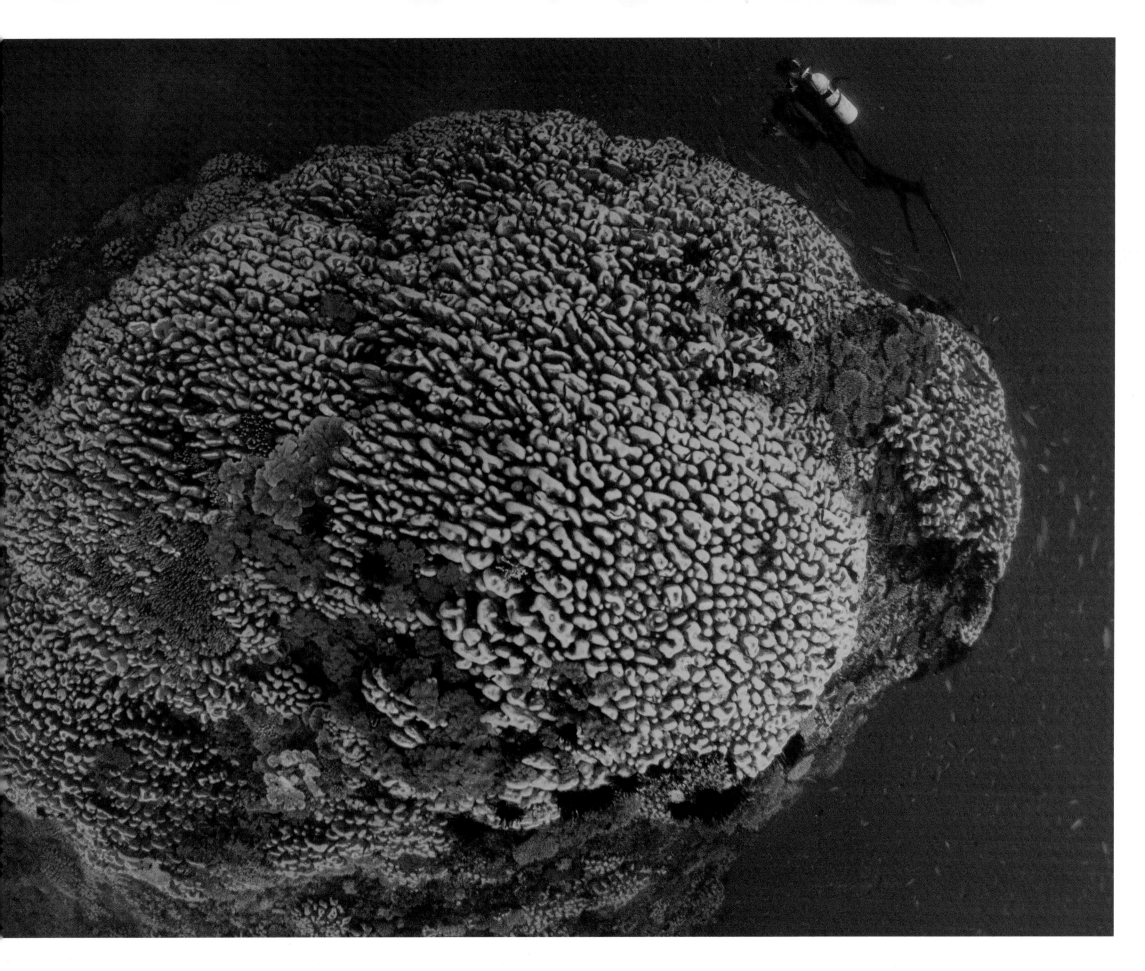

photographer. To escape, it squirts ink and pumps water through its siphon to jet away.

The top of the pinnacle is covered in clouds of schooling fish. They swim in a constant carousel. Yellow-striped bream blend with yellow-striped goatfish. In the blue water, a school of metallic, silver-colored jacks hang motionless in the current. Purple and orange anthias swim out from the reef, feeding in the current. There are thousands of them, and when a jack on patrol tries to eat one, in a frenzied dash, the entire school of anthias covering the top of the pinnacle flinches.

Blue-striped cleaner wrasses swim from the gills of a blue-spotted grouper. A male anthias stops to display, stretching his fins to impress the drab purple females. A little blue-striped cleaner wrasse takes advantage of this motionless fish and does a bit of cleaning. Striped sergeant majors guard their recently laid eggs. The egg masses look like patches of dark purple stucco plastered against dead coral. The sergeant majors make flying rushes and croaking sounds at any predator that approaches the eggs.

I spot an anemone with short tentacles the color of a putting green. A porcelain crab lives in the anemone, cleaning it like a greenskeeper. The crab also uses its complicated mouth to sweep and filter the water for planktonic morsels. I stay on the top of the reef till the sun begins to set. It makes a glittering ball just under the surface and bathes the top of the pinnacle in yellow light. The lionfish come up

from the deep sides of the reef, spread their winglike fins, hover, and begin to hunt as the twilight deepens.

Out of the corner of my eye I catch two pieces of reef detach and swim into the open blue water—a pair of stonefish. Stonefish are the largest and most venomous of the scorpionfish family. They are about the size of bread loaves and hump and waggle through the water rather than swim. One is a mottled maroon; the other is red and yellow. They have an upholstered look—their thick skin covers even their venomous dorsal fins. The two stonefish found a perfect niche in the reef and became…well…stones, so perfectly camouflaged that it took me a minute to find their eyes and downturned mouths with social worker smiles.

Stonefish, like all scorpionfish, hunt by waiting totally camouflaged on the reef. When an unsuspecting fish bumbles past, they strike, springing forward half their body length as their complicated mouth unfolds, elongates, and inhales their unlucky prey. All of this happens in about a tenth of a second.

The blue water turns gray, still holding the last of the twilight. The feather stars open and begin to feed. Basket stars unfold into delicate white nets that catch the rising night plankton. Red squirrelfish, with their large eyes, emerge from the reef into the dark sea. I push away from the pinnacle and swim toward the light of the dive boat. The minor cosmos of coral disappears in the night.

Schools of yellow-striped snappers and yellow-striped goatfish, Pixie Pinnacle, Number 9 Ribbon Reef

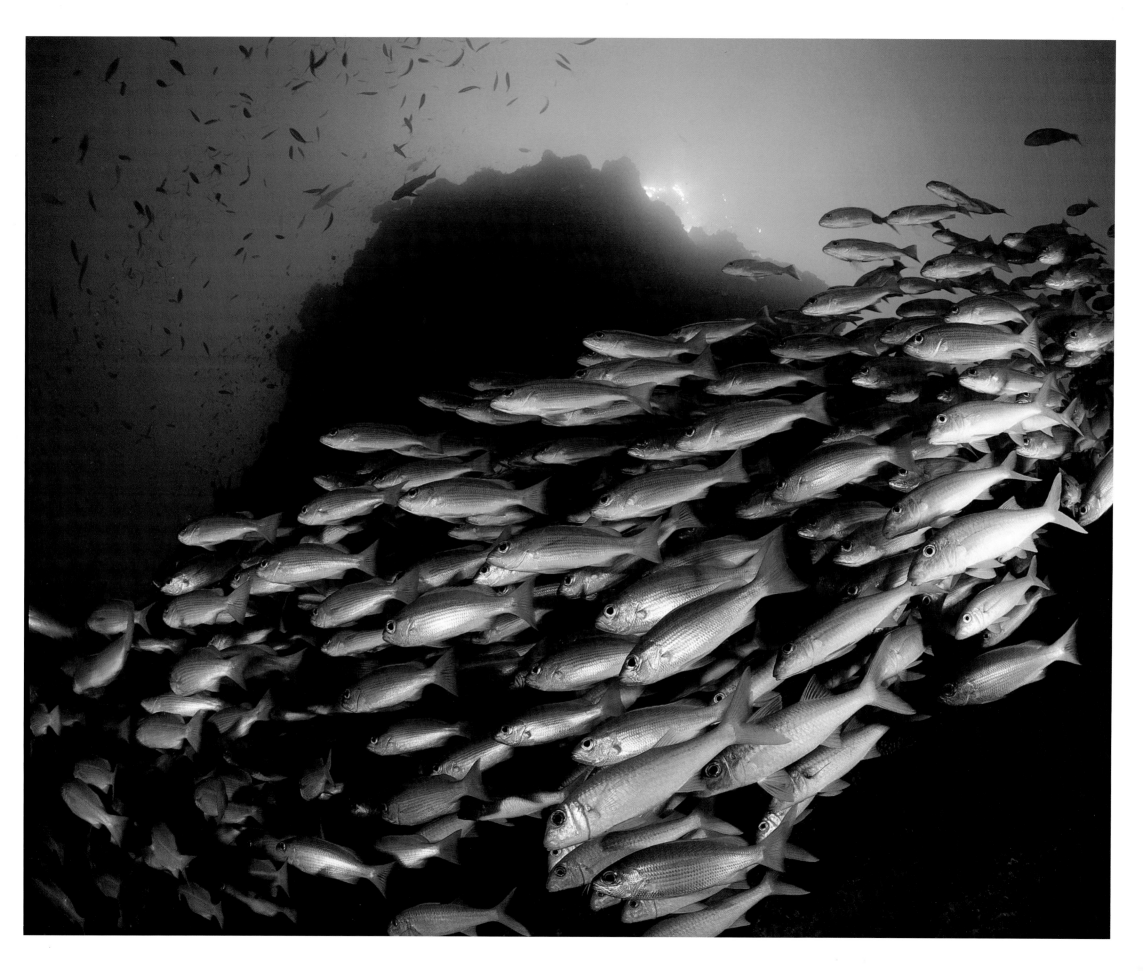

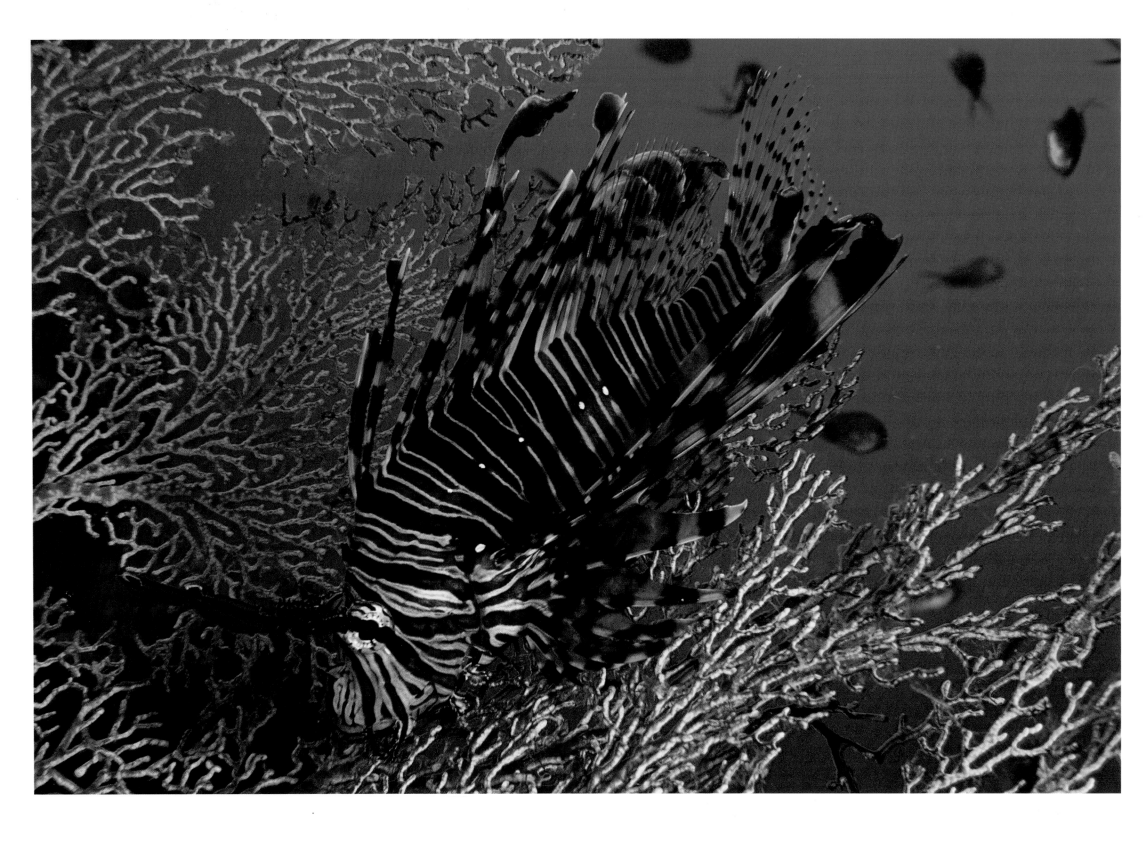

Lionfish hunting in gorgonian coral, Pixie Pinnacle, Number 9 Ribbon Reef

Stonefish, Pixie Pinnacle, Number 9 Ribbon Reef

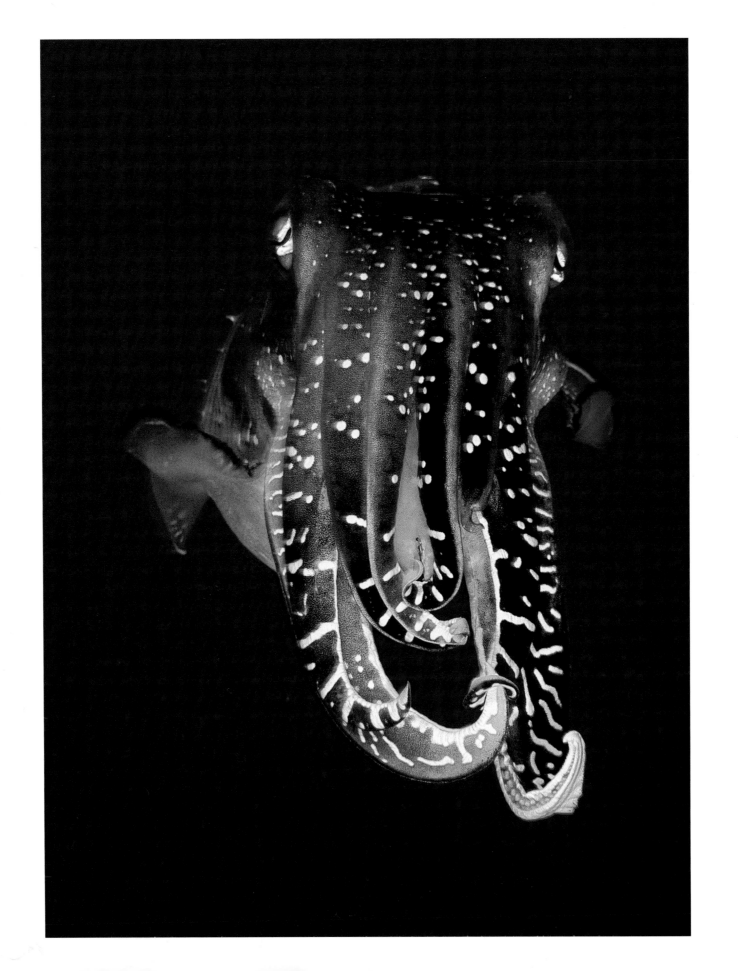

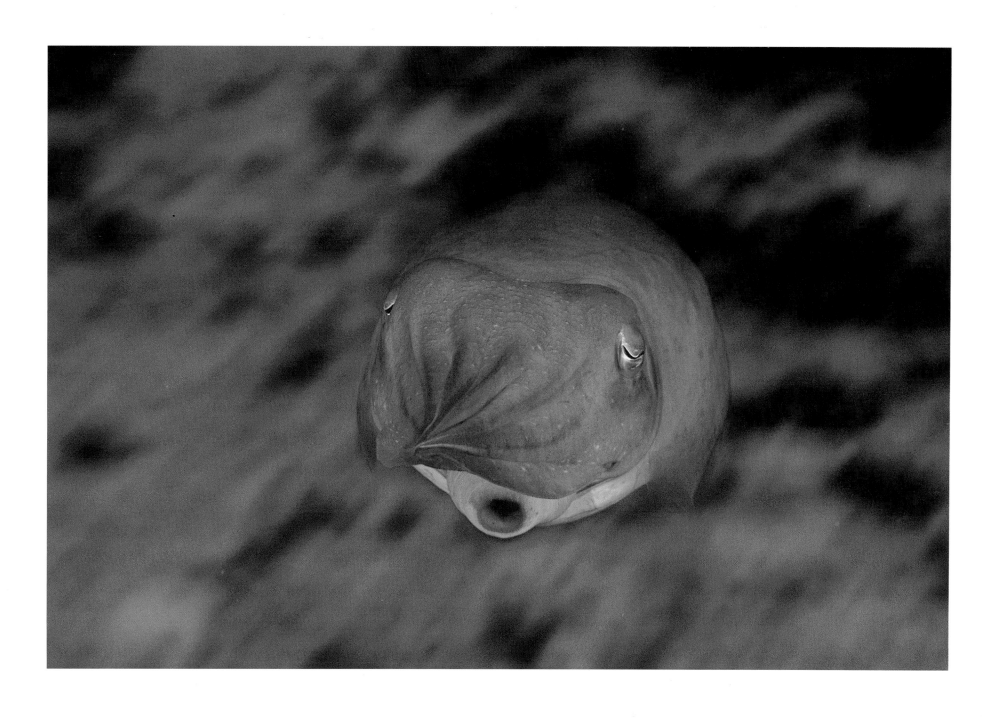

Cuttlefish jetting away, Pixie Pinnacle, Number 9 Ribbon Reef

OPPOSITE: Cuttlefish displaying, Pixie Pinnacle, Number 9 Ribbon Reef

THE COD HOLE

Number 10 Ribbon Reef. It is the classic barrier reef: an unbroken, narrow 13-mile-long coral bastion that holds back the wild, open Coral Sea. At the north end of the reef there is a small coral alcove, a sanctuary from the sweep of the currents that sluice through the Cormorant Pass. A wonderful group of creatures live here, *Epinephelus tukula*, potato cods. They are big gray fish, piebald actually, with blubber lips and turret eyes that have a ponderous sadness about them. The largest may be six feet long and weigh more than 200 pounds. They are the stars and starlets of the reef.

The Cod Hole was discovered nearly 30 years ago and drew worldwide attention from the works of Australian naturalists and filmmakers Ron and Valerie Taylor, who not only popularized the residents of Number 10 Ribbon Reef, but were instrumental in protecting these fish in Australia's waters. The cods are friendly, inquisitive creatures, easy to catch, easy to spear, and in the blink of an eye could be wiped out.

Divers feed the potato cods. In the morning when the dive boats arrive, the cods race to the moorings with torpedo anticipation. A diver descends with a feeding drum and is mobbed. There are cods suspended overhead, others, belly to the sand, are underfoot; there are underarm cods and elbow cods. They don't bite or grind, but inhale with great thumping gulps. Like feeding dogs, it is very satisfactory. In five minutes the food is gone, disappeared, or, as the Australians like to say, "down the tucker-shoot."

The fish mill about until the next dive boat arrives. The dive masters try desperately to be equal opportunity providers for all the fish; big, small, shy, aggressive, but it's not an easy task.

When they are satiated, their stomachs full, they wander about dazed, in gastronomic bliss. Now come the cleaning shrimps and wrasses, which set up shop for the business of vacuuming cod parts. For a moment the cods cease to be fish and resemble old men at a club. They look as if they should be smoking huge cigars. After a while they slowly drift off into deeper water at the edge of the channel.

Away from where the cods gather there is another special place at the Cod Hole. A large bommie is a gathering spot for many-lined sweetlips. These are 20-pound fish with alternating yellow-and-white dotted stripes and pink, bubblegum lips. They form a school that hovers over the bommie like a cloud. The fishes' lines blend together with M. C. Escher-like precision. Where does one fish end and another begin? Viewed head on, the school is a series of eyes swimming above pink lips that really do look like candy store lips. One by one the fish peel off to be cleaned. The cleaner wrasses appear to be much like attending physicians, helping to heal the wounds. As the fish yawns and stretches, the little blue-and-white wrasses swim into the labyrinth of gills and out of the mouth.

The swells push over the outside of the reef. The large tide changes, the water goes from blue to green, and another day at the Cod Hole ends.

Potato cod being cleaned by a blue-striped wrasse, Cod Hole, Number 10 Ribbon Reef

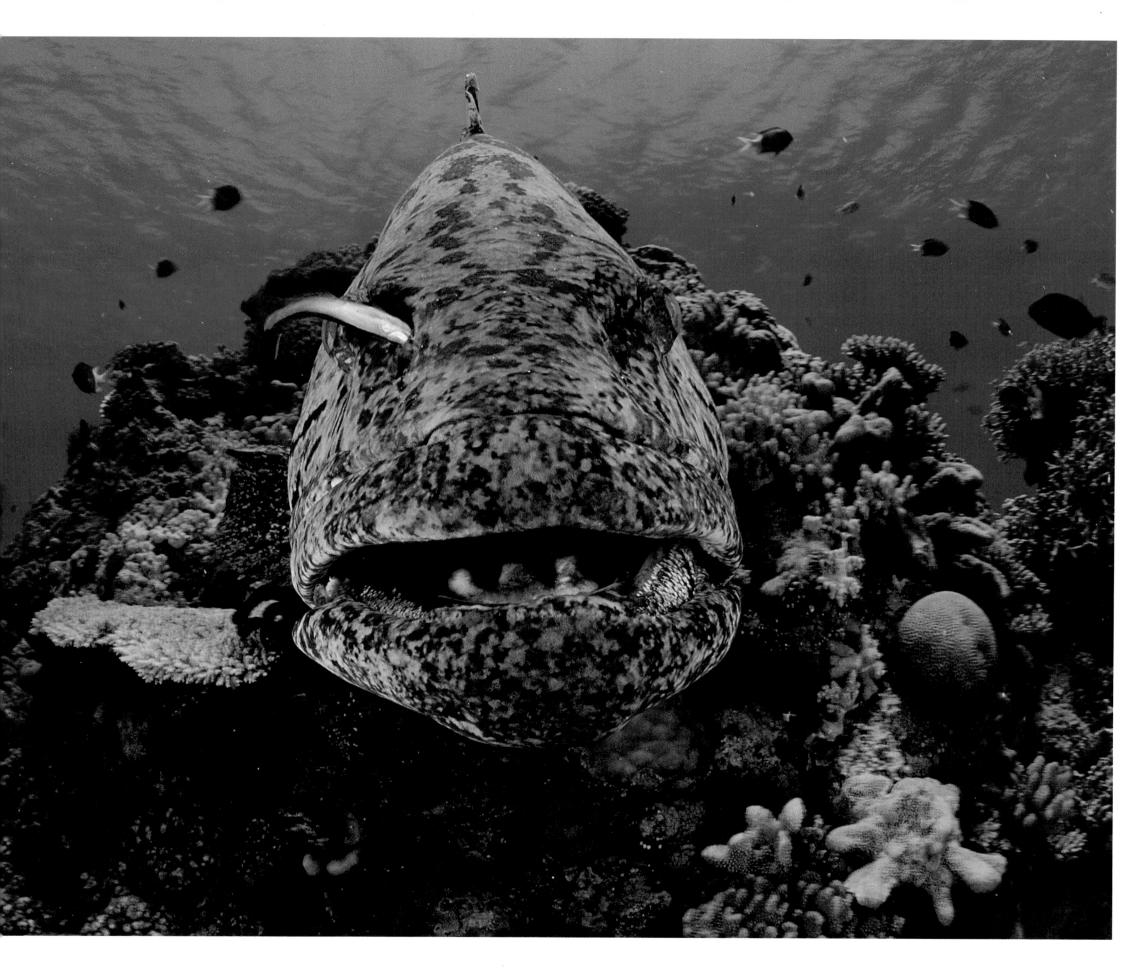

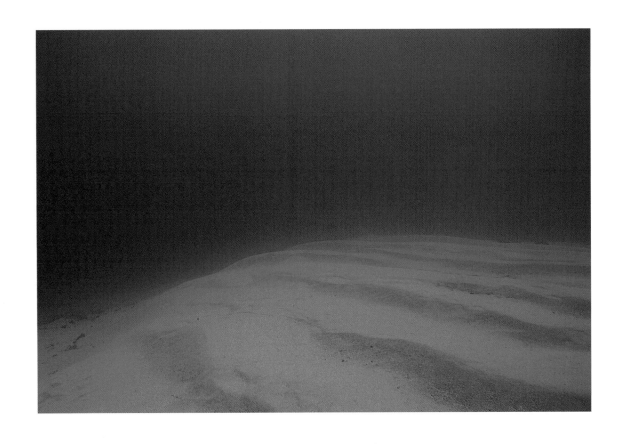

Sand fall, Number 6 Sand Cay, Northern Reefs

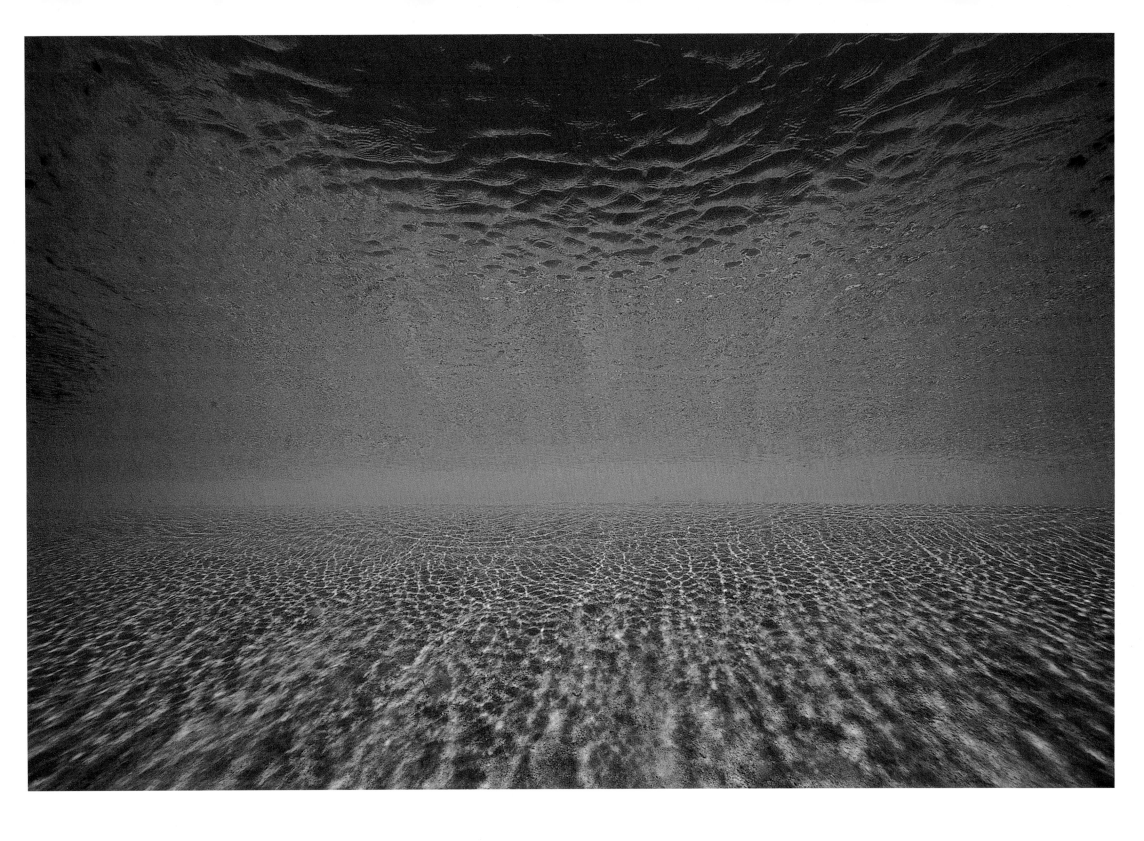

Sand field, Number 6 Sand Cay, Northern Reefs

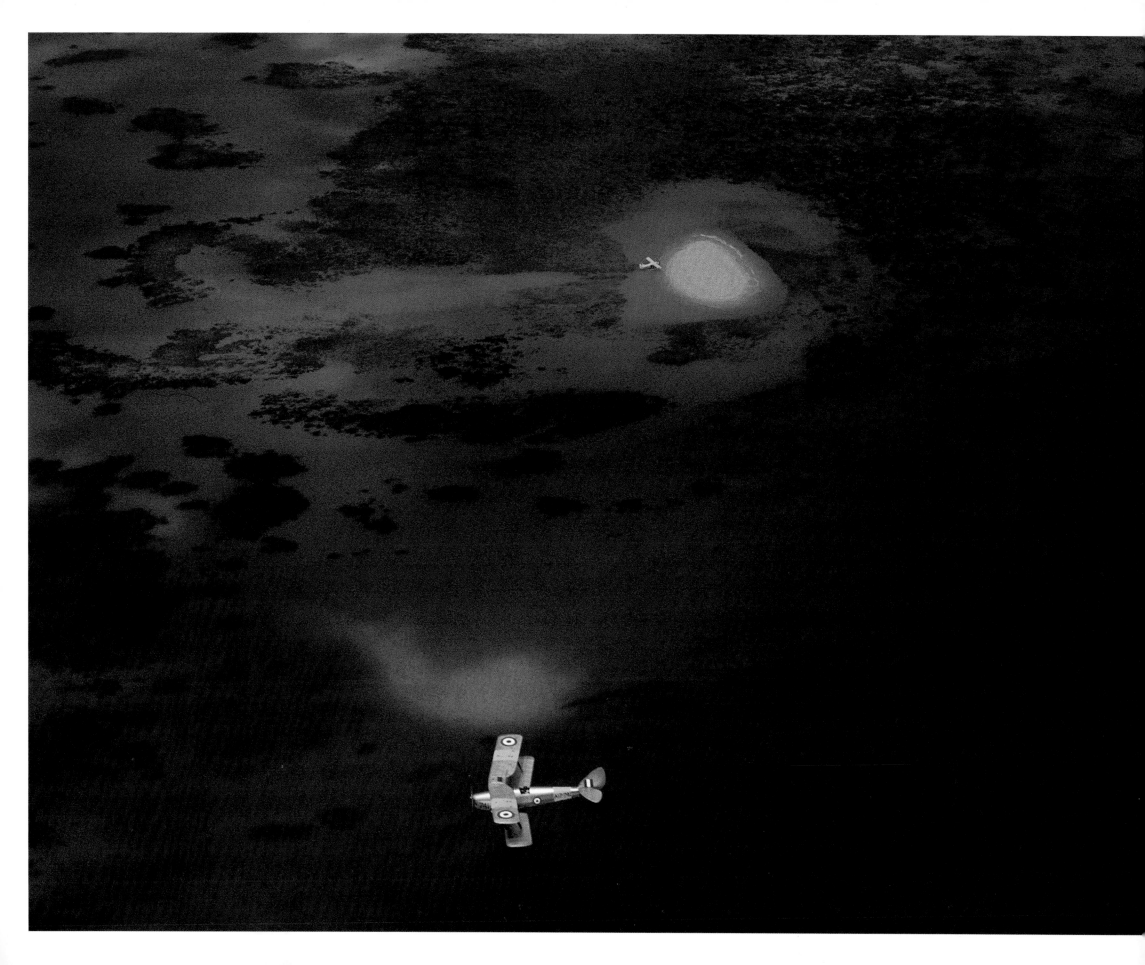

De Havilland Tiger Moth aircraft over Sand Cay, near Cairns

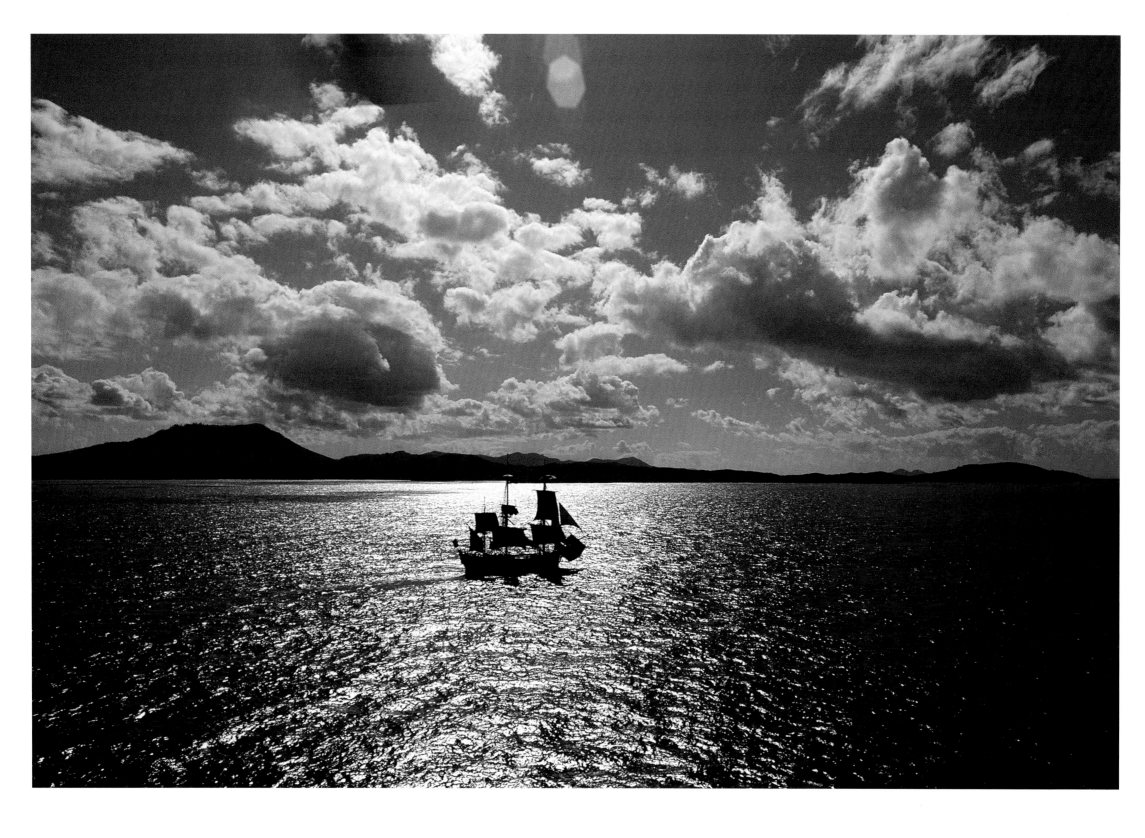

Endeavour replica sailing past the Whitsundays

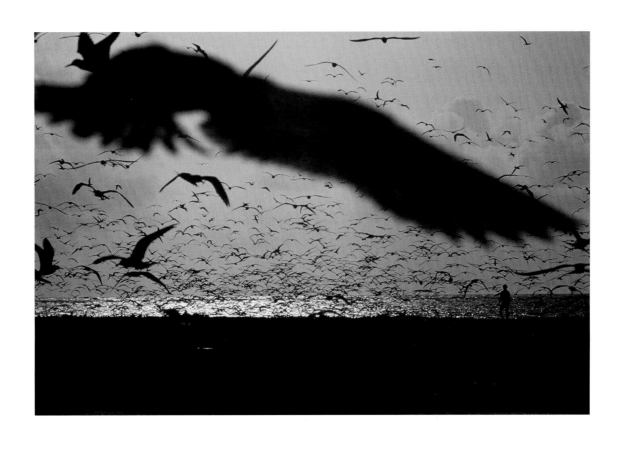

Morning, Number 6 Sand Cay, Northern Reefs

Number 6 Sand Cay, Northern Reefs

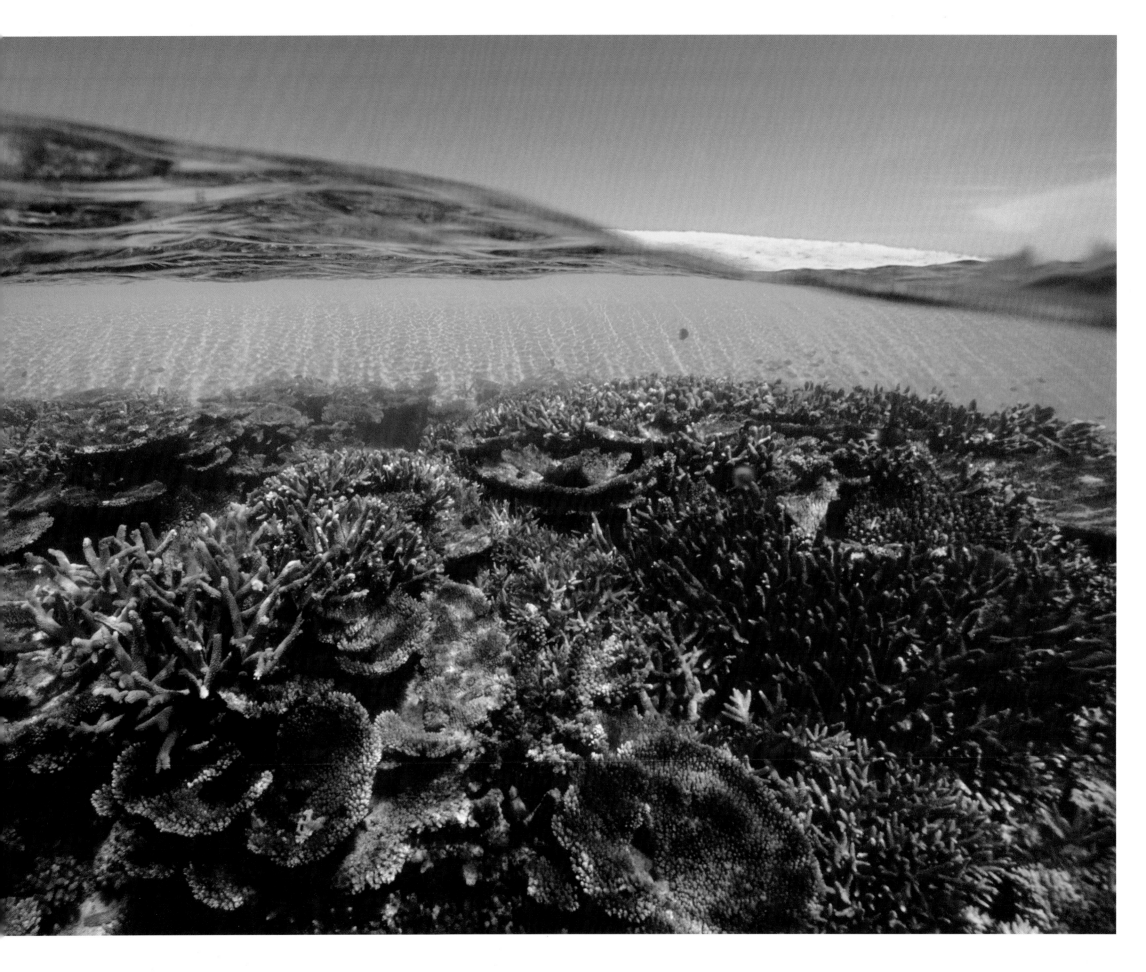

LAYERS OF LIFE

FOLLOWING PAGES: Clownfish and anemone, Northern Reefs

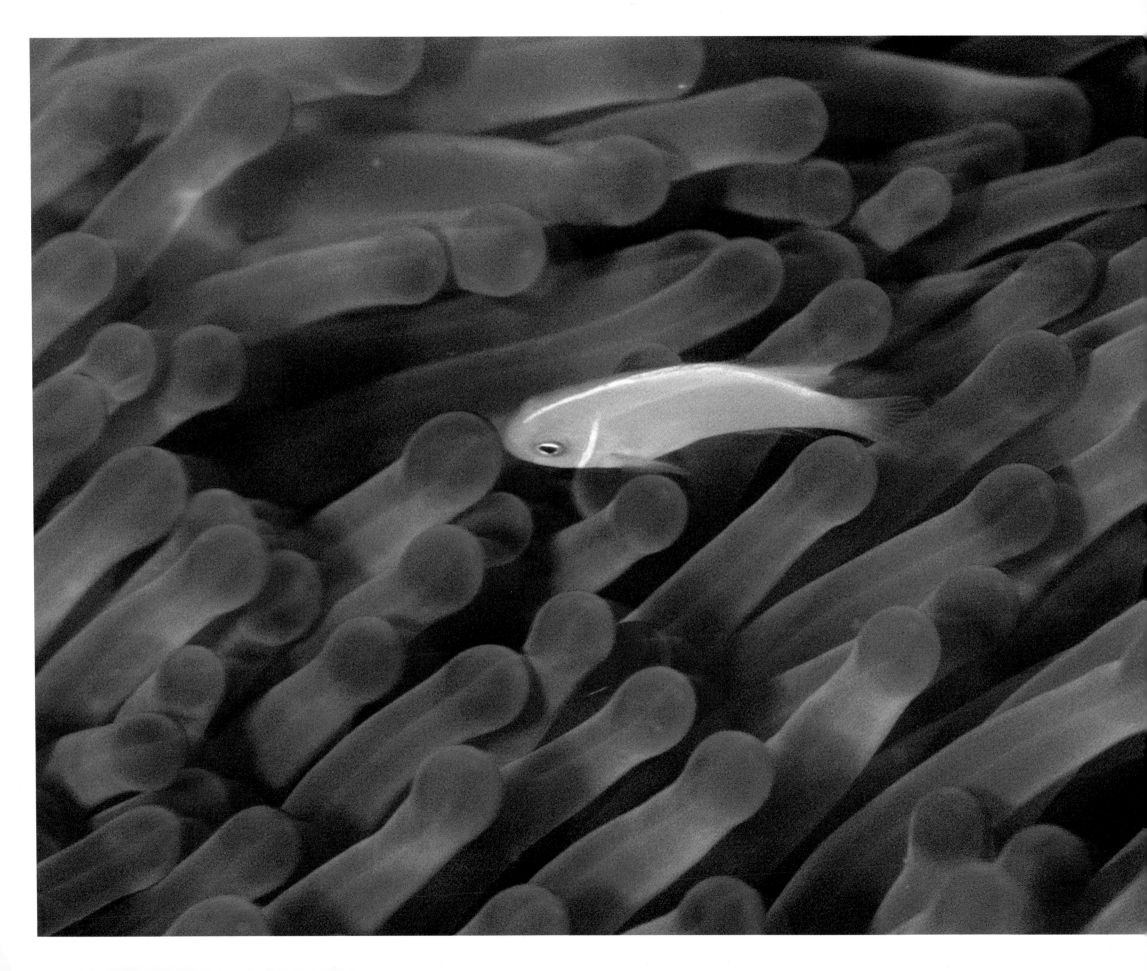

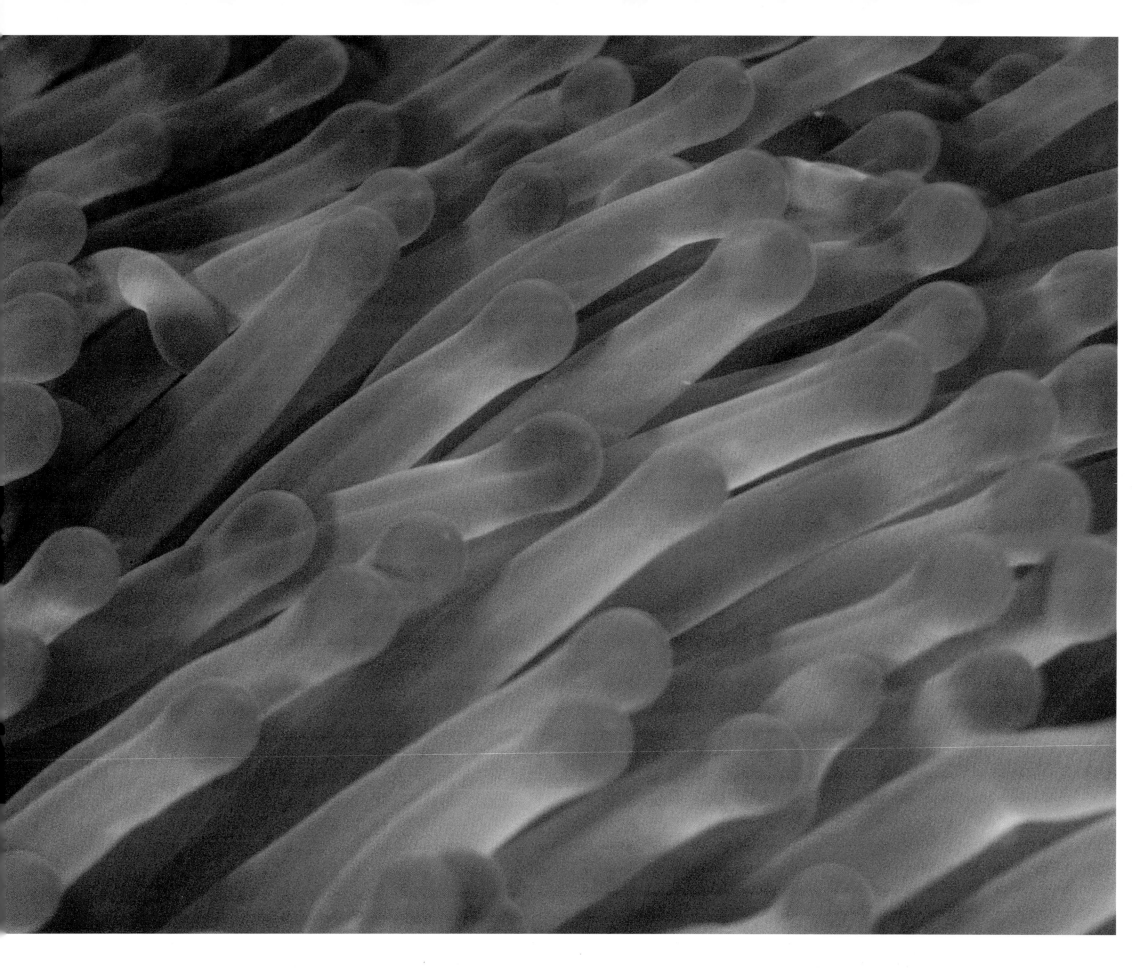

"CITIES IN THE SEA"—IT IS A WONDERFUL PHRASE. Dr. Robert Ginsburg of the University of Miami is a marine geologist who looks at reefs with biological spectacles. He uses the metaphor as a teaching tool: "Corals are apartment houses, sponges are the water purification system, and crustaceans are the street cleaners." Reefs *are* cities—coral condominiums, townhouses, and office towers built in a world without gravity or geometry. It is architecture driven by a fine madness, governed by light and water. It is total visual chaos, and to try to organize a coral reef into a graspable image is like trying to bring order and discipline to a Jackson Pollock painting.

Here is a reef with table corals, tree corals, staghorn corals, sea fans, and soft corals. Sponges, sand, rubble, canyons, mountains, towers, and domes of brain coral. Flowing over it like veils, hiding in cracks within it, grazing on it and burrowing into the sand around it are fish, invertebrates, and carpets and lawns of algae. Everything is related, and they are all feeding on each other. We see this not by walking over the reef like mountain climbers, but, as divers, we soar above it, around it. It moves, we move, pushed by the rhythm of the ocean.

There are layers of behavior. A simple necessary function such as cleaning behavior is not so simple—it is surrounded by other behaviors. The blue-striped cleaner wrasse does a complicated dance to attract a fish. As the fish relaxes, the wrasse moves about cleaning its gills, removing dead skin and parasites. Meanwhile, there is another fish, not a wrasse but a blenny, with huge hidden fangs, which looks very much like the cleaner wrasse and imitates its dance. The unsuspecting fish relaxes, and the imposter bites the hell out of its customer.

Like people in a city, every type of fish has a different job, its niche in the coral complex. There are the grazers: the feisty damselfish; the parrotfish, whose bionic jaws and chisel teeth allow it to eat coral and produce sand for beaches; butterflyfish, with long forcep snouts; and wrasses with trunk-like snouts that probe and vacuum coral corners. Then there are the hunters, such as the jacks, designed to give chase, while others, like the scorpionfish, are designed to lie in wait. Reef life is not only complex, it is very busy. Try to follow one fish, such as a blue chromis (they live in the tops of corals, usually in groups of two or three dozen) for ten minutes. It's impossible; it will make you crazy.

I find the most beautiful image on a reef, one that captures color, movement, gesture, and rhythm, is that of the anemone and its partner, the clownfish, also called the anemonefish. Anemones are the crown jewels of a reef. Here, a garishly colored clownfish lives in what looks to be an enormous flower, and everything is moving, flowing. The "flowers," of course, are anemones, which take their name from a flower they resemble. Their tentacles, which move in the sea like a mermaid's hair, surround a central mouth. The anemone uses its tentacles to feed on plankton and, like coral, cultivates algae in its tissue. It uses nematocysts, or stinging cells, on its tentacles to defend itself and capture prey.

Clownfish slip in and out of this forest of tentacles. The effect is of wildly costumed actors moving in front of an elegant curtain. It is hypnotic. The relationship is complex, and only now are scientists, such as Dr. Gerry Allen of Conservation International, beginning to understand how this partnership works. There are about a thousand species of anemones worldwide, but only ten species harbor clownfish. The ten species are found only in the Indo-Pacific Ocean, and all of them are residents of the Great Barrier Reef. Anemone and clownfish partnerships do not occur in the coral seas of the Atlantic. Clownfish are members of the damselfish family. There are 28 species of clownfish, of which 6 species partner with anemones on the Great Barrier Reef.

The clownfish finds safety among the anemone's stinging tentacles. But why is it not stung? Does the clownfish exude a mucous that protects it? Not exactly. A good experiment is to remove the clownfish from its host anemone for a few hours and then return it. Upon its return, the fish is stung but continues to rub its body among the tentacles and acquires a mucus coating from the anemone. The tentacles of the anemone have a mucus coating for self-defense—otherwise it would be devoured by polyp-feeding fishes. A complete explanation? Not exactly. The fish has special chemical properties in its mucus that inhibit the nematocyst-triggering mechanism.

Home life in the anemone is not exactly a simple down-on-the-farm existence. It is a bizarre,

big-city lifestyle. The largest clownfish is a dominant female who began life as a male. Sex change is commonplace here on the reef—wrasses, groupers, and parrotfish share this alternative lifestyle, but they begin life as a female. The next largest clownfish in an anemone group is a male, her consort. If the female is removed or dies, the dominant male becomes a female and within a week can grow to twice its size. The next largest fish takes its place in the line of succession. This preserves the reproduction cycle. Although the smaller fish are constantly on guard against the dominant female and her male consort, they do not venture far from the anemone to other feeding areas.

Clownfish in the warm tropical waters of the northern barrier reef mate all year; their fabulous mating dance is full of chasing and nipping, as well as bobbing and tender touches. They lay their eggs, usually orange in color, beneath the protective skirt of the anemone. The male fans the eggs, which will hatch in about a week, releasing the larvae to the water column where they will drift for another week. Then, if the tiny progeny are lucky, they will settle down into another host anemone. People have been looking seriously at anemones for more than a hundred years, and the same question always surfaces: The anemone protects the clownfish, but what does the anemone get out of this arrangement? The clownfish does not attract food for its host—the anemone is competent to that end. The clownfish keeps the anemone free of silt and debris but it is cleaned by groups of shrimps that live in the tentacles. Recent experiments have shown that if clownfish are removed, their host anemone is eaten by butterflyfish. This suggests that the aggressive, highly colored clownfish defends the anemone against predators. There are no simple answers on the reef. In fact, most reef relationships read like O. Henry stories—there is always a bizarre twist.

Most fish on the reef are broadcast spawners. At dusk, males and females usually squirt eggs and sperm into the water column in upward-flowing bursts. However, there are examples of more attentive parents. Titan triggerfish are big, blue-and-gold fish with big teeth, which they use to excavate a nest in the sand. They lay their eggs, and the female defends their nest with immense aggression. Years ago at Raine Island, I told my friend Rodney Fox, the great and fearless white-shark expert, to go and pat the beautiful fish for a picture. The thing went after him like a buzz saw—it wouldn't quit, and then it came at me. Even higher on the parenting scale are the cardinalfish. After fertilization, the male cardinalfish brood a ball-shaped egg mass in their mouths with great dedication and tenacity.

In the branches of some fan corals (gorgonians) it is possible to see tiny gobies. The fish are about an inch long, and they live in the gorgonians just as birds live in trees. Soft corals have a soft, feathery skeleton. Their thick branches, filled with water, look like massive heads

of broccoli in psychedelic colors: yellow, purple, pink, orange, and mauve. I once spent 15 minutes probing the thick, water-filled branches of a giant yellow soft coral tree, looking for tiny gobies. The tree was 6 feet high and growing 120 feet down. I found two species. The giant one, two inches long, was taxicab yellow. Gobies live on the soft corals, cleaning them and feeding on passing detritus.

Different species of gobies inhabit sea-fan shaped gorgonian corals, black corals, bubble corals, elephant ear sponges, and, the most exotic spot, the mantles of giant clams. The mantles or lips of the clams contain gardens of algae that supply the clam with nutrients. These mantles are wildly colored with greens and purples, brown with green eyespots, and a most dramatic midnight blue, shot through with bright white lines that resemble lightning flashes. The little red-eyed gobies vacuum the lips of the clams. The visual effect is that of a fish living on a brilliant carpet beyond imagination.

Whip corals provide another home for gobies. They are related to black corals and stick out from the faces of reefs like giant nose hairs. One species forms a 20-foot-long corkscrew that spirals away from the reef. The diameters of the whips range from that of spaghetti to the width of a human thumb. Gobies can spend their entire lives on the whips. It's like life on a power line. A pair of gobies will clear a space to lay their eggs by biting off a section of polyps to expose the coral skeleton. They guard their young from passing predators and neighbors such as the armored shrimp that also live on the whip coral. The coral protects and camouflages the gobies. The gobies clean the polyps and make leaping forays into the open sea to eat plankton.

Golden damsels live in the arms of giant sea fans. The coral acts as a living net, and the damsels pick at it. When it comes time for a pair of damselfish to spawn and lay their eggs, they may choose a whip coral. They chew a bare spot on the coral, and, as the eggs are laid, the male fertilizes them and then tends them. The busy male cleans the areas around the eggs and pumps water over his gills as he blows on the eggs to aerate them. The eggs grow and change from gold to silver. A few days before they hatch, it is possible to see tiny eyespots. As the eggs hatch, the larvae drift into the water column high on the reef.

The layers of life on a reef seem endless. I have watched groups of divers cruise the reef as if they are looking at cathedrals in Europe, moving as quickly as possible and not seeing the gargoyles. It's wonderful to hunt for tiny subjects, but there is always an element of sacrifice. Just as I am watching a tiny shrimp clean its antennae, a group of manta rays in V formation swim past me in the blue.

There are a million stories in the cities of the sea. ✦

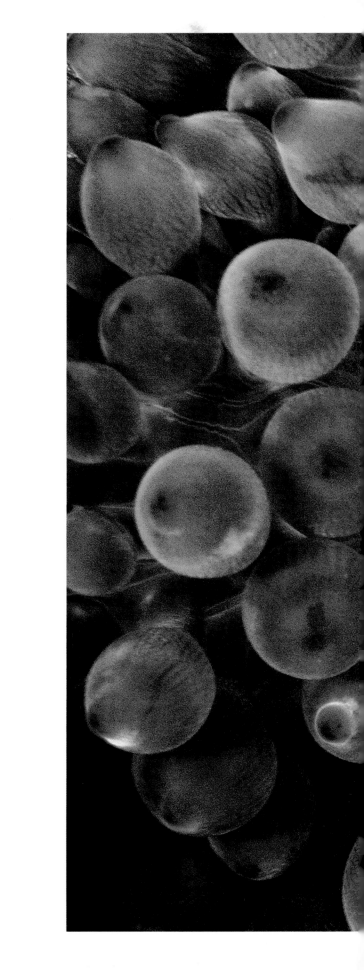

Spine-cheek clownfish and anemone, Little Detached Reef

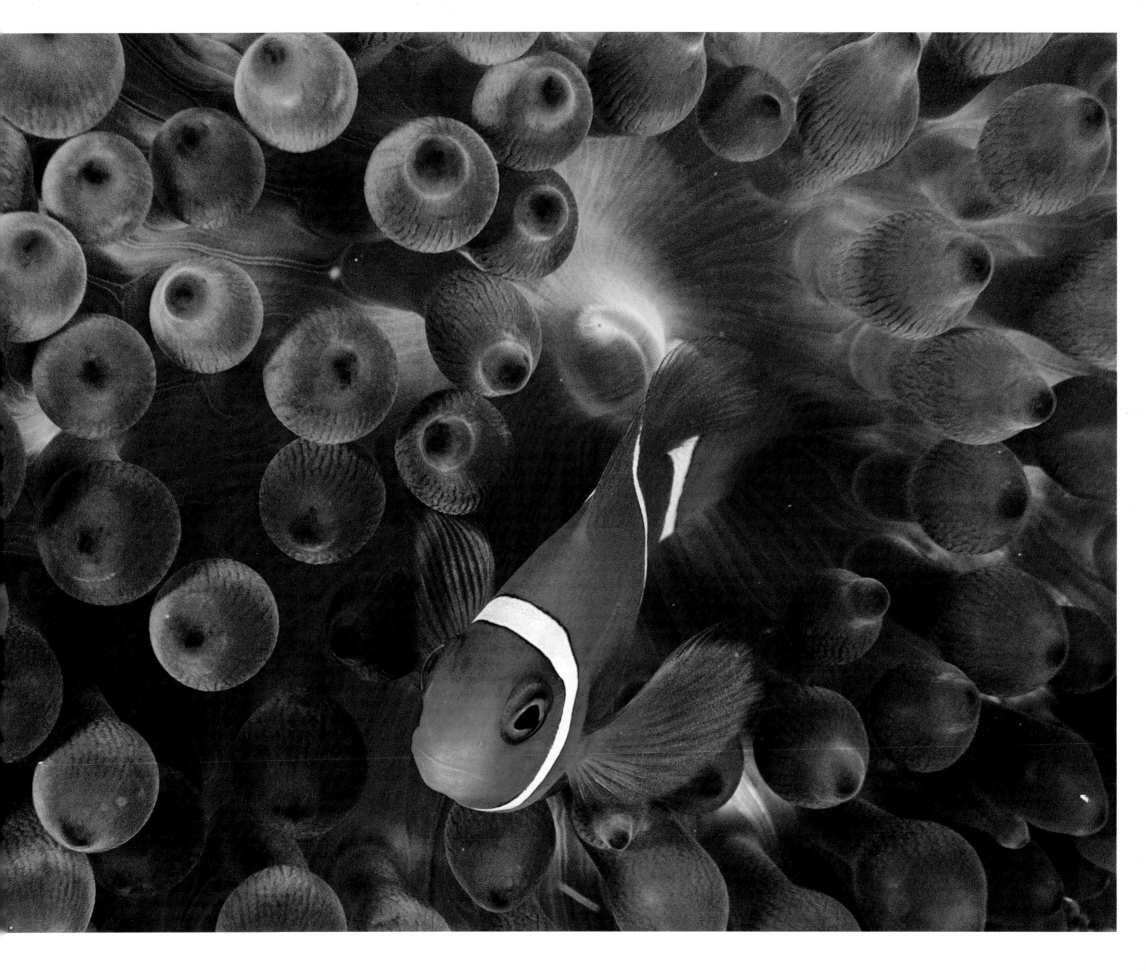

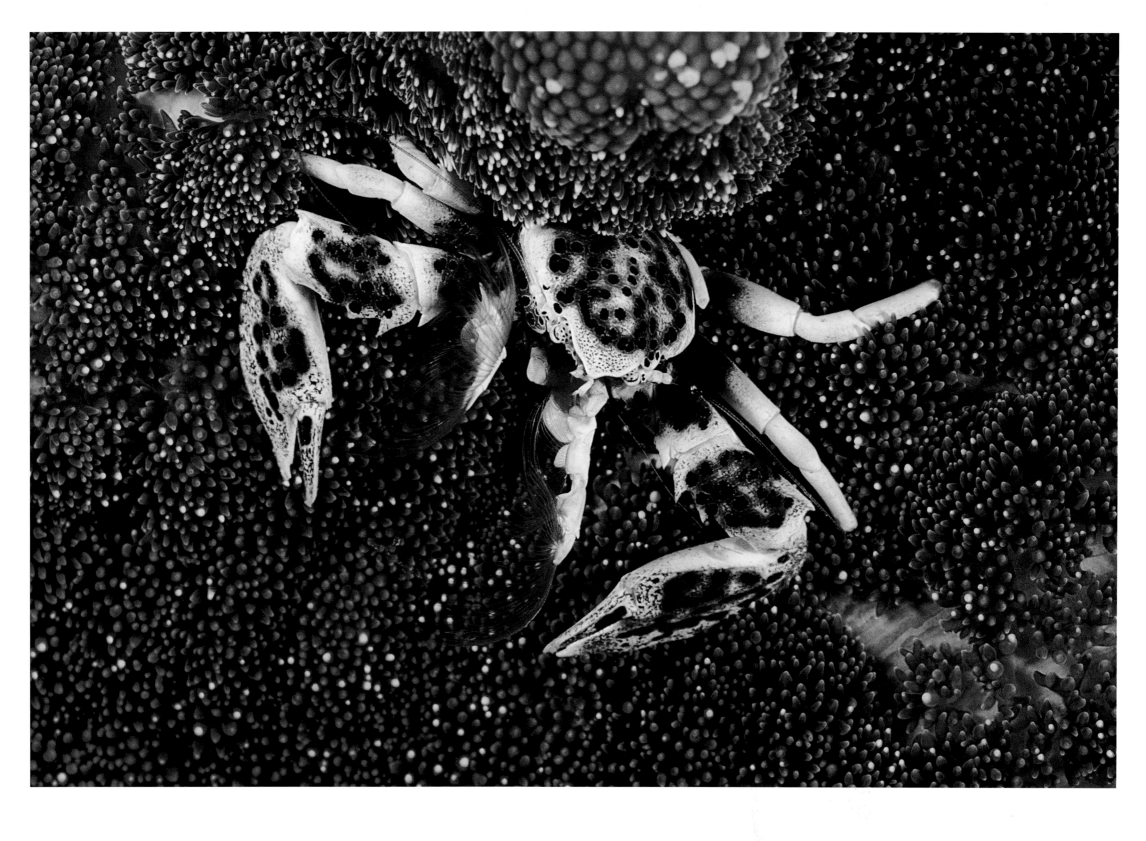

Porcelain crab and anemone, Pixie Pinnacle, Number 9 Ribbon Reef

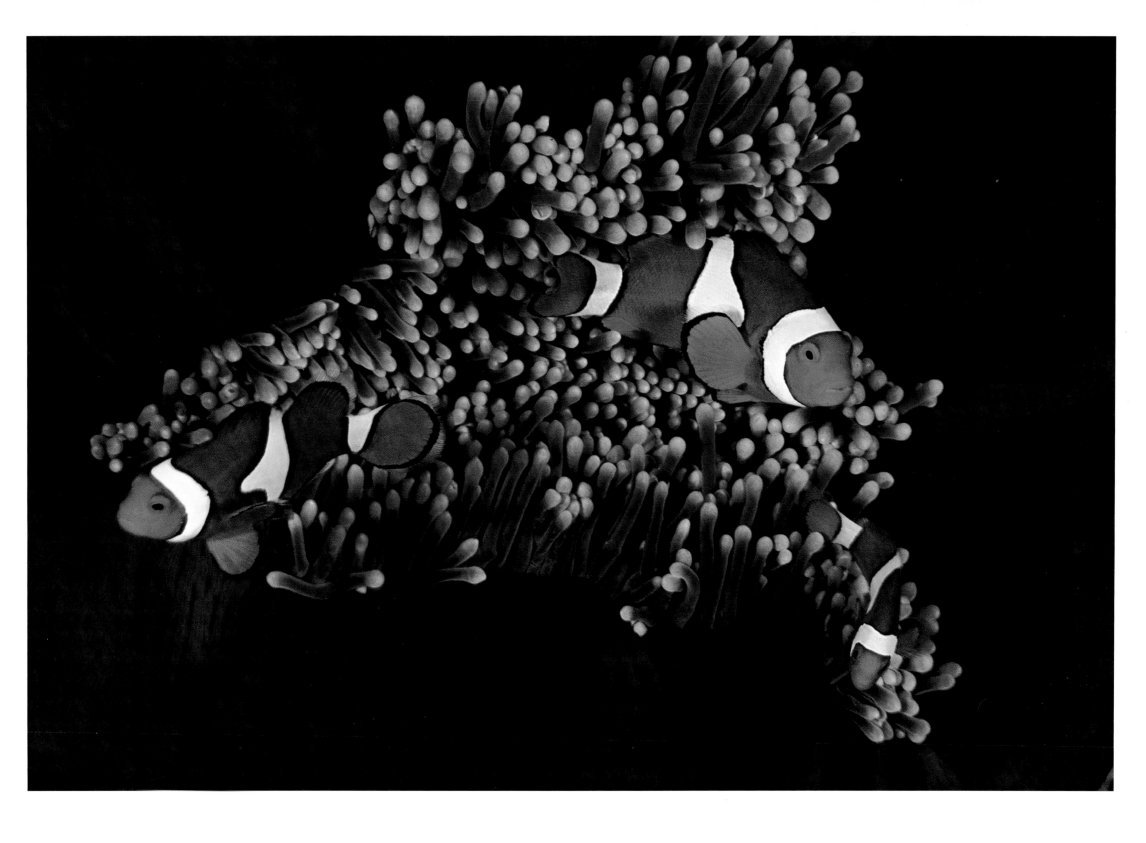

Percula clownfish with anemone, Little Detached Reef

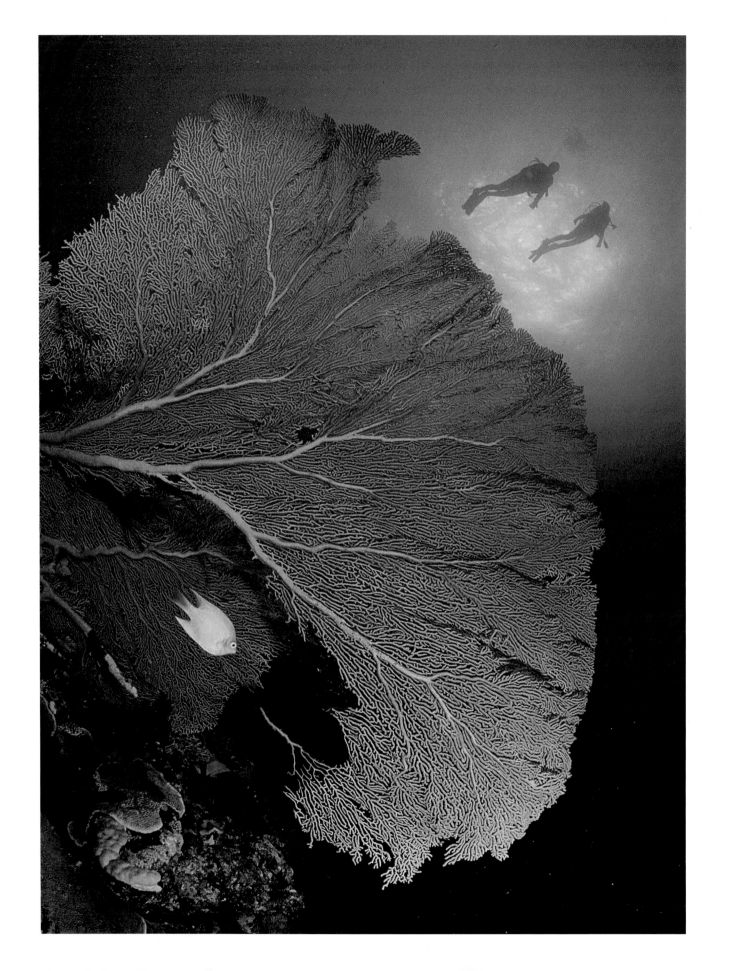

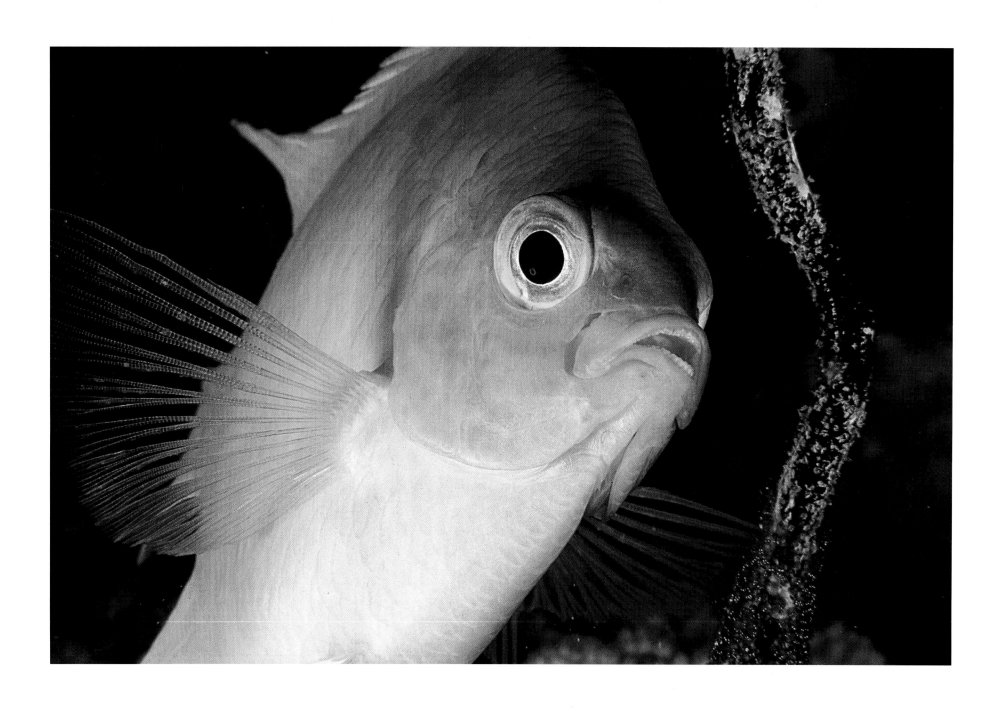

Golden damsel tending its eggs, Great Detached Reef

OPPOSITE: Golden damsel and gorgonian coral, Great Detached Reef

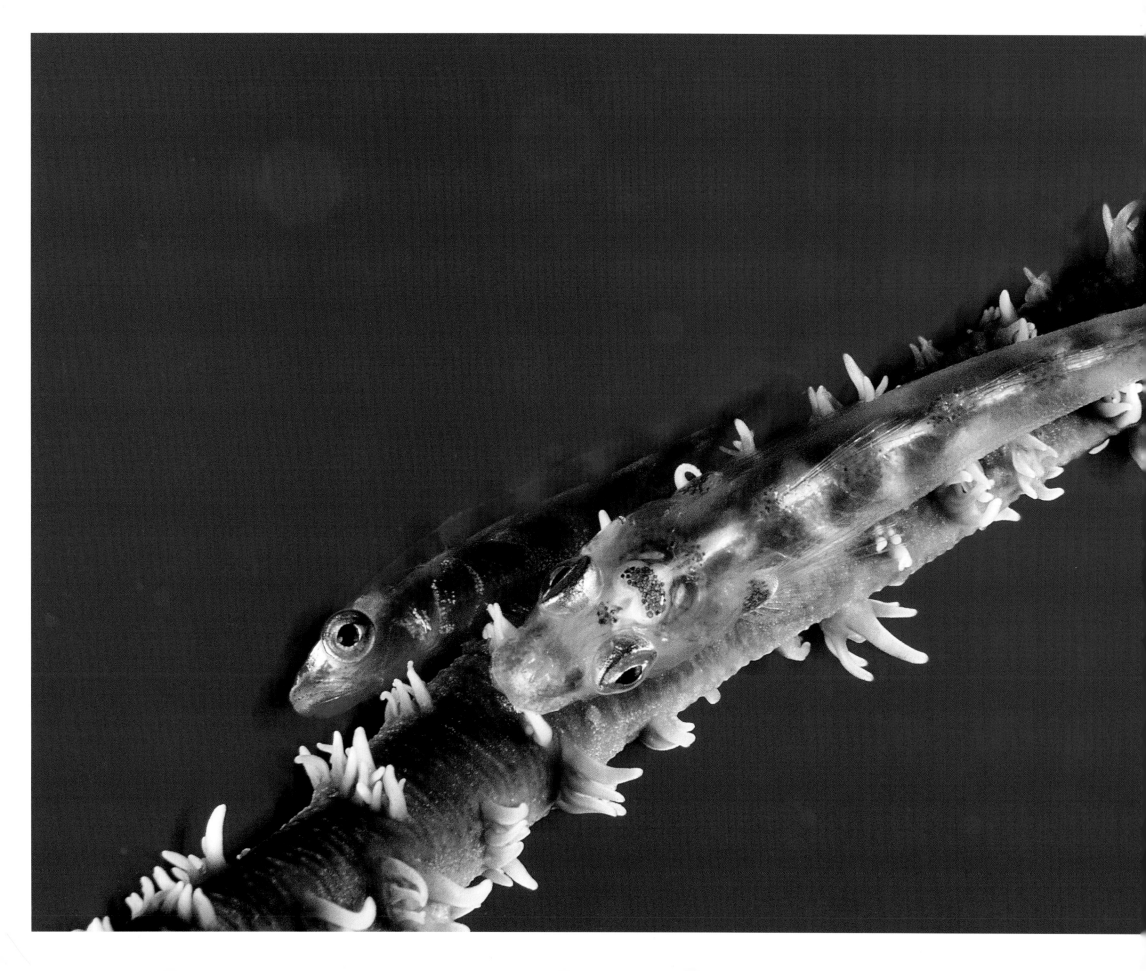

Pair of gobies on a whip coral, Eastern Fields

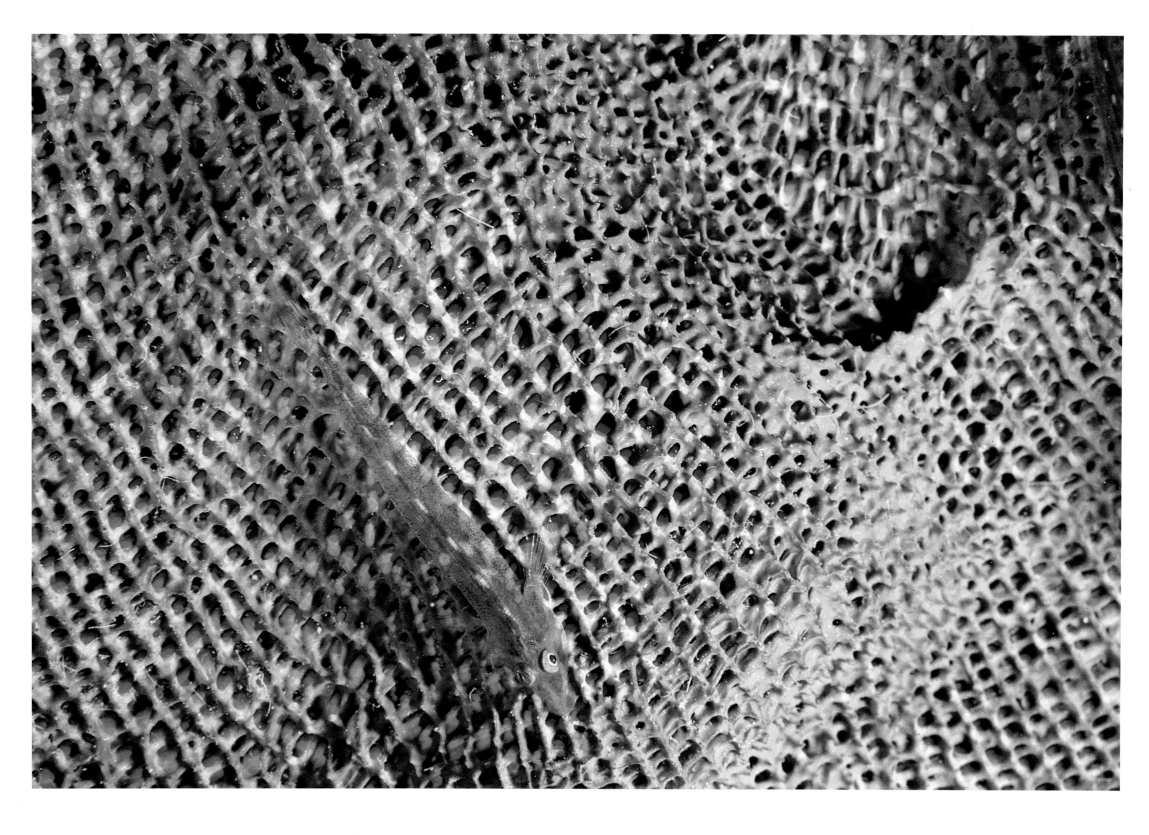

Goby on elephant ear sponge, Pixie Pinnacle, Number 9 Ribbon Reef

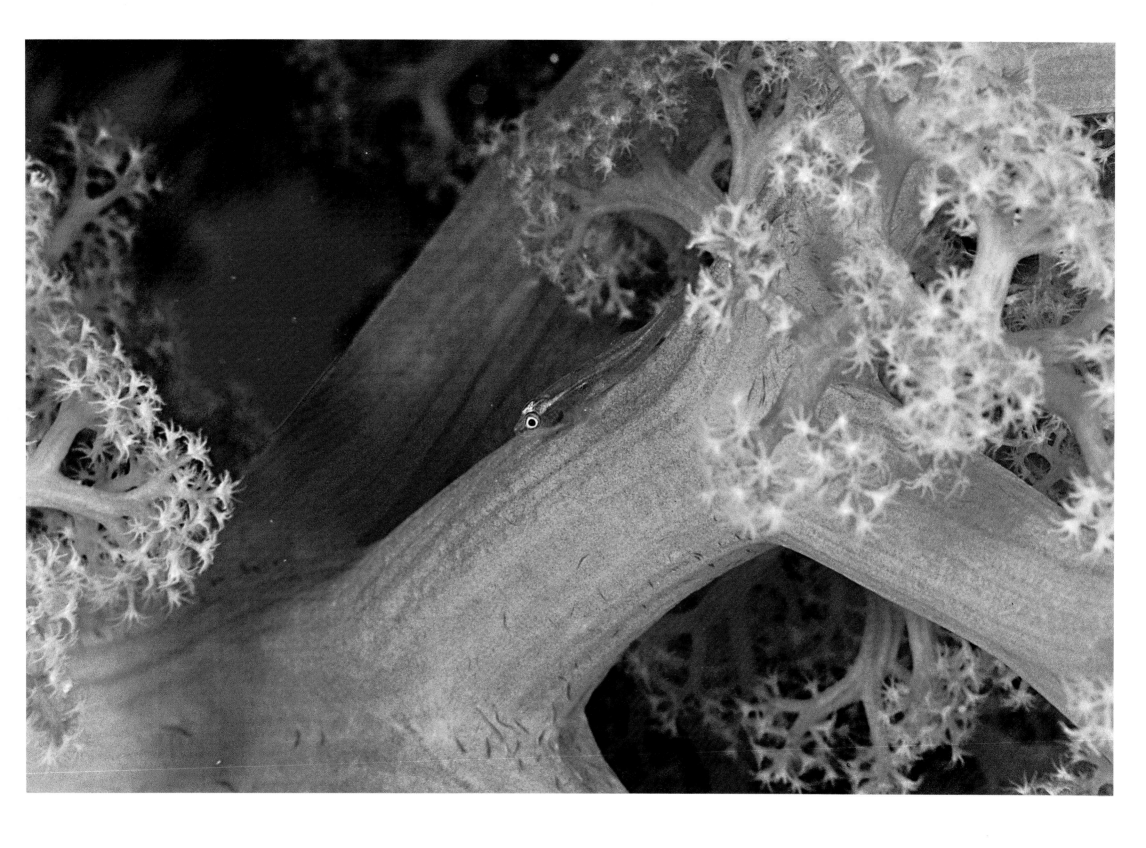

Goby on yellow soft coral tree, Northern Barrier Reef

Goby on giant clam mantle, Raine Island

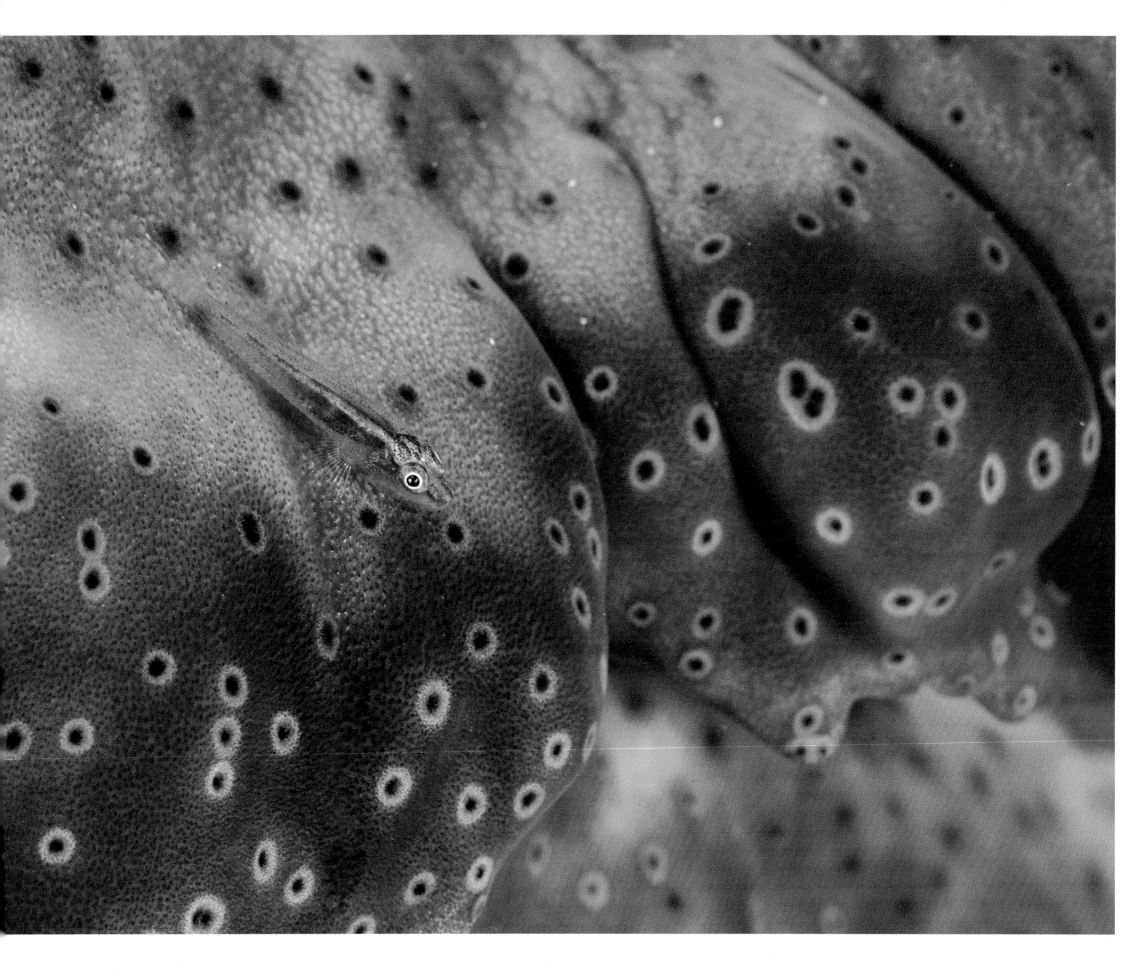

CHAPTER THREE **OVER THE REEF**

FOLLOWING PAGES: De Havilland Beaver aircraft taking off from Hook and Hardy Reefs

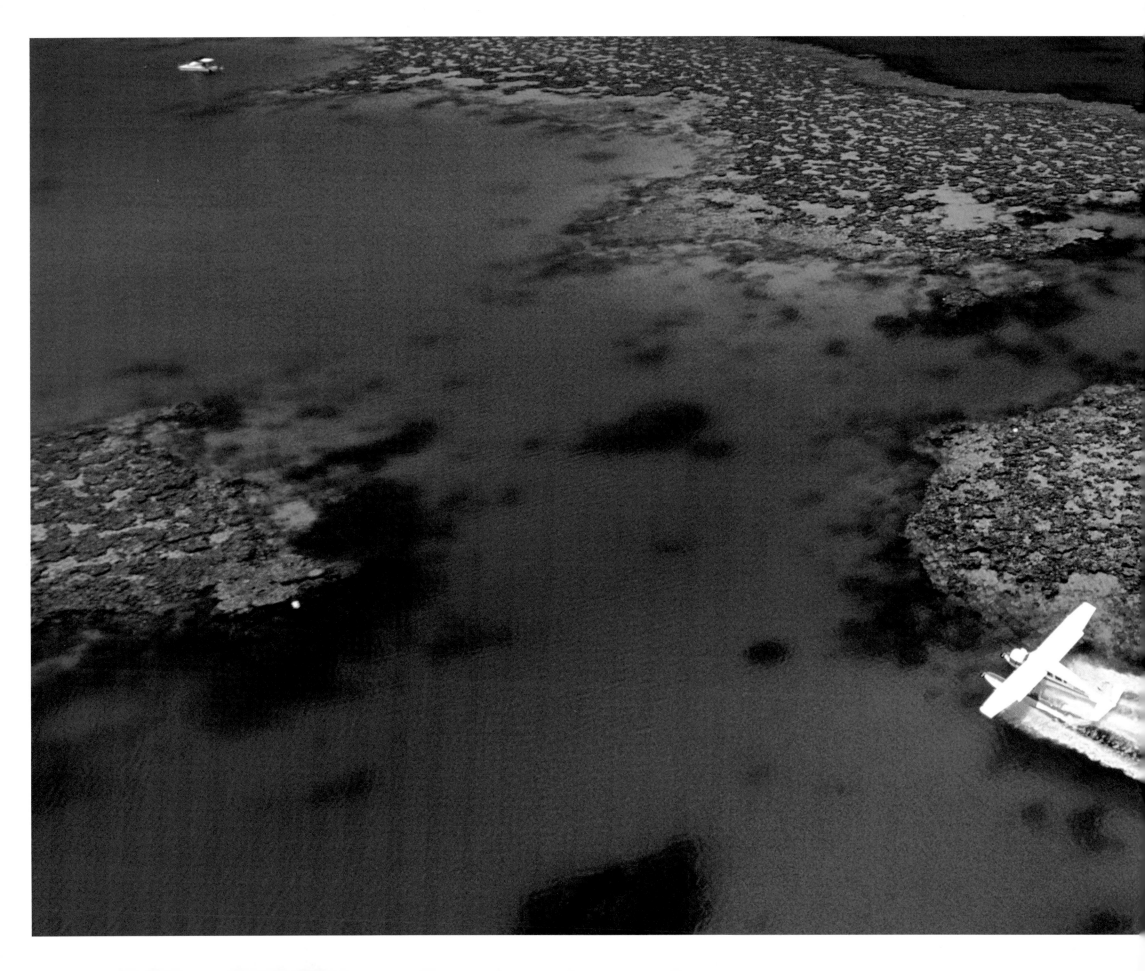

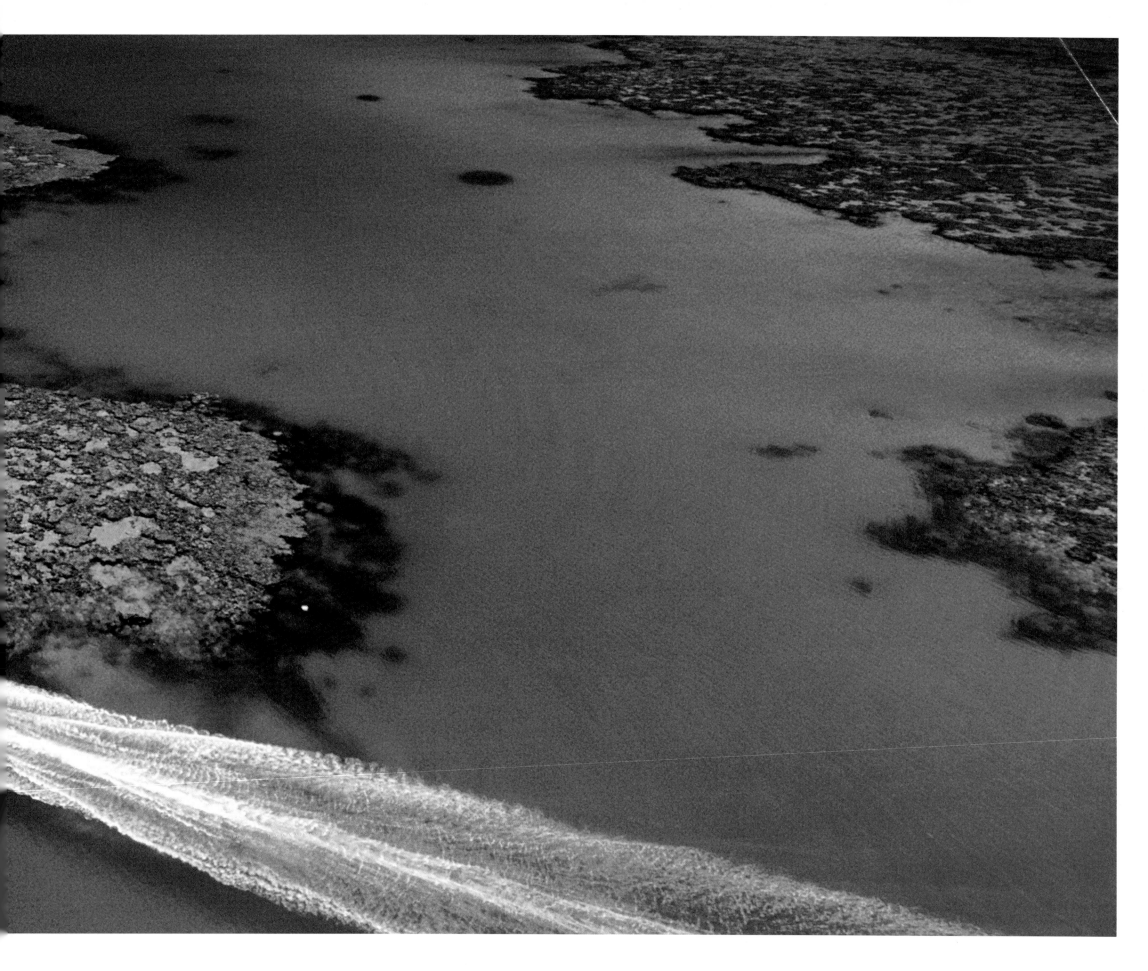

THE GRASS STRIP of WHITSUNDAY AIRPORT sat in a bowl of pinnacle hills at the edge of the sea and caught the morning light. Two Cessnas were on final approach while a 60-year-old Tiger Moth biplane sat cocked to the runway, with its wooden propeller ticking over as it waited. This unremarkable airfield is the most joyous place in the world to fly in and out of because of where you are going—it is literally a springboard to the Great Barrier Reef, far out to sea.

The truly royal conveyance out of Whitsunday Airport is the de Havilland Beaver. The aircraft, built in Canada more than 50 years ago, is a high-winged monoplane with a large radial engine. At Whitsunday Airport de Havillands all perch on amphibious floats with retractable wheels. It is without a doubt the most elegant way to see the Great Barrier Reef.

On a clear, calm December morning in the Australian spring, Jennifer Hayes and I, along with Gary and Merri Bell, loaded a de Havilland with gear. We crawled into a gray leather-upholstered passenger compartment. The interior of the plane had the ambience of a 1950s Cadillac limousine. Even the doors shut the way an automobile's do.

The radial engine barked at the start-up and then settled into a series of rumbling detonations that sounded like a heavy snore. The plane climbed to 2,500 feet and pointed its nose directly out to sea, out to the reefs near the horizon hidden in the blue morning haze.

Capt. James Cook saw his Great Barrier Reef universe from masthead height. The total environment of a coral reef escaped him. Strangely, even underwater, a real grasp or comprehensive feeling of what a coral reef consists of cannot be achieved. You can only see a

section of the reef, a small wall or a little coral cove, but not the whole range of the reef.

Wind and engine noise filled the compartment as I slid open the window of the Beaver. The airplane, like a facemask, can open up a coral reef to human eyes. Ten miles out the sea seemed to be clogged with reefs. The coral growth here is completely different from anywhere else. The northern reefs are composed of winding ribbon reefs, sand cays, and atoll-like reefs with lagoons. The reefs in the Whitsunday section are giant raised platform reefs that are miles long and miles wide. They are perpetually submerged coral lands.

Hook and Hardy Reefs are the most spectacular. They are nearly nine miles long and are divided by a dark blue channel that snakes between them. From the air, they are a light aqua-marine blue touched with emerald green. The patch reefs that cover them are brown and grow in swirls, curling around themselves in amoeba patterns and kidney shapes. One reef resembles a heart. It is an amazing piece of coral architecture, an absolute maze of corals that looks like a blue-green Persian carpet interlaced with Arabic calligraphy, framed by very blue ocean.

The pilot throttled back and set the plane onto the smooth surface. We came to a stop with a cascade of water, floating not flying. We suited up and rolled over for a dive. Strangely, the underwater landscape was dull because the large tides make the water milky. We wandered down sand channels between reefs that were like hedgerows of coral. The splendid isolation was wonderful. We were at the far reaches of the Great Barrier Reef, brought there by a wonderful old plane that bobbed on a mooring under an infinitely blue sky.

Later, we flew north for ten minutes to another dive station, a pontoon moored at the edge of the channel. The dive master caretakers who remain on board overnight took us underwater to show us their specialty—huge fish that lurk in the shadowy world beneath the pontoon. A Queensland grouper the size of a refrigerator swam at the edge of visibility. But a family of humphead wrasses had no such qualms. The green slab-sided creatures have thick blue lips and turret eyes that never cease moving. These wrasses can grow to a truly enormous size, sometimes reaching lengths of 7 feet and weights of 400 pounds. They are prized by the gourmets of Asia, so much so that they have all but disappeared from the reefs of much of the western Pacific. Sadly, they are more than just a giant fish: As top-end predators they have played an important role in the complex workings of coral reef systems. But here at Hook and Hardy Reefs they are safe, protected. I reached out and touched the fish; its large scales felt like warm plastic. It rolled its turret eyes and swam off into the evening.

We took off across the channel into the wind. The plane flew low and slow over the perfect heart-shaped reef. We turned toward the west, flying into a misty sunset that obscured the distant Australian coast. I closed my eyes and drifted in a sea of dreams. ✦

Coral head with yellow chromis, Hook and Hardy Reefs

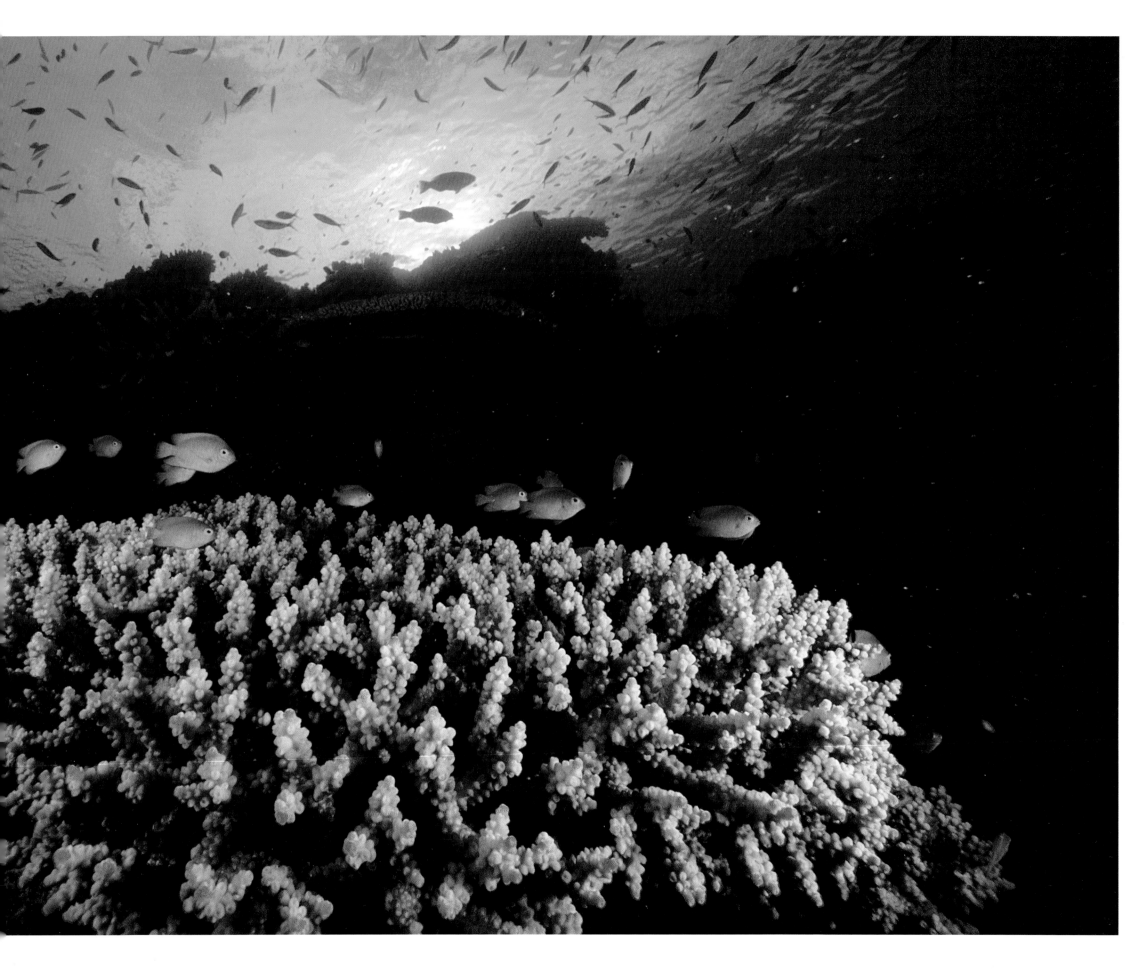

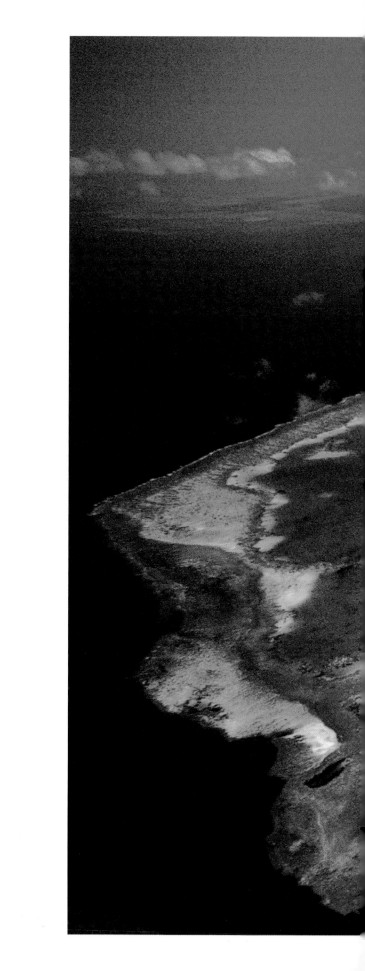

Hook and Hardy Reefs, Whitsundays

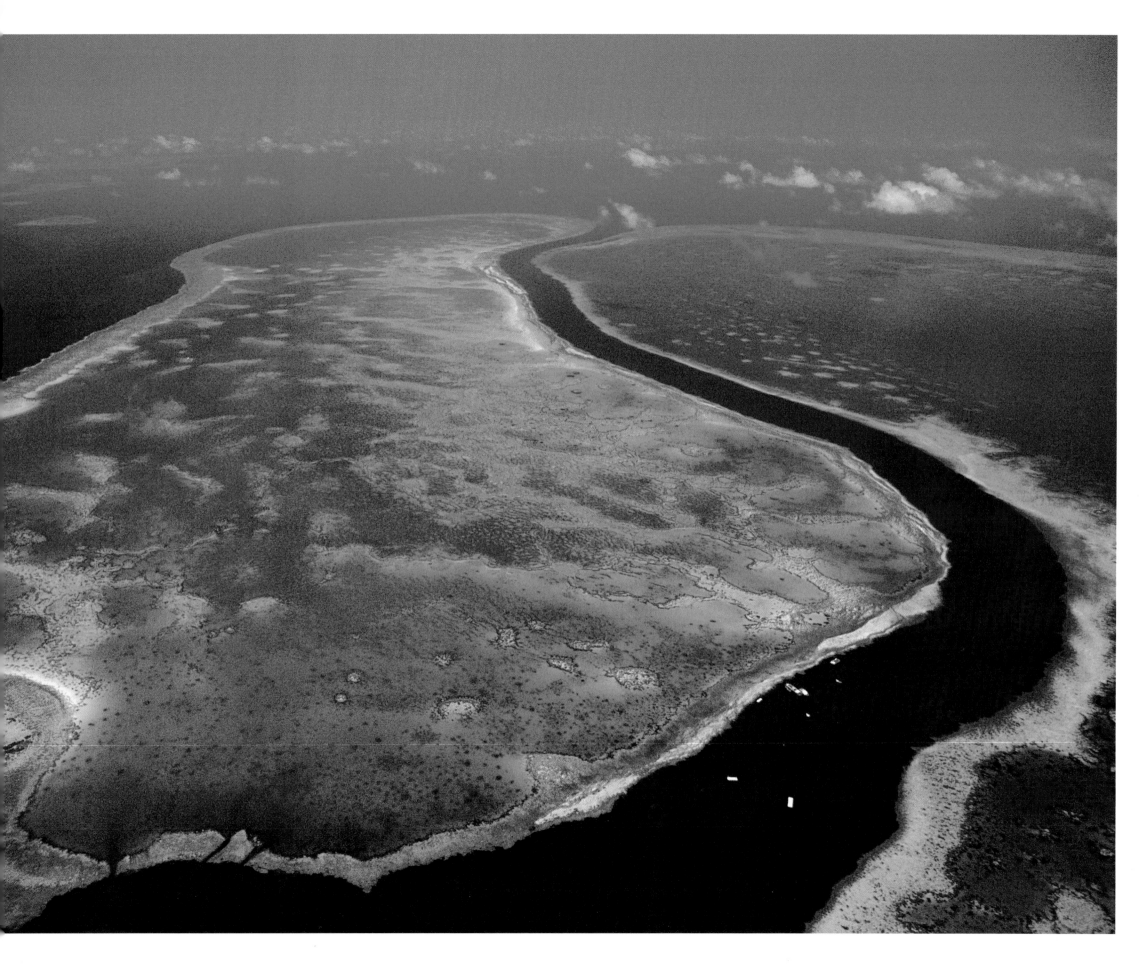

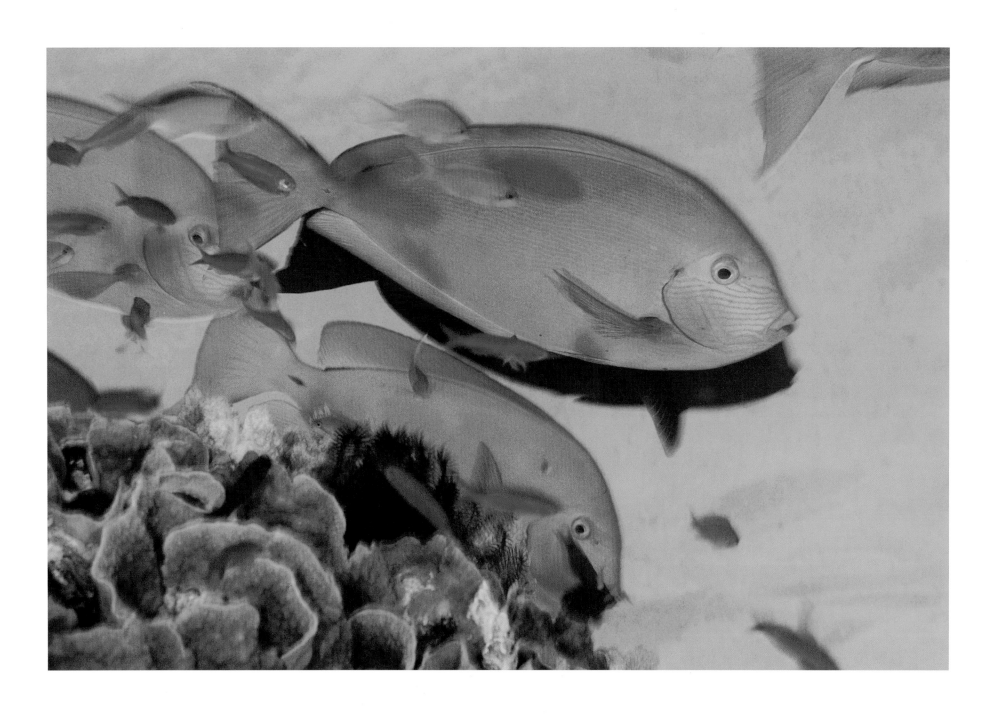

Surgeonfish, Hook and Hardy Reefs

OPPOSITE: Gorgonian coral, Hook and Hardy Reefs

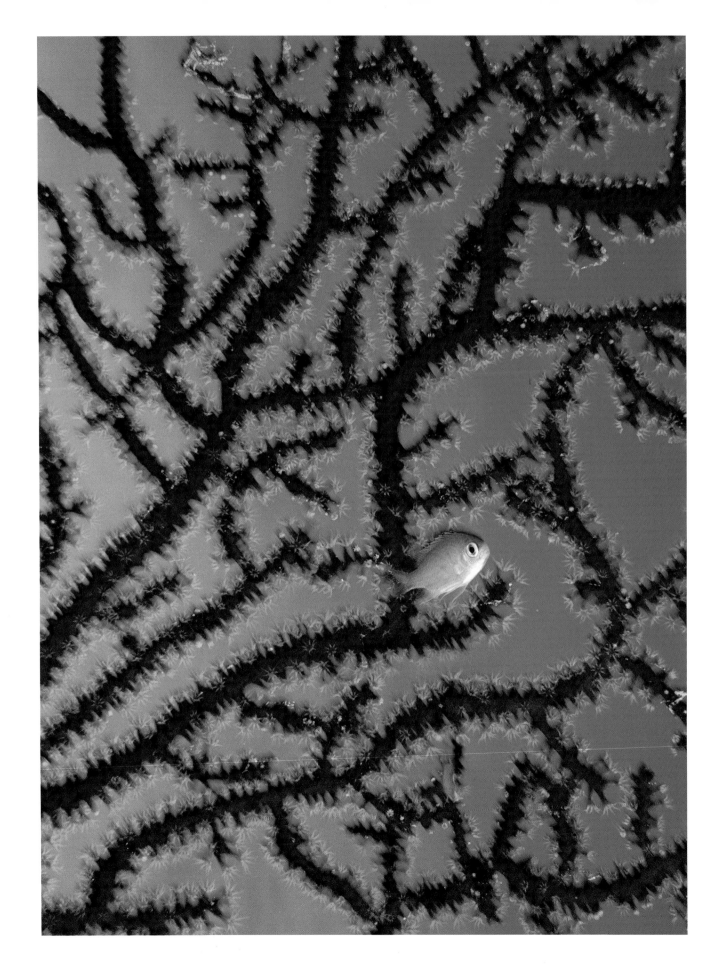

Humphead wrasse, Hook and Hardy Reefs

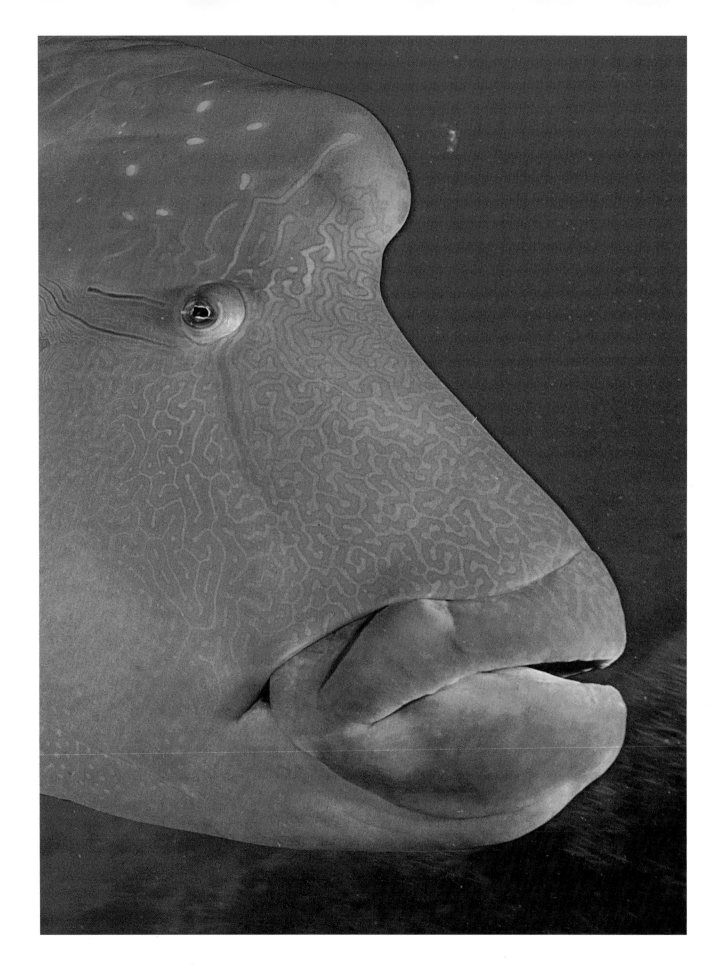

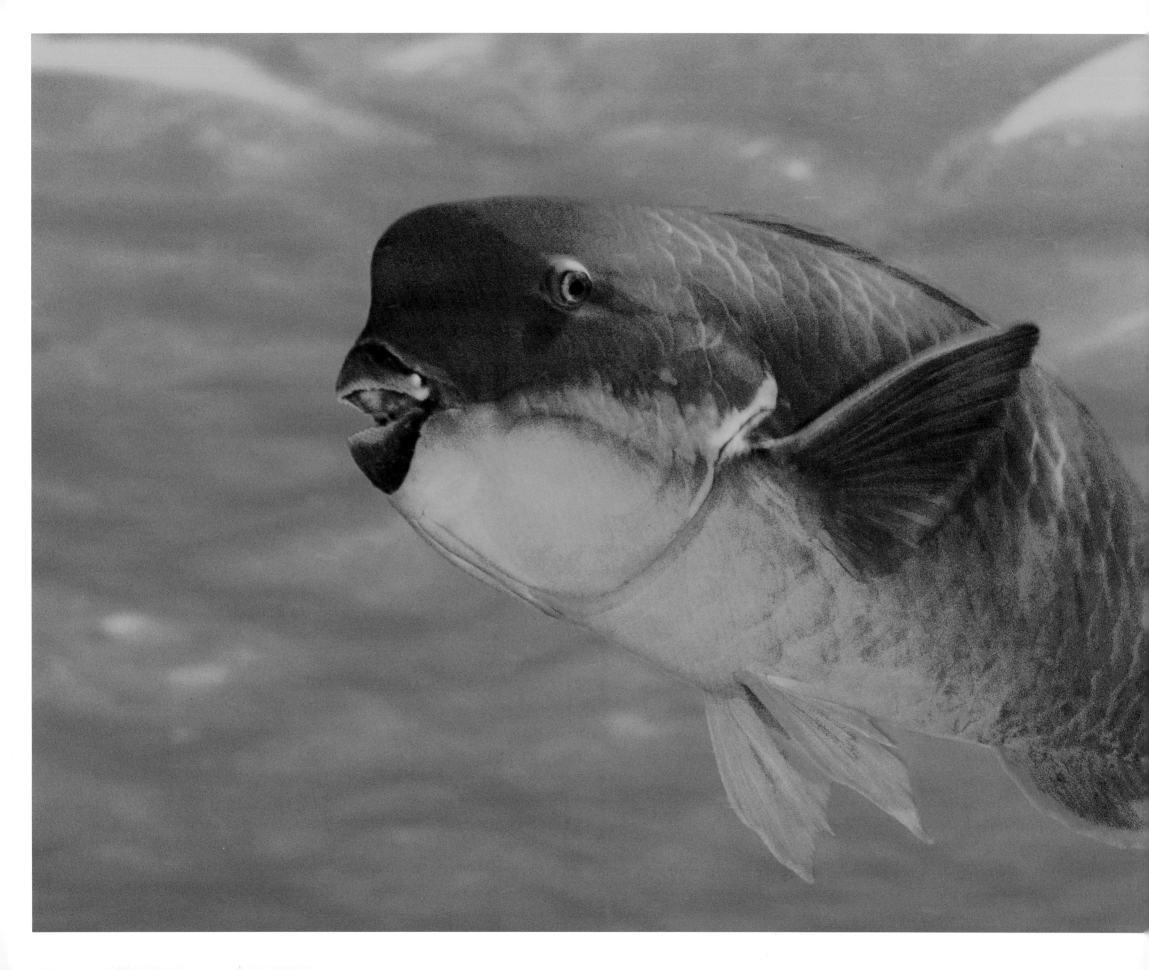

Parrotfish, Whitsundays

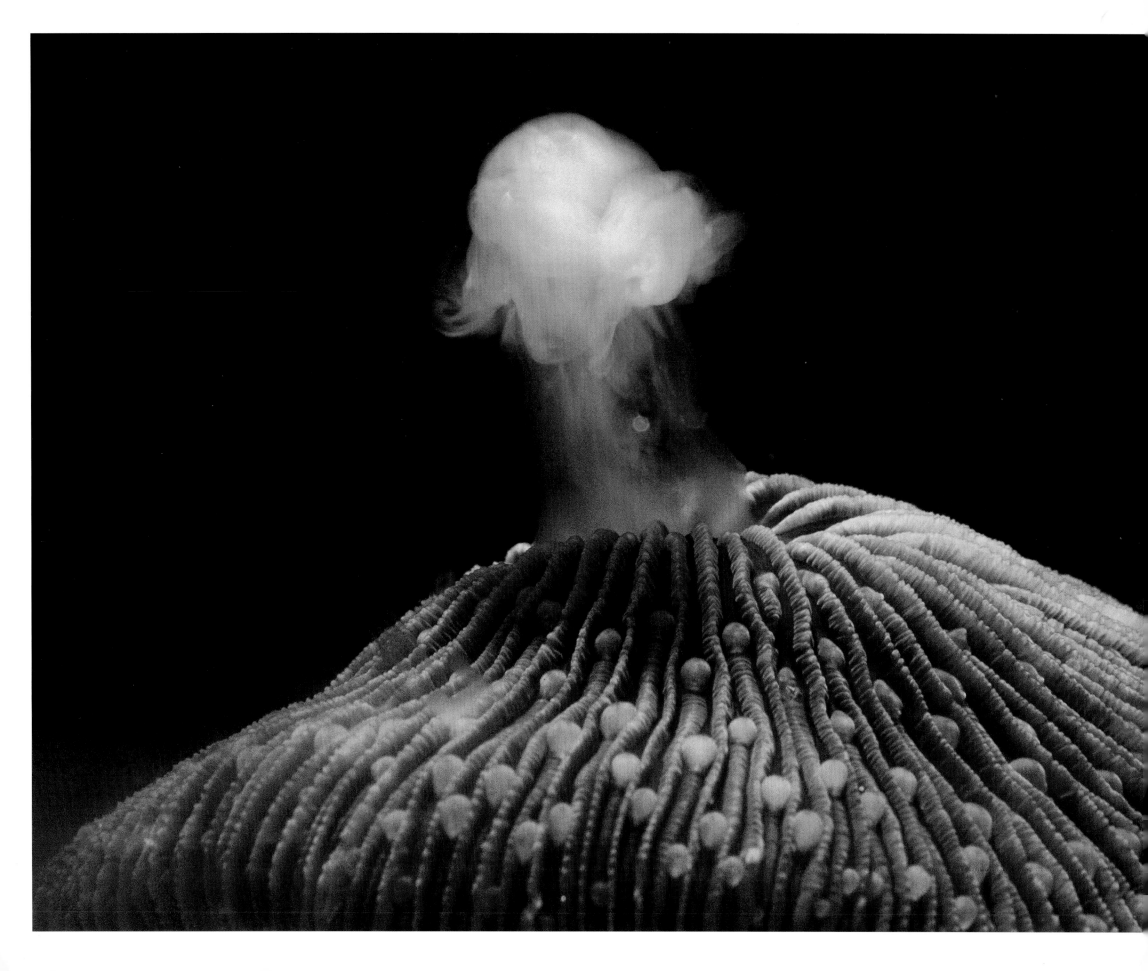

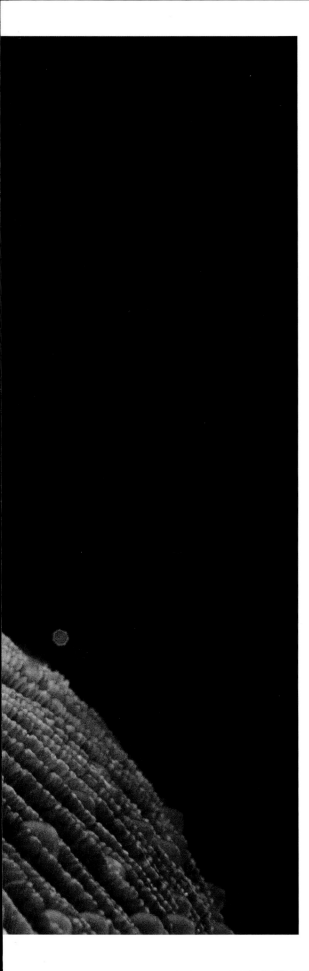

CORAL SPAWNING

It may be the most spectacular sex act on the planet. In one or two nights in the austral spring or early summer, entire coral reefs spawn. It is a cyclonic orgy of life.

Most, but not all, corals are hermaphrodites, meaning they contain both eggs and sperm. The eggs begin to develop deep within the coral structure months before the big event. The corals rely on rising temperatures and tidal conditions for their reproductive cue. After twilight, on a night when the conditions are perfect, the coral polyp's mouth begins to open as if it were yawning. Sperm packets within the coral skeleton combine with red and orange eggs. The eggs and sperm glue themselves together, producing a pink orb in which the egg completely surrounds the sperm. One by one, the egg clusters are spit out of the yawning mouths of the polyps. The eggs' high fat content makes the egg-sperm bundles float, creating what looks like a swirling snowstorm across the reef.

Each coral species has a different strategy to disperse its gametes. Some acroporas elegantly drizzle out their pink bundles while others pulsate like fountains. Organ pipe corals produce whitish snow squalls. But without a doubt, the most dramatic are the mushroom corals. These single-polyp corals spawn on a fixed cycle—a very fixed cycle. One pancake-size male that I was photographing released sperm precisely every five minutes on the dot. The coral's central "mouth" would open up and erupt like a volcano, and as the sperm cloud reached its zenith, it would trail off into curlicues and tendrils like wafting smoke. Somewhere farther down the reef a female mushroom coral would have released an explosion of eggs into the dark sea in anticipation that a tendril of sperm would reach the rising veil of her eggs.

By 10:00 p.m. the reef was in full bloom, and the sea full of clouds of tiny shrimp, wriggling worms, and fish feasting on nature's banquet. The surface looked as if it were covered with pink hailstones, and a pungent smell hung in the air, a reminder to the senses that the coral world below is not just a stone forest but a vast menagerie teeming with life.

The release of eggs and sperm to the fate of the sea is called broadcast spawning. The strategy is to cover as much territory as possible and spread the coral progeny far and wide. The sperm-egg bundles burst apart and allow sperm from one colony to fertilize eggs from another and produce planulae, which will drift with the currents and eventually settle out of the water column and begin to build a new reef. The concept of a mass, multispecies reef-spawning event is a relatively new scientific discovery, little more than 20 years old.

When the early light of day appears, the sea is a Pepto-Bismol pink and has the forlorn look and feel of the morning after an extravagant party. The tide changes, and the wind massages the surface of the water, dissolving the pink bundles and slowly erasing all signs of the explosion of life that occurred the night before.

Mushroom coral spawning, Heron Island

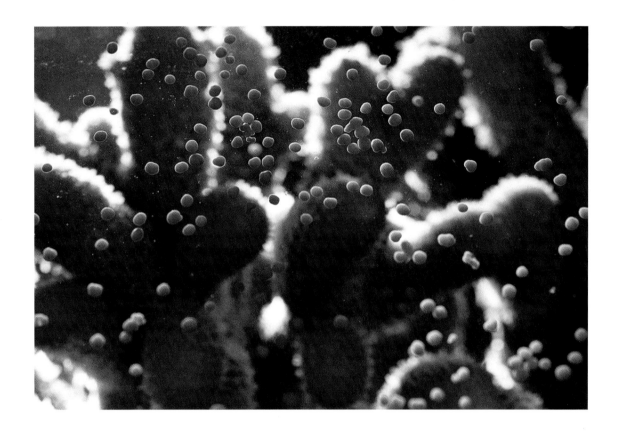

Acropora coral spawning, Heron Island

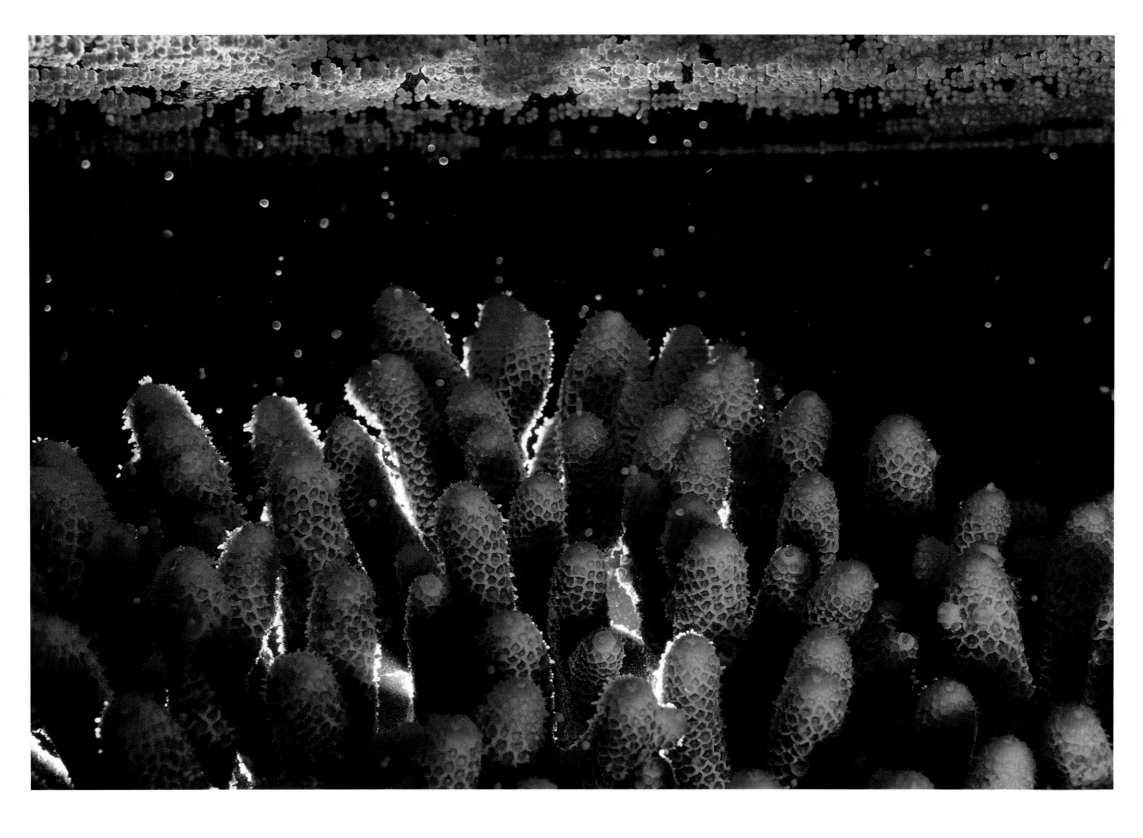

Acropora coral spawning, Heron Island

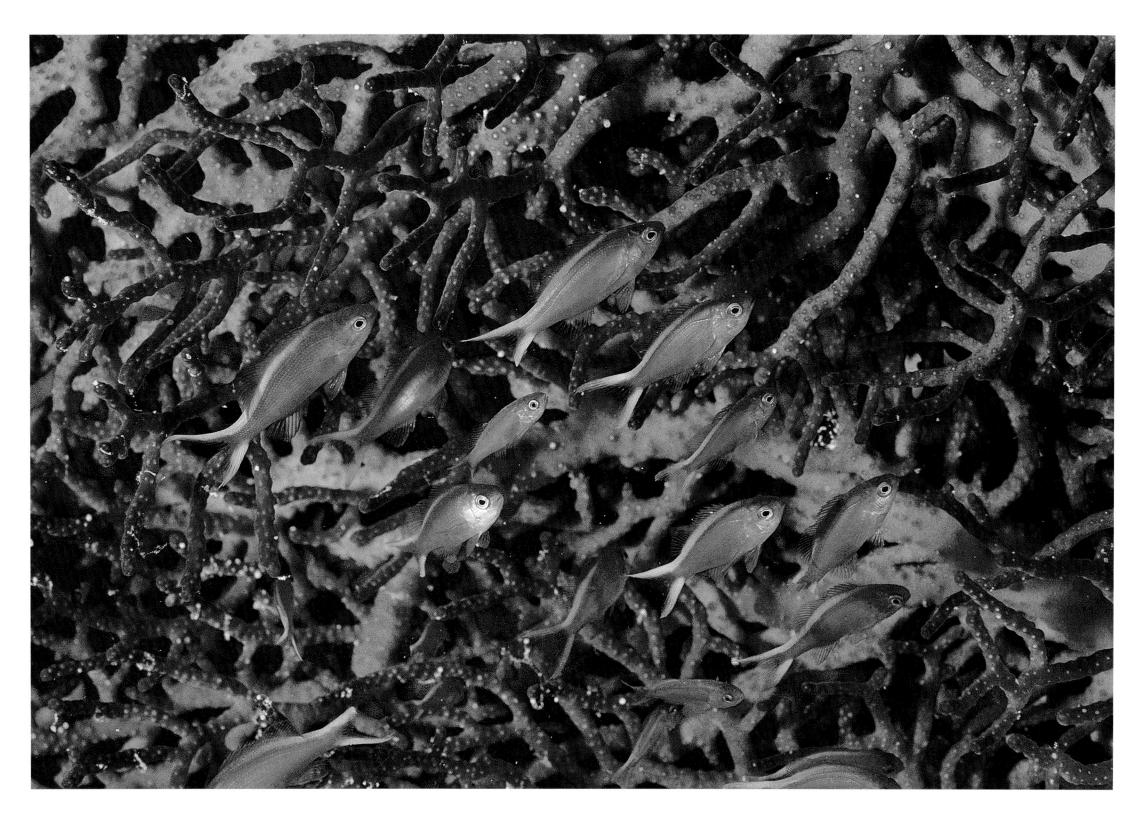

Purple anthias and gorgonian coral, Hook and Hardy Reefs

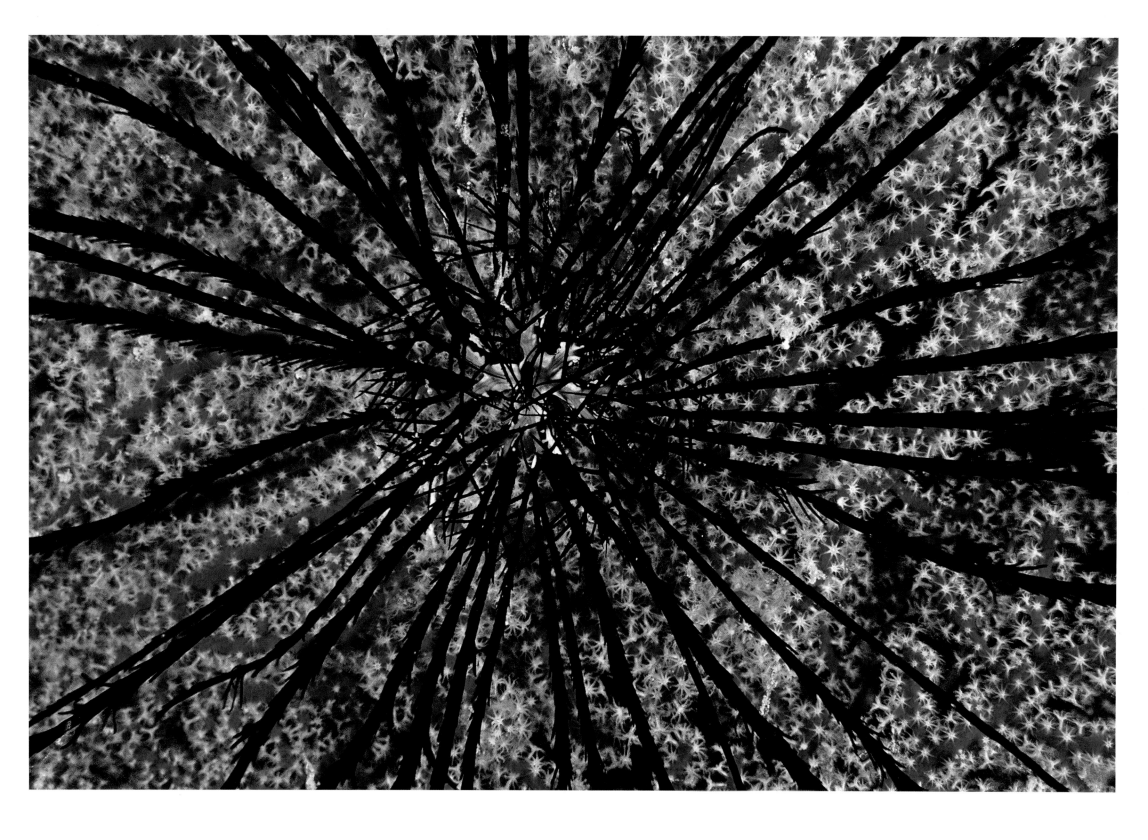

Crinoid and gorgonian coral, Northern Reefs

Great barracuda, Hook and Hardy Reefs

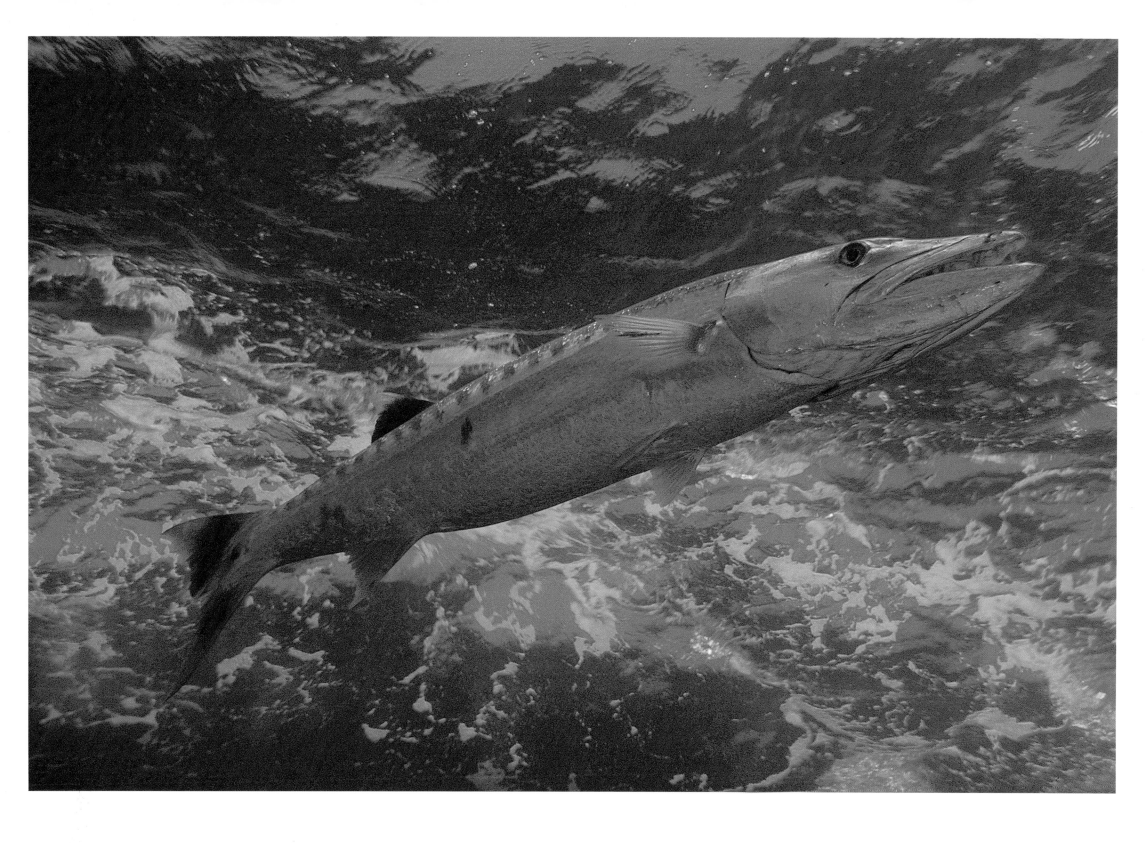

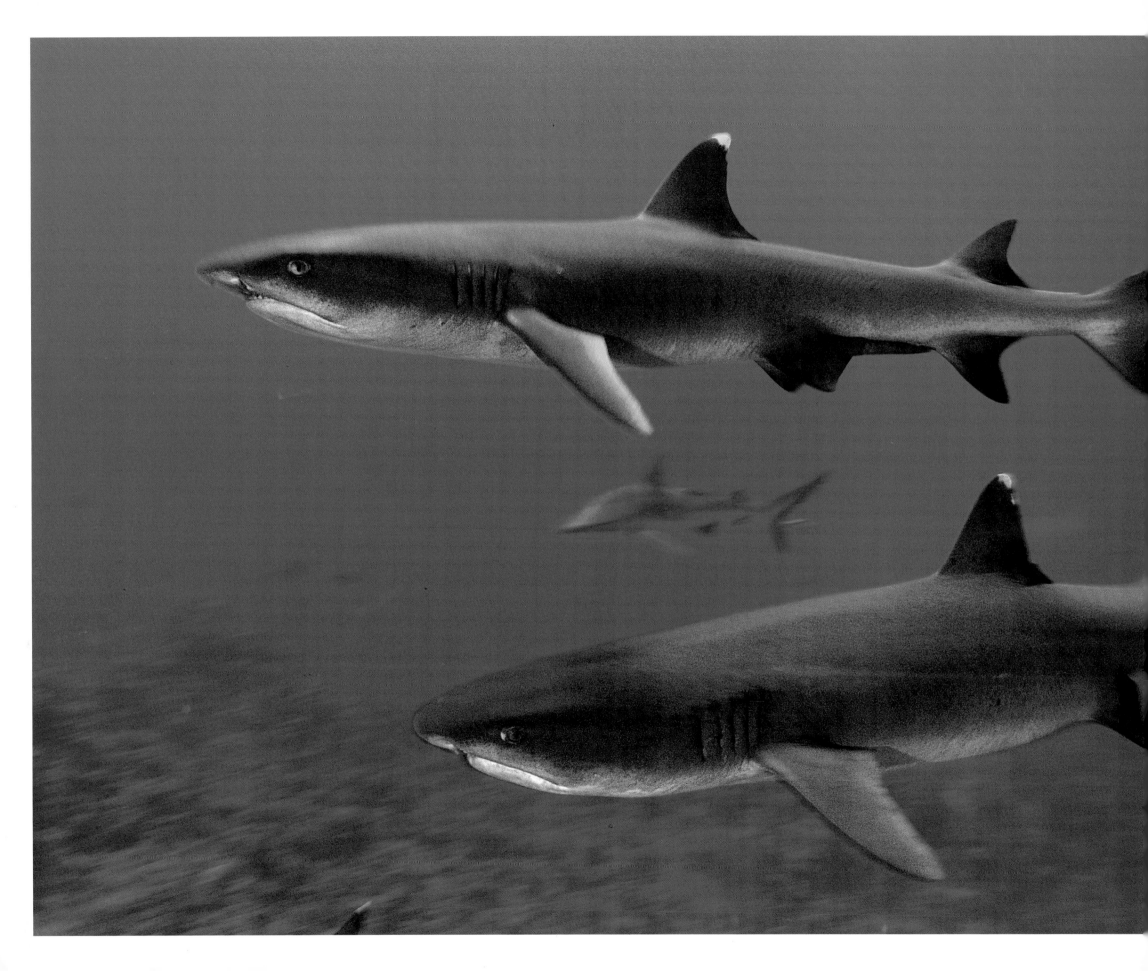

Whitetip reef sharks, Northern Reefs

HERON ISLAND

FOLLOWING PAGES: Wistari Reef, Heron Island in the background

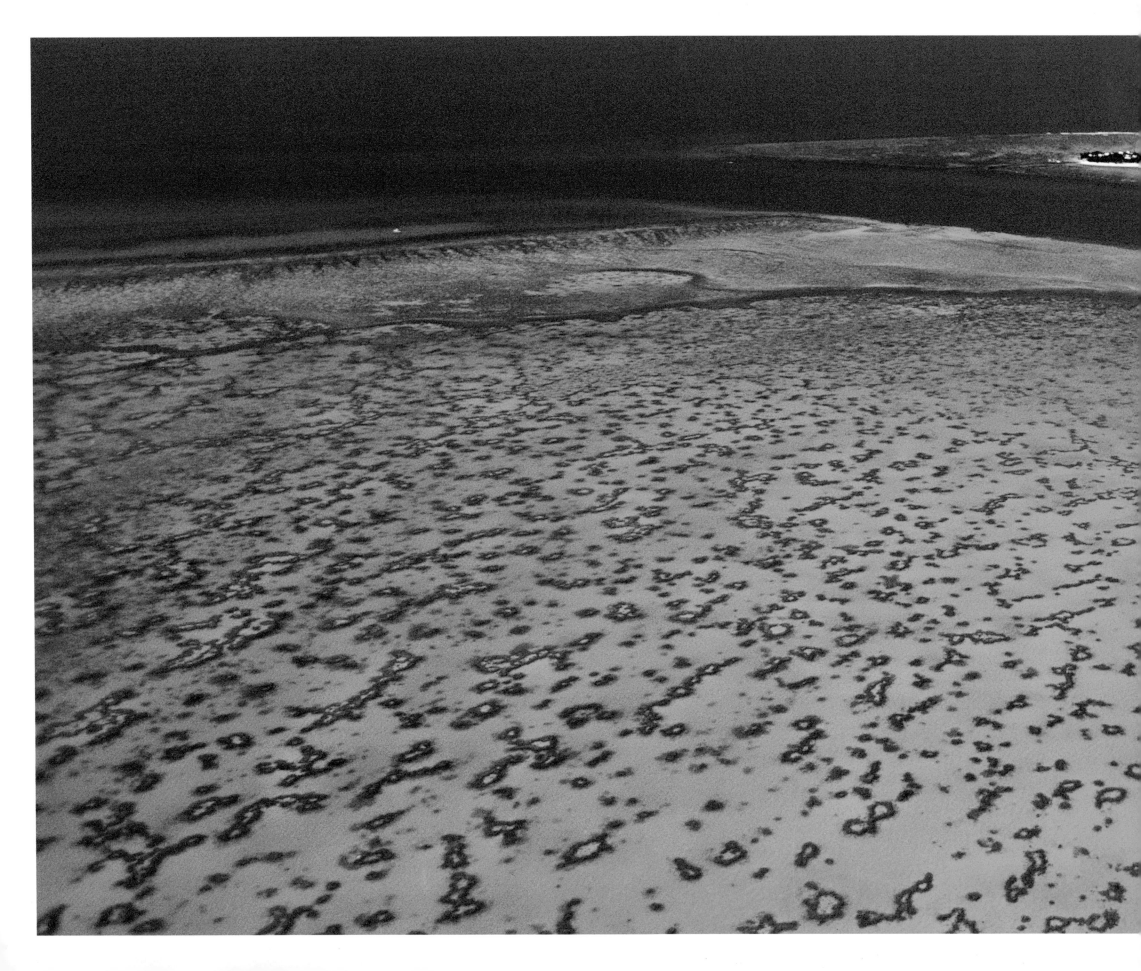

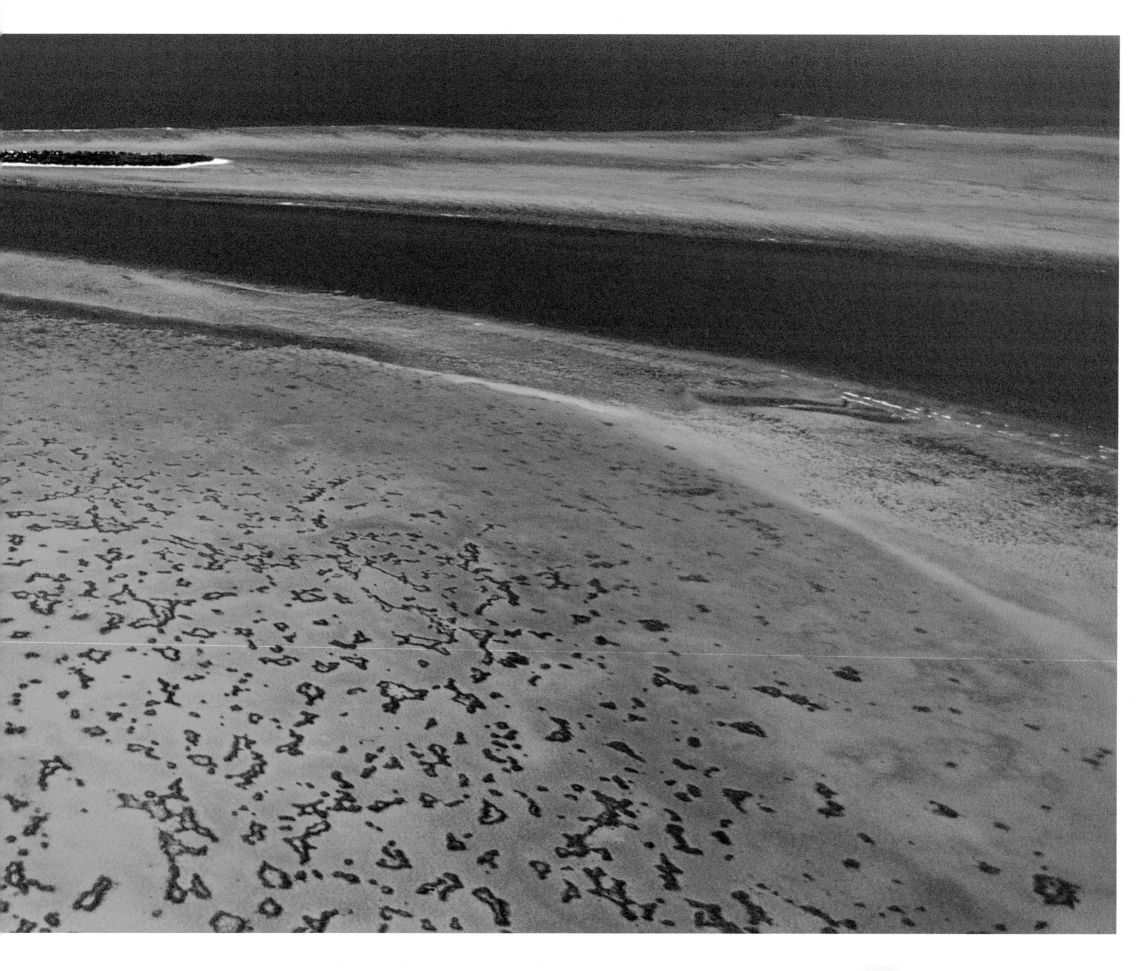

HERON ISLAND

AFTER THE RAIN, HERON ISLAND SMELLS. It is the smell of tens of thousands of wet birds: noddies, wedge-tailed shearwaters, and the occasional heron, for which of course the island is named. Coming in from the sea the smell assaults you—an acrid knife-edged smell that instantly inhabits your nostrils. Strangely, within an hour you'll scarcely notice it. Heron Island is part of the Capricorn Group and is geographically one of the southernmost islands on the reef. It is a coral cay, a small forest-covered island surrounded by a large platform reef system that goes dry at low tide. From the air, cays look like enormous blue-green lily pads.

For me, Heron Island is a place where I can sense the workings of the southern reef. It is one of the oldest ecotourism resorts in the world and one of the few places where one can actually live on the reef. Originally, there was a turtle abatoir here, built in the early 1900s. Sea turtles coming ashore to lay their eggs would eventually end up in tin cans. Now the turtles coming ashore are closely monitored by scientists from the Heron Island Research Station and are observed by tourists, who kneel in silent reverence to watch a female's egg-laying ceremony.

Heron Island is about 50 miles northeast of the town of Gladstone, on the southern end of the reef. The southern winds make this inside passage very rough. The water is cooler, there are fewer corals, and the fish life is different here. It is a coral outpost compared with the teeming coral jungles of the tropical north. The sandy pathways between the trees are flyways for black noddies. In the evening, the mutton birds (wedge-tailed shearwaters) begin their mating rituals. These sooty, gray-brown birds are about the size of a cat. They have just flown half

the length of the Pacific to mate and lay their eggs on Heron Island. They emerge from their burrows and perform a mincing, head-bobbing dance and howl. The combination of howls and moans resembles a soundtrack from a 1950s werewolf movie. On occasion, a heron will wander through the resort's dining room at mealtime, oblivious to all. In fact, nature itself on Heron Island is oblivious to the actions and foibles of humans. Beneath the sea it is the same.

The bommie is not much to look at. There are no waving sea fans or glistening coral caves. About 50 percent of its coral cover has been killed. It is, however, an incredibly busy street corner in the sea, a place of biological commerce. Batfish line up, and one by one swim by horizontally, blushing a pale gray to signal the cleaner wrasses to service them. Toward midday manta rays hover, their enormous jet-engine-intake mouths open as an invitation for the wrasses to swim into their gleaming white gill arches.

At the bommie's base, where the coral meets the sand, harlequin tuskfish frantically feed. They have a schizophrenic lifestyle, moving rapidly on their mysteriously appointed rounds, suddenly repeating themselves as if they have forgotten something. They are beautiful little fish with red stripes and tiny cobalt blue tusks that protrude, giving the fish a sweet, nerdy look.

Jennifer Hayes and I crawl over the bottom looking for nudibranchs. Nudibranchs are wildly colorful marine snails without shells and are named for their "naked gills," which look like badly arranged bouquets on their backs. They feed on toxic sponges and anemones, absorbing the poisons in their flesh. Their brilliant colors can act as a billboard to predators, saying "Don't even think about it—I am poisonous."

With a sky full of rapidly moving dark clouds and a rising wind, the late afternoon sea turns a slate-gray. Spangled emperors with long snouts and iridescent scales cross over fields of staghorn coral next to the bommie. At sunset, the resident barnacle-adorned loggerhead turtle returns to sleep in a chamber beneath the bommie. I come to the surface at sunset and watch the turtle take a deep breath, then dive for the bottom for its first sleep of the night.

Sea cucumbers spend most of their lives slowly grazing across the sand. They support a host of tiny creatures such as red-and-white shrimp with purple claws that graze on their rumpled backs and tiny crabs that inhabit the folds of the cucumbers' elephantlike skin. The terribly dull lives of sea cucumbers change during mating time when they actually sit up in a sensuous curved posture. At twilight, the sea cucumbers begin to mate. The male releases sperm into the current, and somewhere downstream at the edge of night a female waits.

On the island, the noddy terns stop building their nests and settle in for the night. The flapping wings, constant cooing, and squawking stops. For a moment Heron Island is silent. Then the mutton birds begin to howl in the windy Pacific night beneath the Southern Cross. ✦

Loggerhead turtle, the Bommie, Heron Island

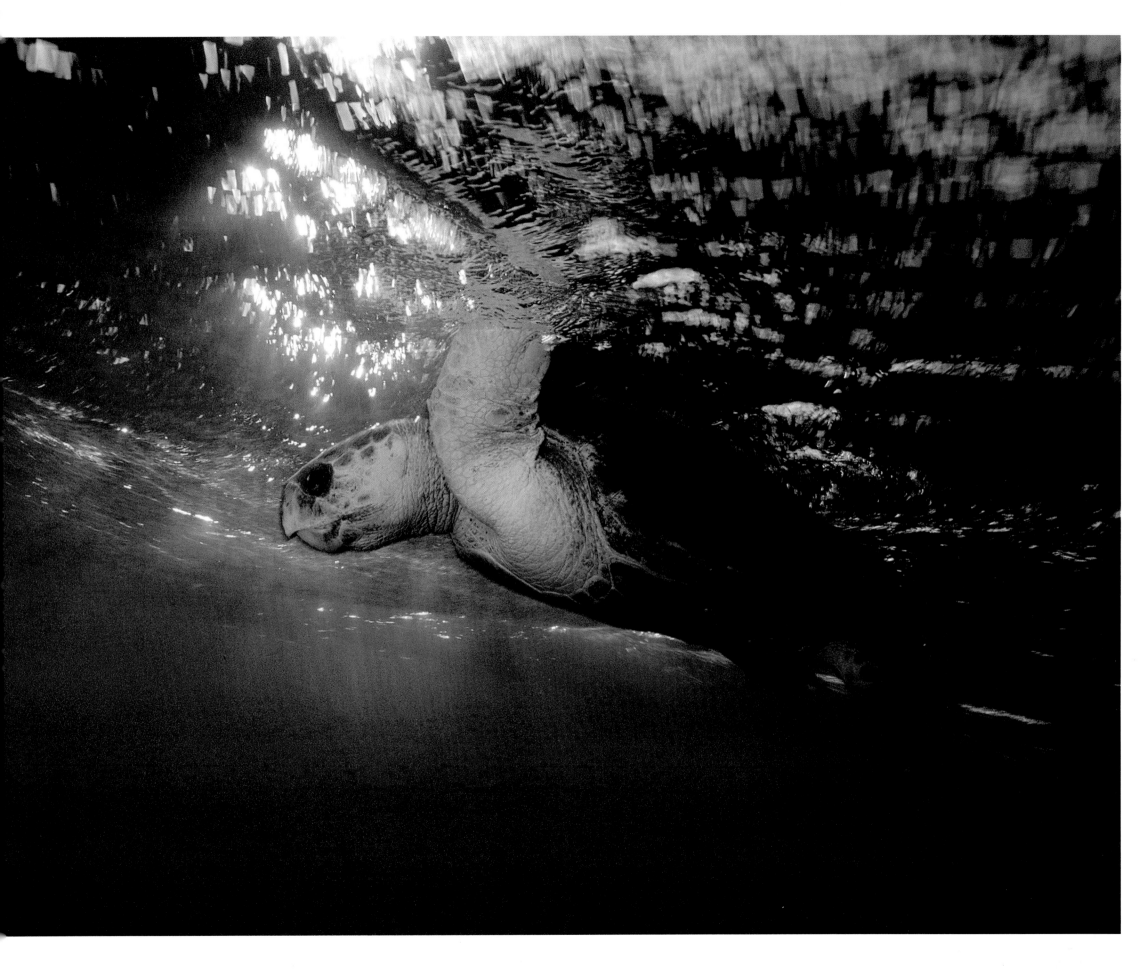

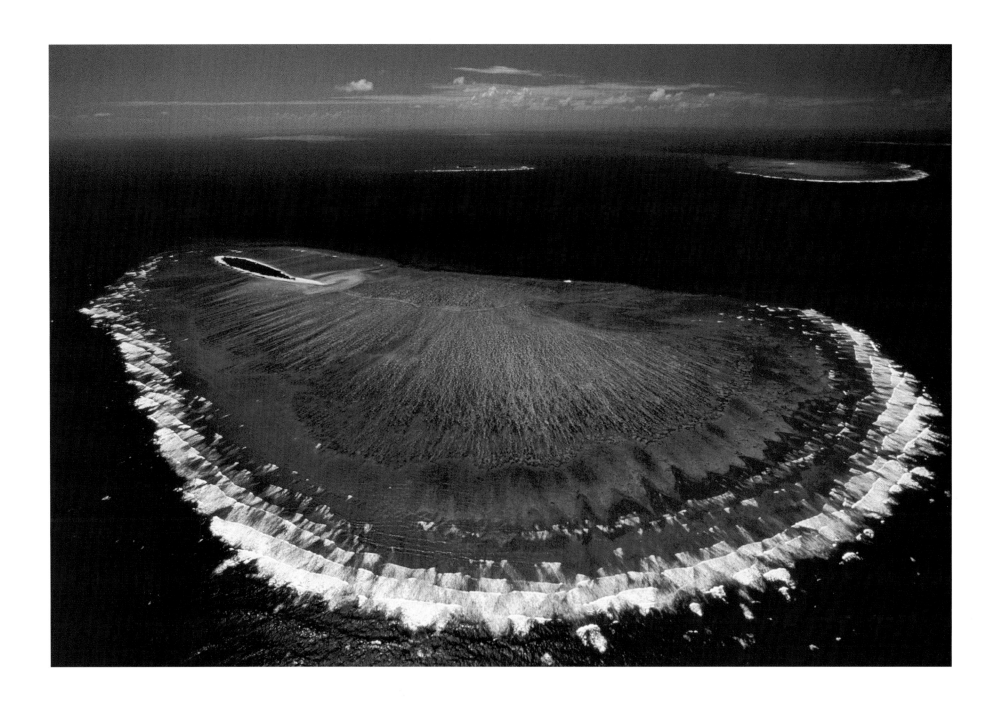

Wreck Island, Capricorn Group

OPPOSITE: Snapper school, the Bommie, Heron Island

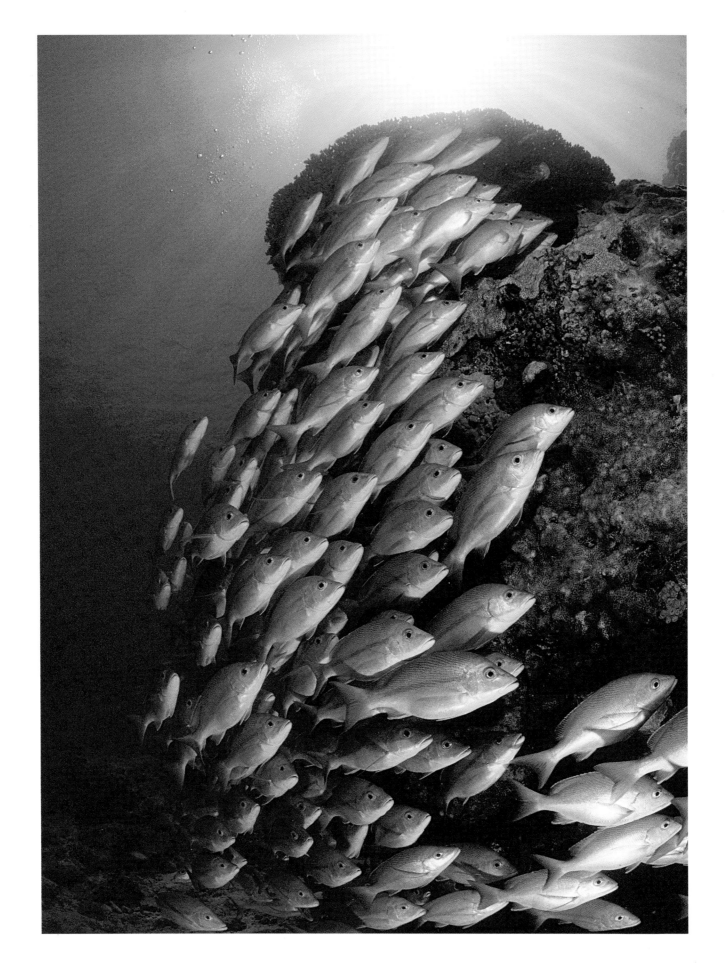

Manta ray, the Bommie, Heron Island

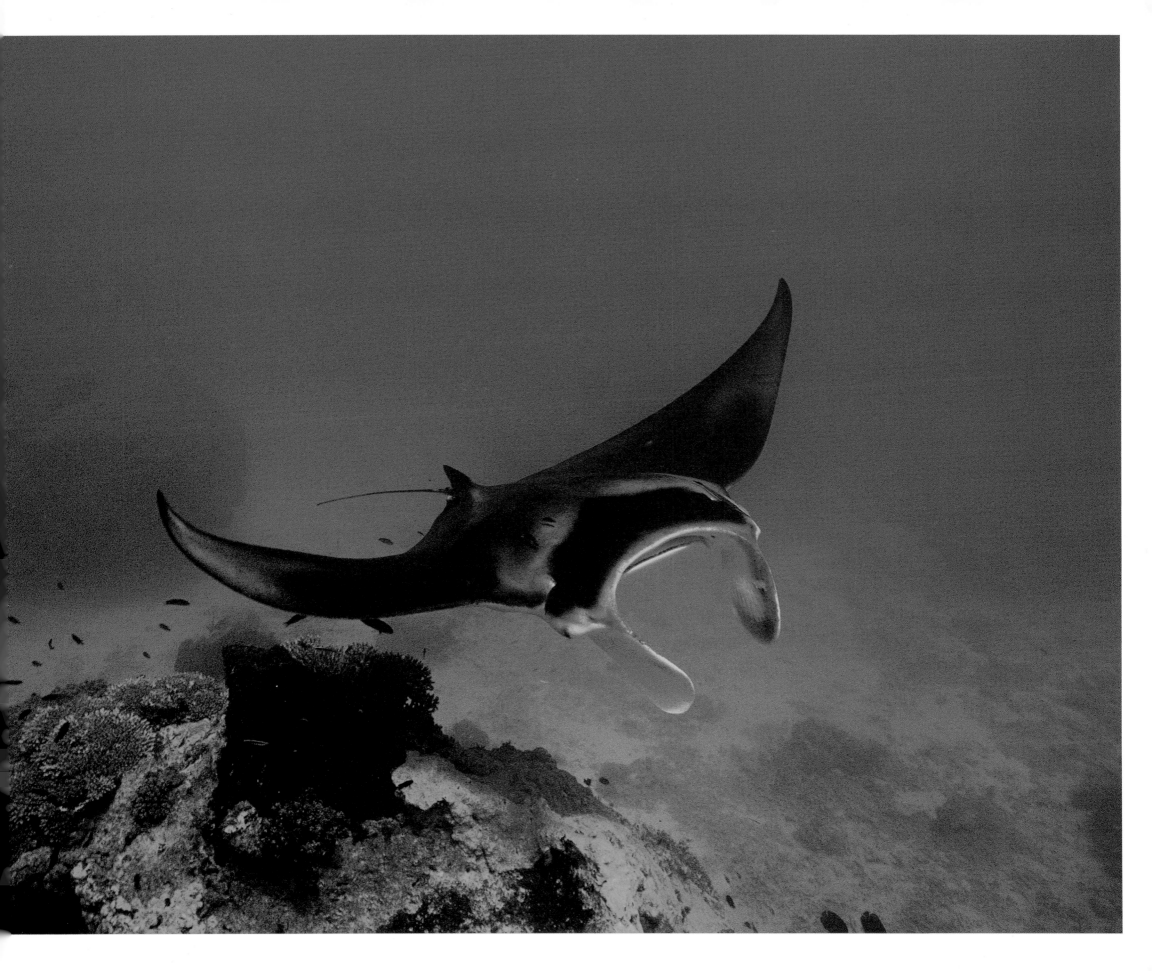

Harlequin tuskfish, the Bommie, Heron Island

Red-faced tuskfish, the Bommie, Heron Island

Spanish dancer nudibranch, the Bommie, Heron Island

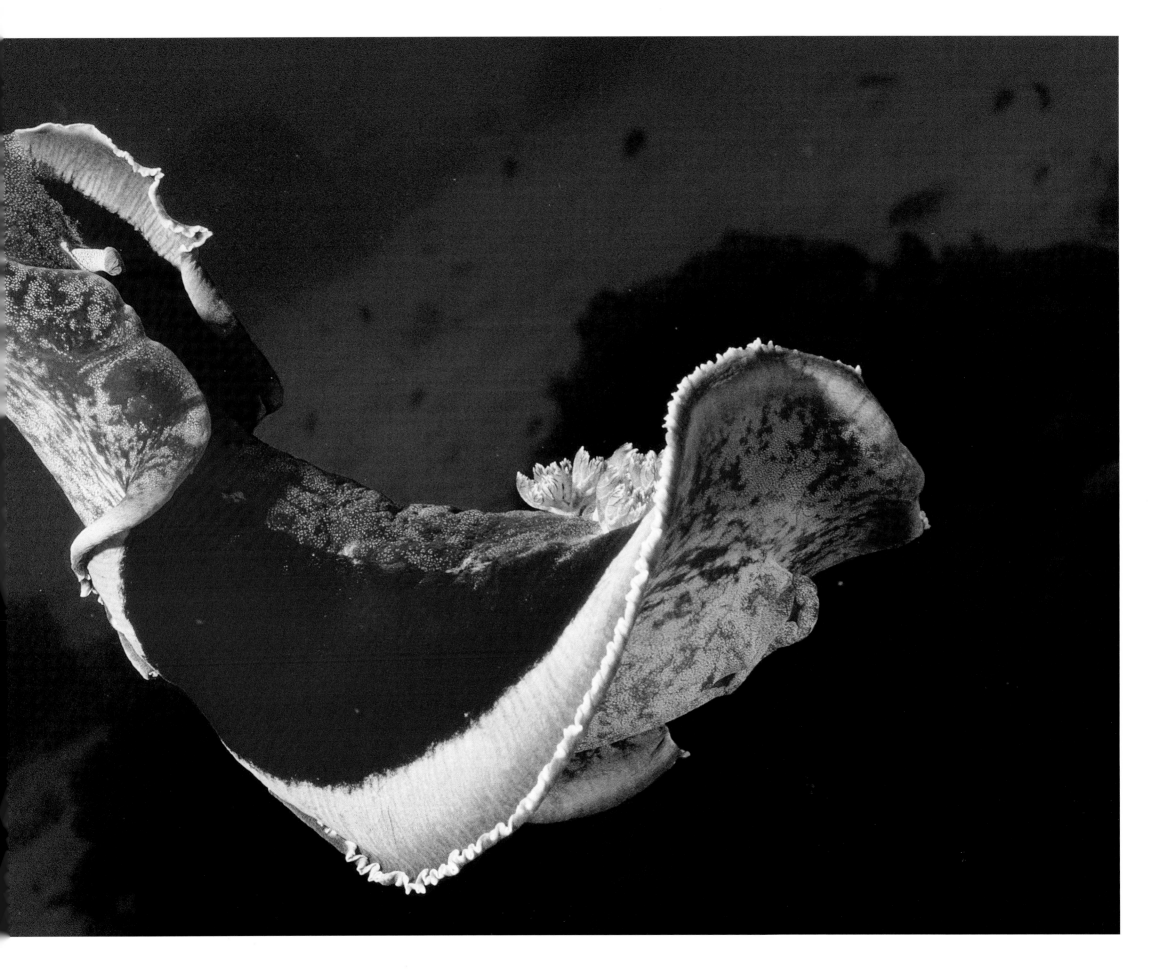

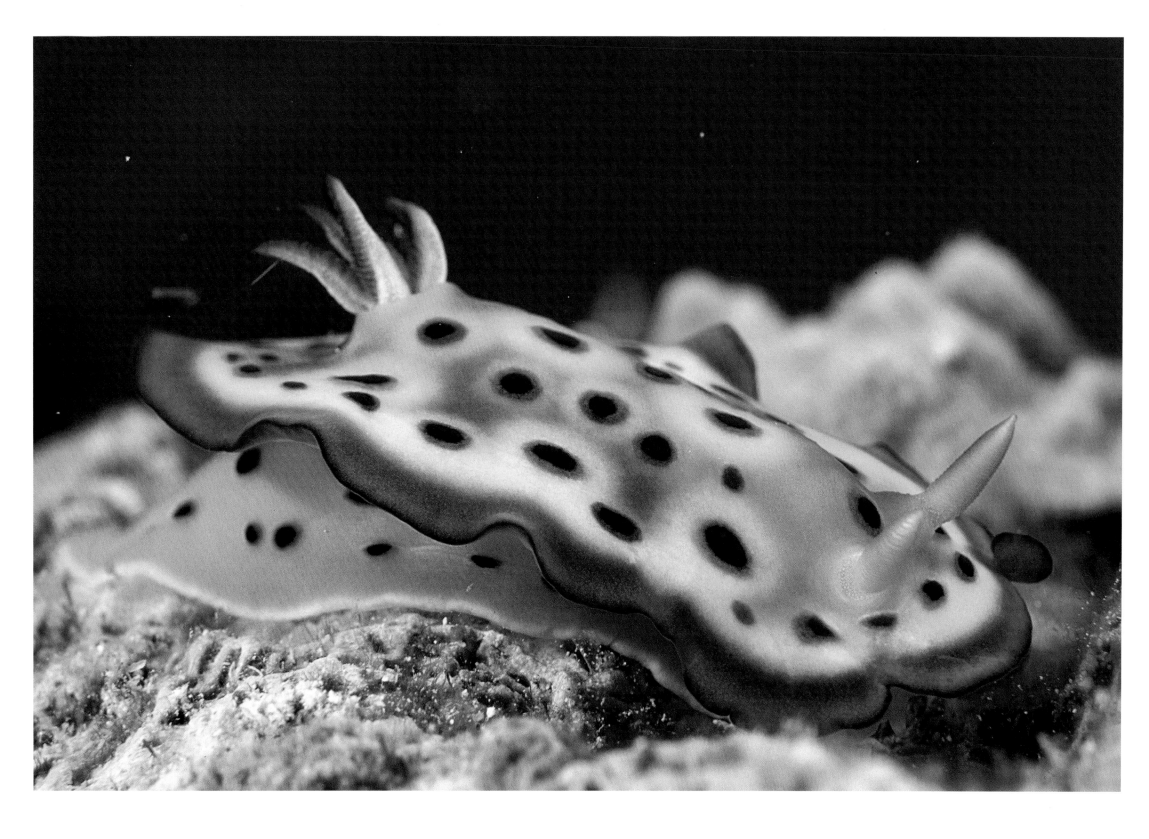

Purple-dot nudibranch, the Bommie, Heron Island

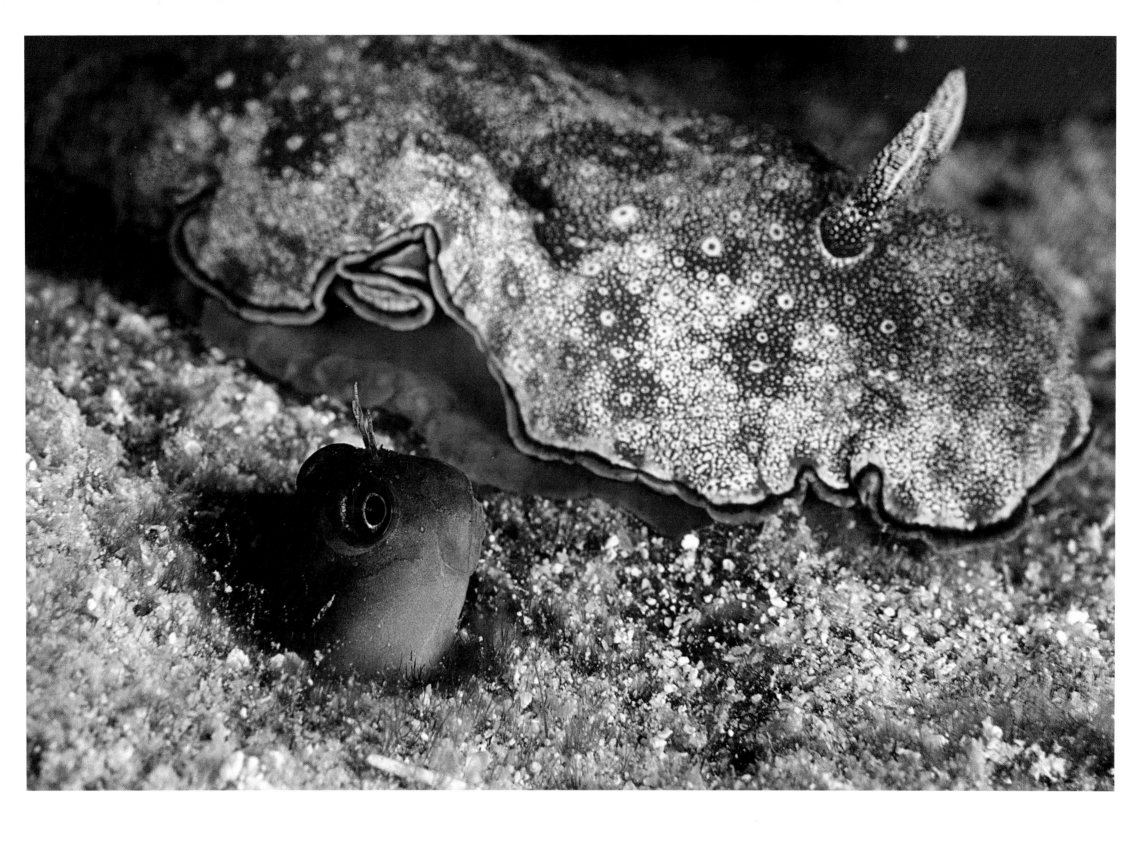

Nudibranch sliding past a blenny, the Bommie, Heron Island

Octopus, Swain Reefs

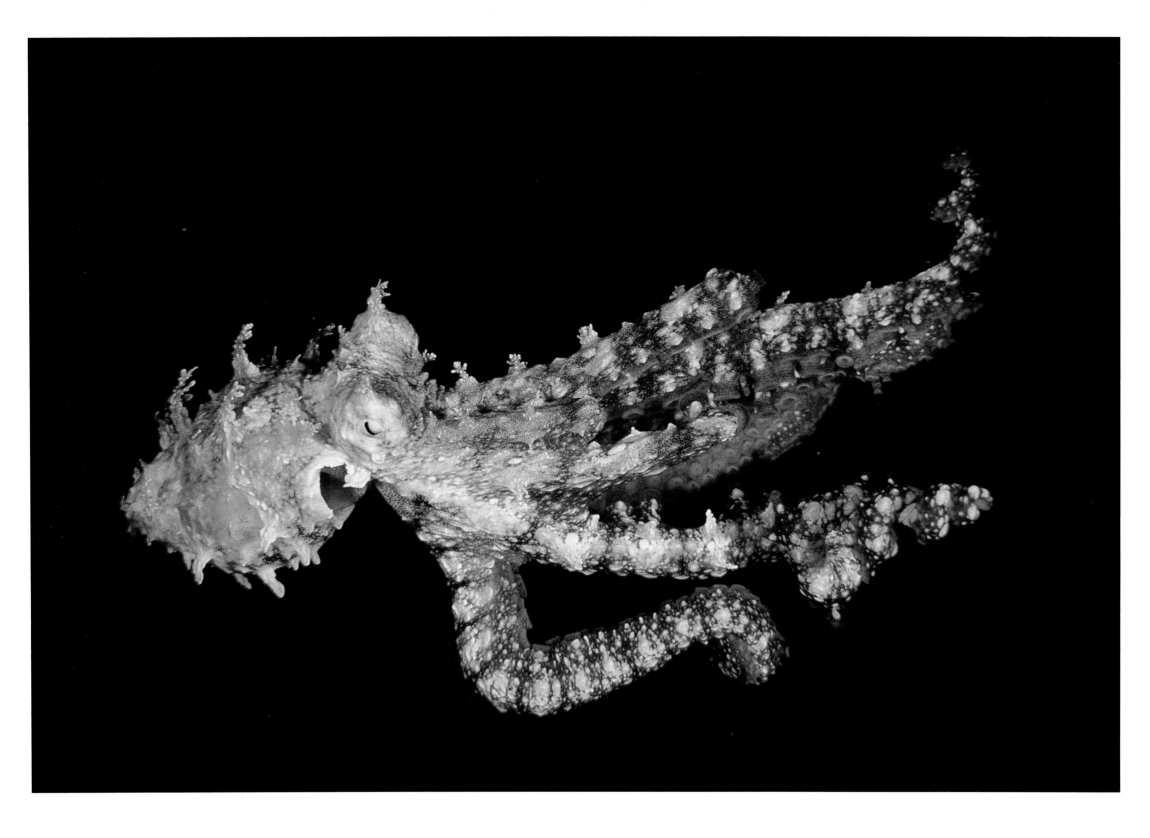

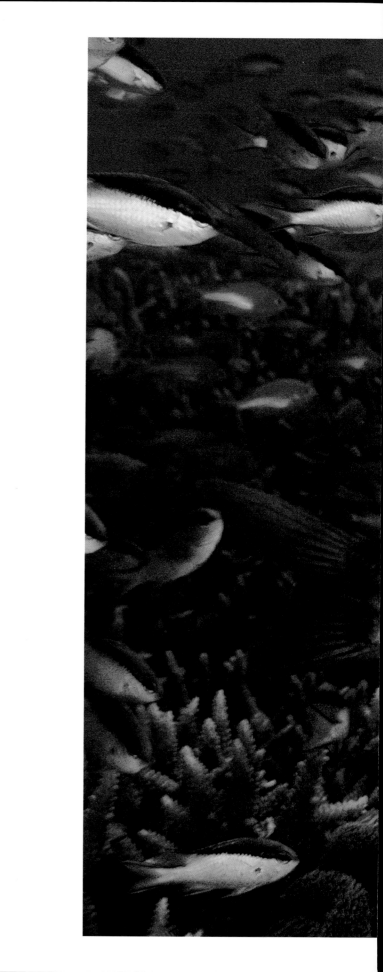

Spangled emperor, the Bommie, Heron Island

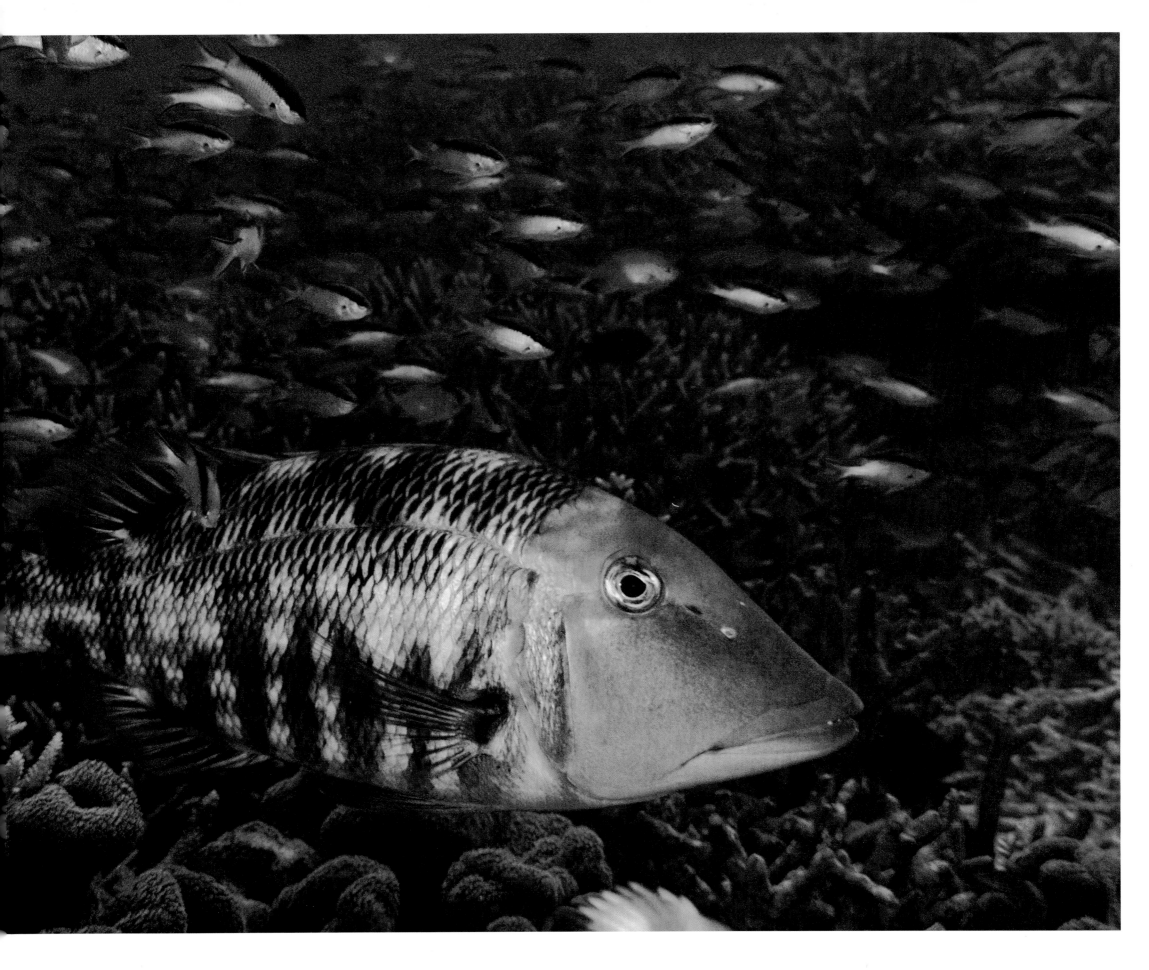

Mating male sea cucumber, the Bommie, Heron Island

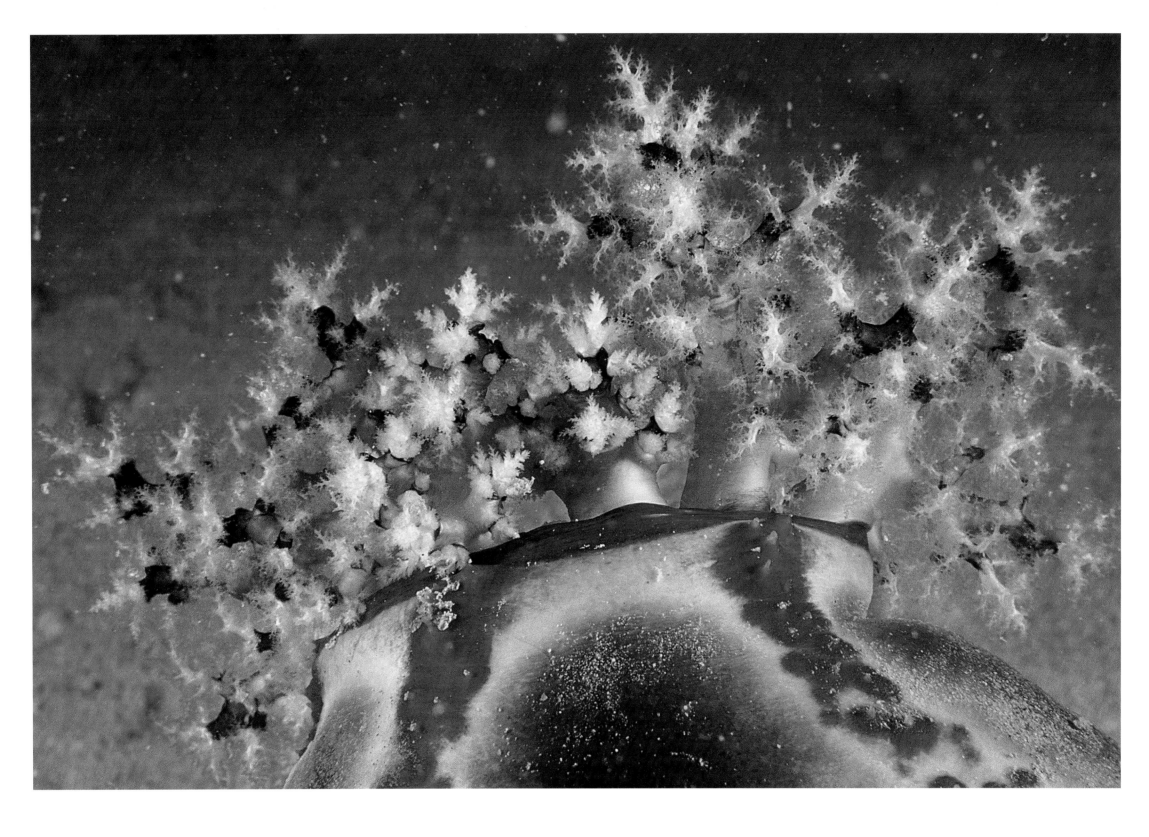

Sea cucumber, Heron Island

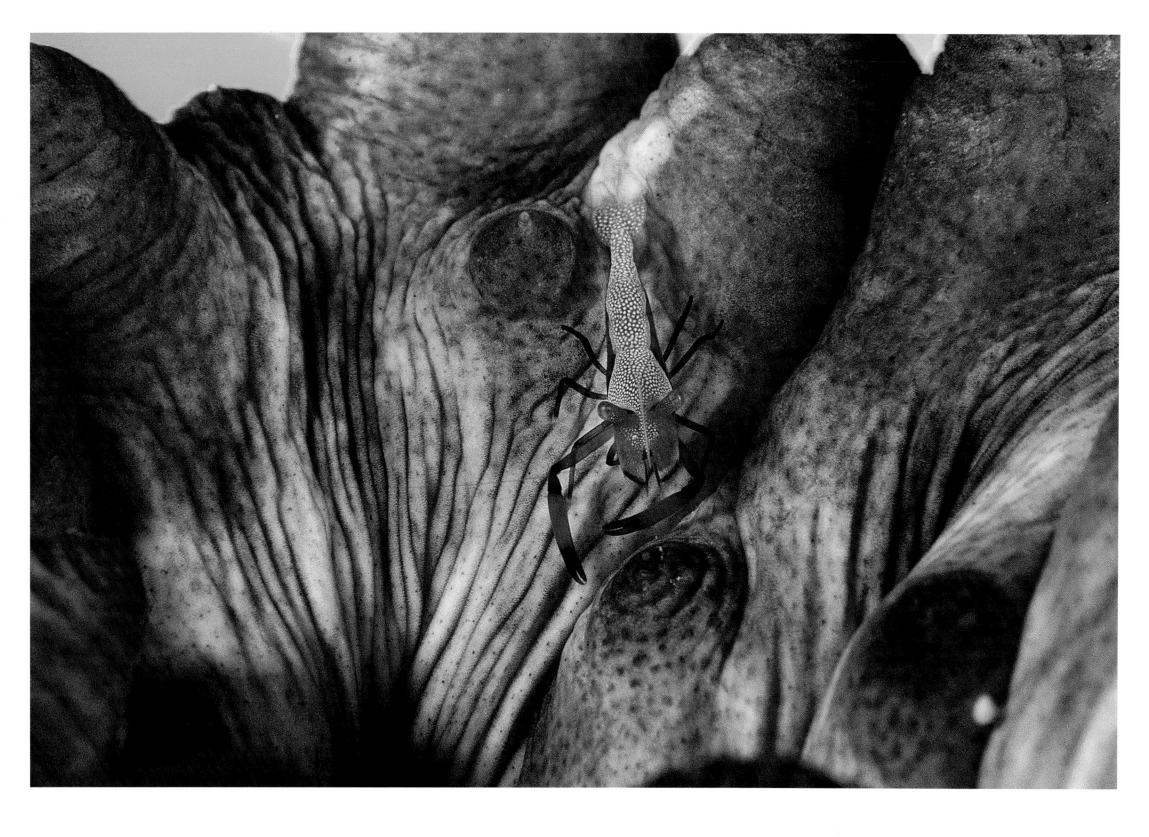

Periclimines shrimp on the bottom of a sea cucumber, the Bommie, Heron Island

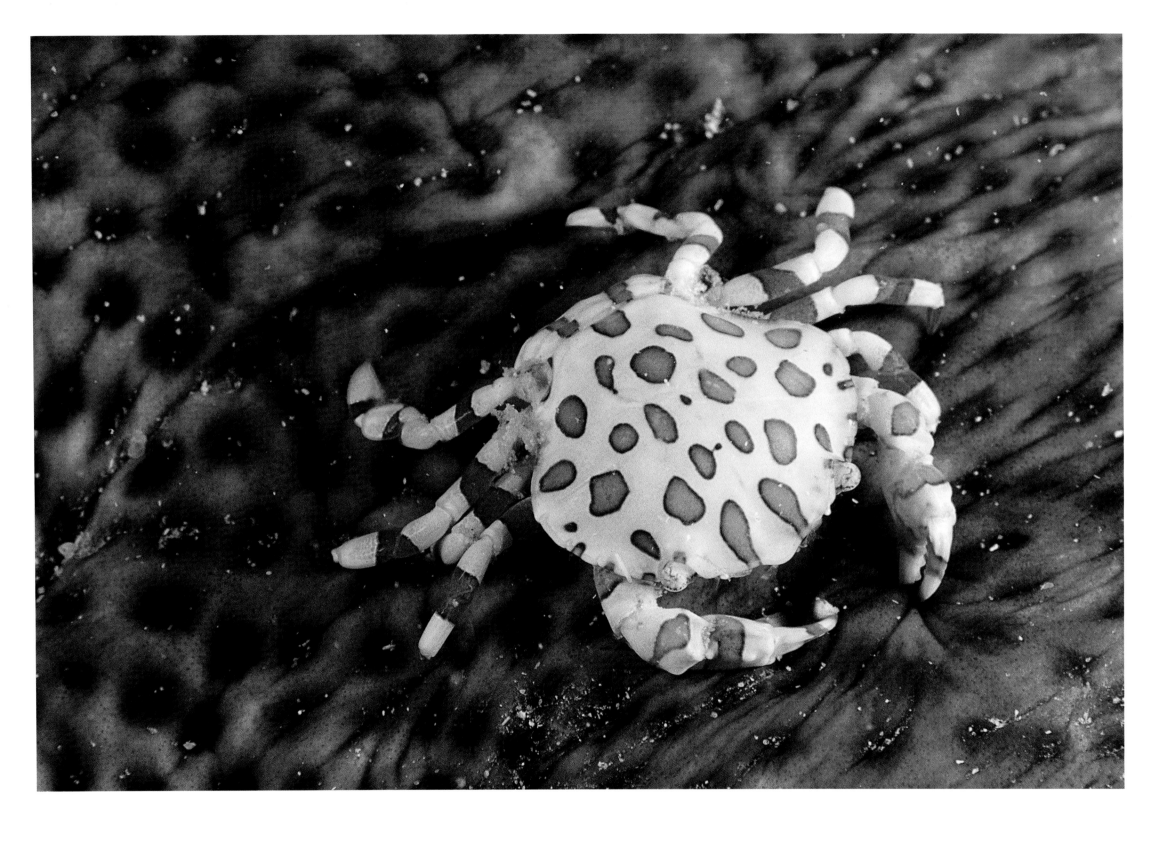

Sea cucumber crab, Heron Island

Periclimines shrimp on the upper side of a sea cucumber, the Bommie, Heron Island

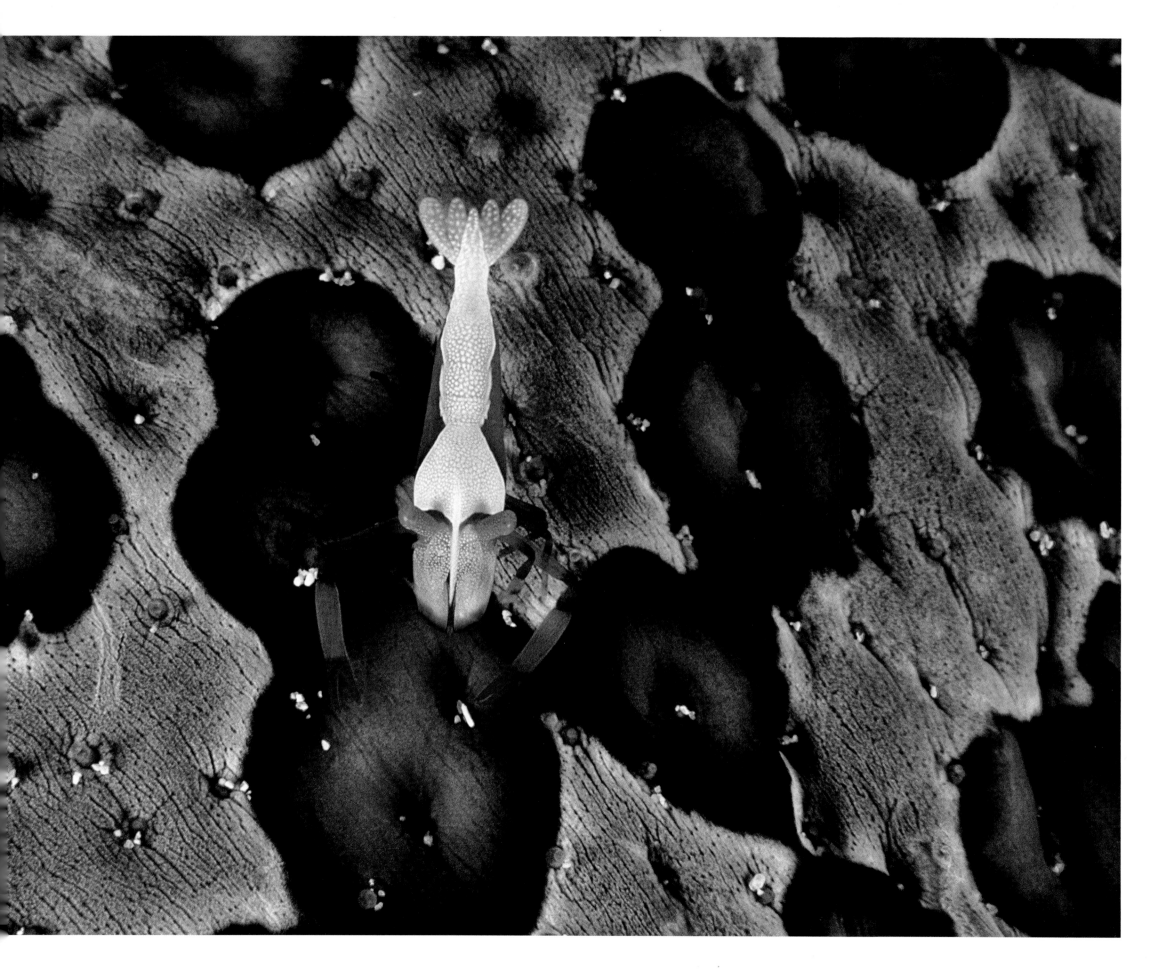

IN THE TIME OF TURTLES

FOLLOWING PAGES: Green turtles gathering at the southeast end of Raine Island

ON THE 8TH OF NOVEMBER, THE SKY above Cairns was a seamless gray. A warm rain seemed to fill the air but lacked the energy to fall. There was no hint of a clearing change, no edge of light on any part of the horizon. It was the beginning of the rainy season or, as Queenslanders call it, "the wet." But there was a report from the Iron Range airfield 300 miles to the north—it looked like it could clear. Gary Bell and I took the gamble. We crawled into a twin-engine Aero Commander, went down the runway, and flew into the gray murk.

Our goal was to photograph Raine Island, nearly 400 miles distant at the northern edge of the barrier reef, some 60 miles offshore and 100 miles from the Iron Range airfield. The island, lying within an empty oceanic wilderness, is rarely photographed—it's too risky to go there with a single-engine aircraft. In 1942, however, the skies over Raine Island were choked with Australian and American aircraft staging out of Iron Range, near Lockhart River. The fighters, bombers, and troop transports invariably battled terrible weather on their way to New Guinea, a front line in the Pacific war.

The time to photograph was now. In a week or two the spring and summer storm cells would constantly fill the sky and make our journey impossible, so on we bumped into the gray world. Suddenly, 40 miles north of Cooktown, the Aero Commander popped out into brilliant, unexpected sunshine, and the Great Barrier Reef unrolled like a starry blue carpet under the wings. It was a gift.

The sea was completely still and had a dark tin-mirror finish to it. In this time just before

the wet, the incessant wind from the Coral Sea stops blowing, and the reef takes on a map-like quality, as if it were laminated under a sheet of Plexiglas. A polarizing filter on a lens cuts out reflected light and makes the reefs explode with color.

To the east, the last of the ten ribbon reefs were outlined against a distant line of cumulus clouds. We flew past Cape Melville, where the reefs tucked right up close to the shore. Here there are a series of large hidden reefs—Corbett, Noddy, and Hedge Reefs among them. They were softly veiled by the green inshore waters. We flew over Number 6 Sand Cay, then passed the long and sinuous Tijou Reef. Great Detached and Little Detached Reefs looked like little atolls, with cobalt lagoons sleeping just beneath the surface. The water was so smooth that we could see the movement of tides, like muscles rippling under taut skin.

And there was Raine Island, a half-mile-long sandy patch encircled by a teardrop-shaped reef. Historically, Raine Island marked the entrance to one of the safer passages through the northern reef system. In 1844 a stone tower was erected as a navigational aide to mariners. It still remains, a silent sentinel visible far out to sea. We flew over at 2,500 feet. The island had its own personal cloud. Spinning off the southeast corner were big rafts of what appeared to be "clouds" of plankton, or an algae bloom.

"That's not plankton!" I shouted to Gary over the engine noise. "Those are turtles, green turtles, hundreds of turtles, no, thousands of turtles." Turtles paddling, turtles waiting—the females waiting to go on the island to lay their eggs, the males waiting to mate with the females.

We went down, pushing the Aero Commander to 100 feet. This was dangerous flying. The pilot made a series of passes across the edge of the reef, which bordered on blue water. Strangely, the turtles were all different colors, and I soon realized this was caused by the depth of water they were in. They were a glistening brown at the surface, aquamarine in mid-water, and dark blue at depth. There were possibly 80,000 turtles spread across the shallow reefs and clustered in the open water. It was astounding: In a single glance we were looking down at one of the largest green turtle populations in the world. The turtle groups shifted and changed, constantly swimming. It was a pattern of life, very similar to the view through a microscope of plankton in water.

The midday sun projected the shadow of the plane on the sea's surface as we flew over the endless carpet of turtles. Every pass ended in a tight pull-up turn that pushed us into the seats with about one and a half g's. Our pilot was working hard, feet dancing on the rudder pedals, arms straining at the yoke. And it was hot, the cockpit full of ground-level, moist Raine Island air. The wild shifts in gravity caused Gary to turn green and begin to resemble a green turtle. I began to taste my ancient breakfast, and we were beginning to get

low on fuel. Iron Range, the nearest airfield, was somewhere over the southwestern horizon.

Turtles begin to arrive at Raine Island in early October. The males arrive first, full of anticipation, after a thousand-mile swim. When the females arrive, they mass on the outside of the reef. They await dusk, when they will cross the reef, gather in the shallows on the inside, and crawl up onto the land as night falls. It is a difficult task. Before dawn, the females leave the island and return to the sea—a sea full of male turtles.

The males mob the females. A male mounts a female and grips her with specialized claws on his front flippers. The female initially resists and then settles into the work of reptilian reproduction. The pair languidly paddles in the sea for awhile, entwined in a slow dance. The calm does not last. Soon other males attach themselves to the mating male. They literally stack themselves up. I have seen as many as four males on top of an exhausted female. A female will mate several times over the course of this brief breeding season, between her trips to shore to nest. The sperm from several males will be stored in the upper portion of her oviduct. She will lay clutches of eggs that have multiple fathers.

At the end of November, we made a fast trip back to Raine Island on board a boat called the *Tusa IV*. We rendezvoused with a group of scientists and students from the Great Barrier Reef Marine Park (GBRMPA), who escorted us onto the island. At night, according to biologist Duncan Limpus, "there are as many as 10,000 turtles laying eggs." The sand is warm and moist and the grains stick to each other, giving it a pudding consistency. The female must hollow out an egg chamber. She uses her hind flippers in a delicate scooping motion. Once she begins to do this she will not stop. Carefully, I hollowed out a view port between one of the female's hind flippers. I watched as the long tube of her cloaca began to contract and then expel a perfect, round Ping-Pong ball egg covered with mucus. It fell softly into the egg chamber.

I was shoved aside by a 400-pound turtle. This is prime turtle real estate. It is so crowded, so much in demand, that the 10,000 or so nesting females inadvertently dig up each others nests. It was reptile bedlam in silent slow motion. Turtles were arriving, leaving; others were digging, then covering their nests. All of this took place in the darkest of night, as a soft wind from the Coral Sea blew across the island.

At dawn the place was all but deserted. The oblique rays of the rising sun illuminated a sandy island mangled by tracks of the silent reptile horde. It looked as if the Marines had been rehearsing an amphibious landing. A few stragglers were left, covering their nests, struggling, lurching to the sea without the anonymity of night to cloak them.

In about two months the sands of Raine Island will begin, literally, to move. The

hatchlings will break through the rubbery walls of their eggs, using their egg teeth, crawl up through the warm sand, and scramble to the sea. For the young males, it will be the last time they touch land. Birds will eat the hatchlings, and the deadly gauntlet of coral reef fish will finish off even more. A few will make it to the open sea, which will become their nursery. The females that survive will return to Raine Island in a couple of decades. For green sea turtles, the rhythm of the sea begins with a mad dash to safety followed by years of wandering the oceans, growing larger with infinite patience. They are herbivorous creatures, feeding on sea grasses and constantly searching for greener oceanic pastures. But from time to time they will also eat jellyfish. They are preyed upon by sharks, and, of course, by man. Traditionally, turtles were the canned goods of the age of sail. Tied up on deck and watered, turtles could be kept alive for weeks or even months. Today they are still prized for their meat and their eggs, which are dug up from the turtle beaches of the Philippines, Malaysia, and Indonesia, where the turtle populations have been decimated. But Raine Island is a sanctuary. Its population is guarded, untouched, a last hope.

I wanted to see the hordes underwater. Gary and I slipped into the open blue water and swam to the reef. The turtles were below us to the left and to the right, moving out of our way, constantly trying to distance themselves from us. We snorkeled because they hated the sounds made by the exhaust bubbles of scuba gear. Several times we saw tiger sharks with large black eyes, their long gray bodies vaguely striped, cruising 20 feet below our fins in the blue water.

As Gary and I crossed the reef, the turtle concentrations grew larger—it was like swimming in clouds of turtles. We would swim toward them, and they would slowly disperse. The spidery light patterns of the noonday sun broke up the turtles' shapes and they blended perfectly with the coral. I would hold my breath and dive, then cling to the bottom, remaining as still as possible. The turtles would begin to drift back toward me. It was pure joy to be swimming surrounded by hundreds of turtles, listening to my own breath, and, when I surfaced, hearing them breathe with their own internal rhythm.

I swam into blue water. The water was not crystal clear; planktonic suspension, which acted like dust, enhanced the shafts of sunlight as I looked down. Turtles swam below, crossing in and out of the light, moving silently across a blue stage. The turtles are truly "ancient mariners" for they swim, as they have for millions of years, across several seas, from as far away as Indonesia and Papua New Guinea. They are age-old creatures—reptiles who lived with the dinosaurs, paddling across time, gathering at Raine Island at the far corner of the Great Barrier Reef, participating in one of the greatest pulses of life on our planet. ✦

Male green turtle, Raine Island

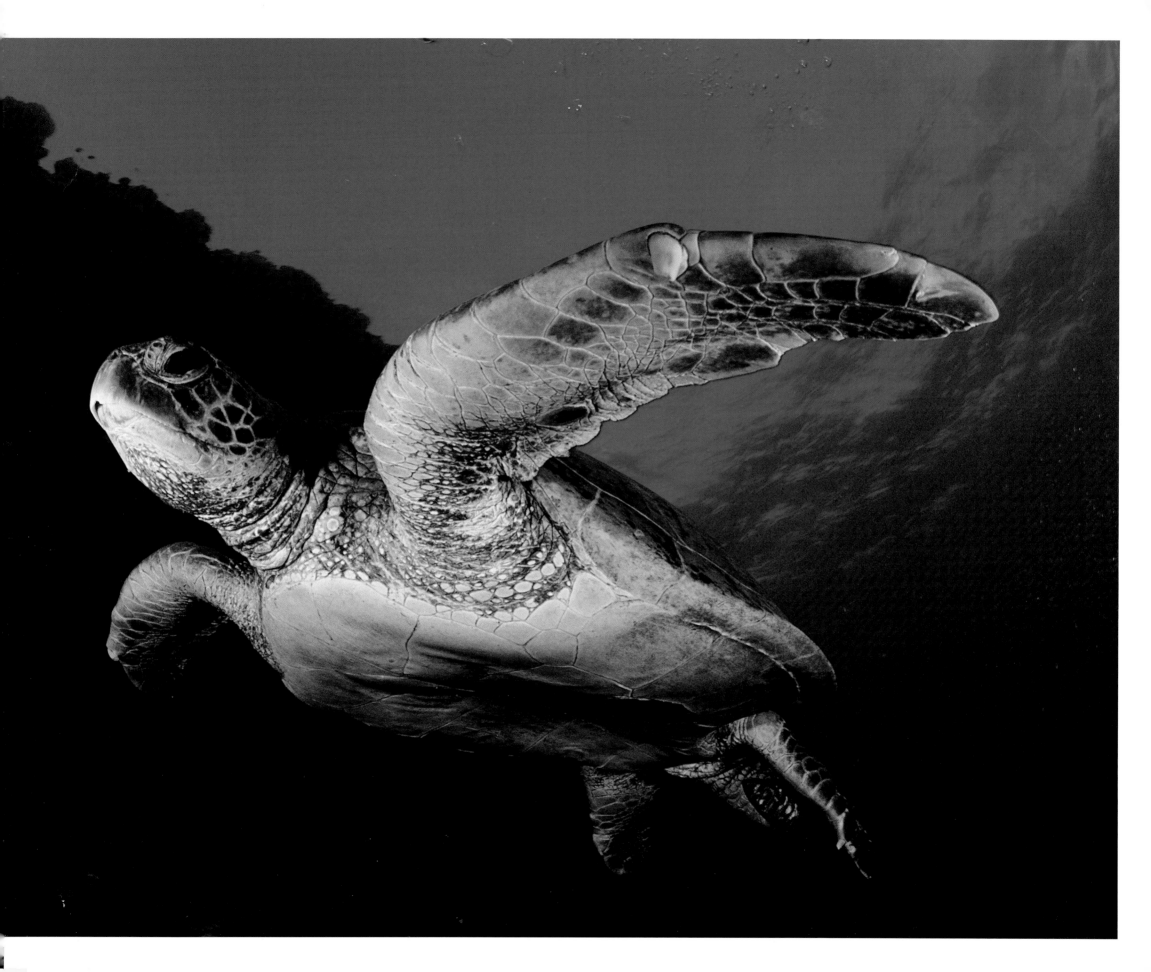

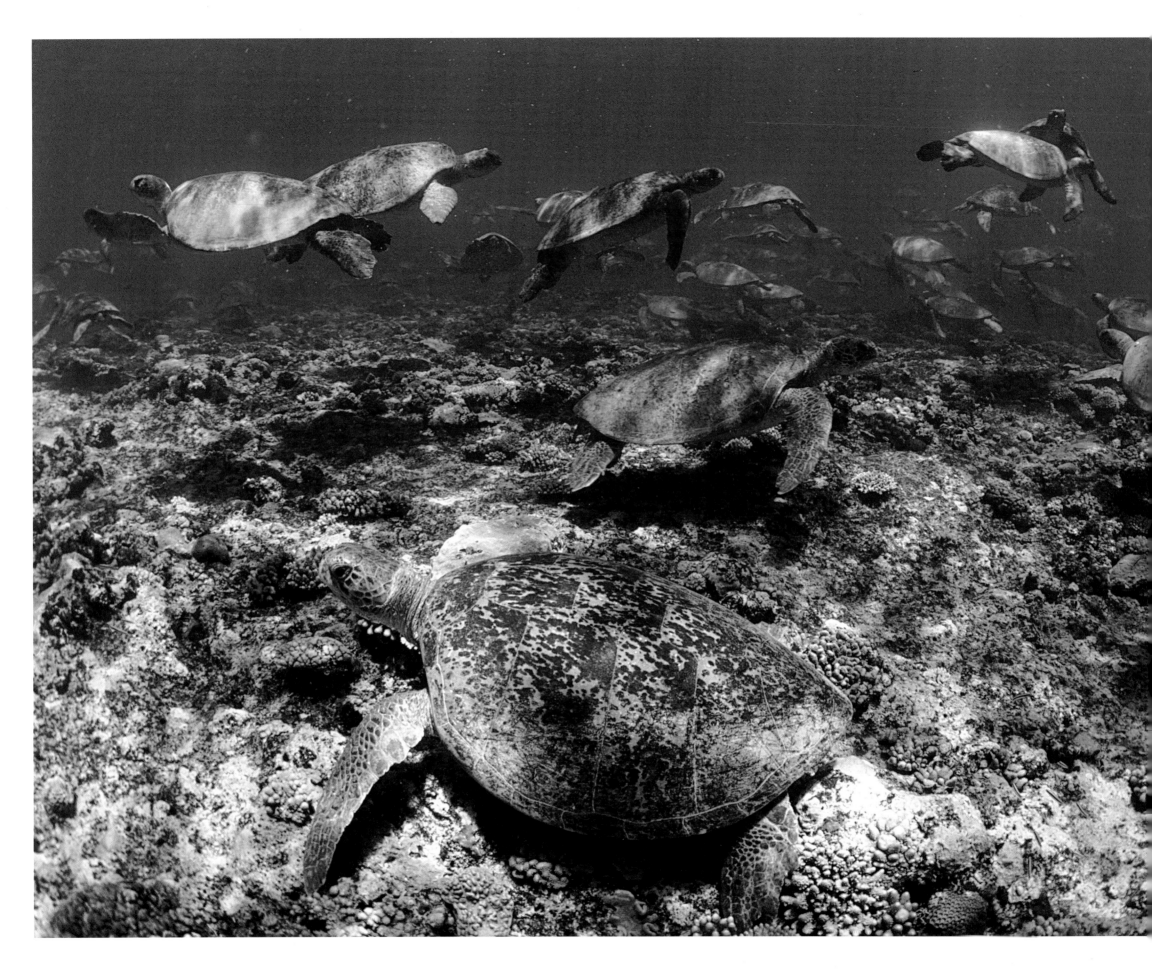

Groups of green turtles on the coral shelf, Raine Island

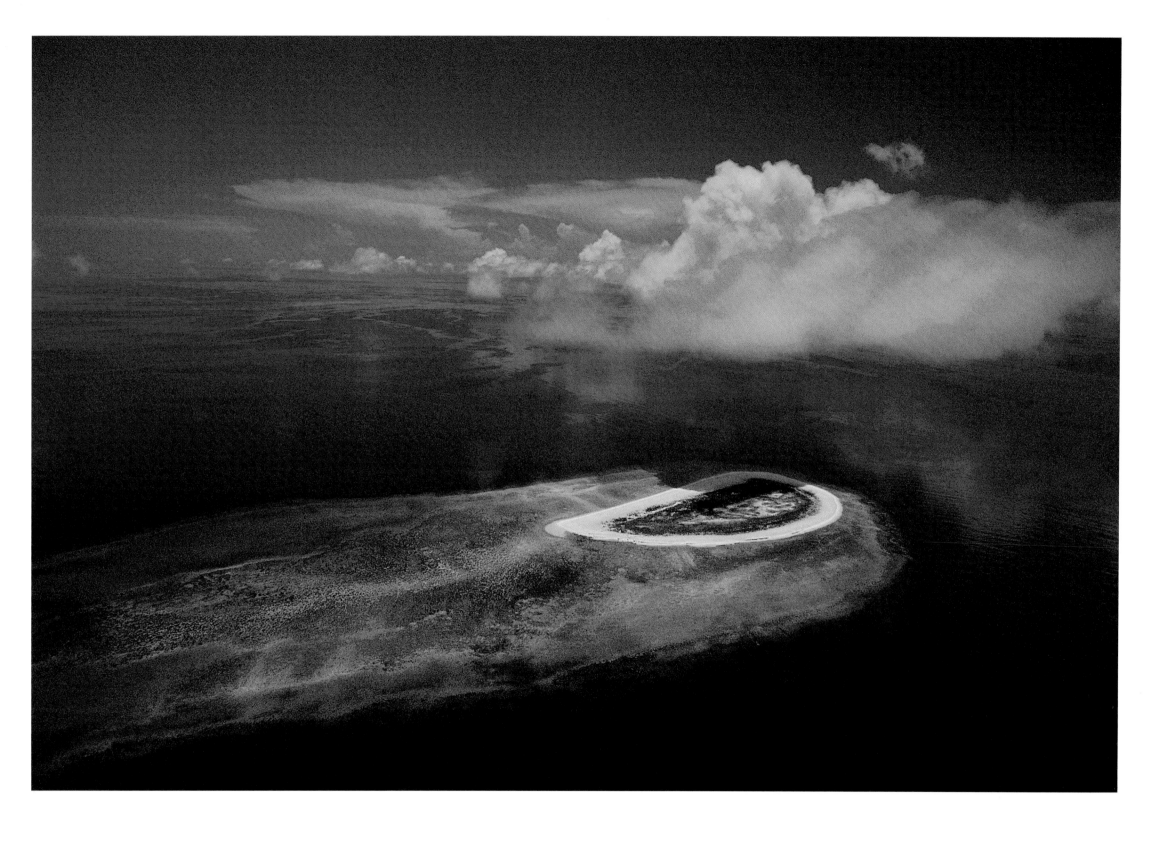

Raine Island

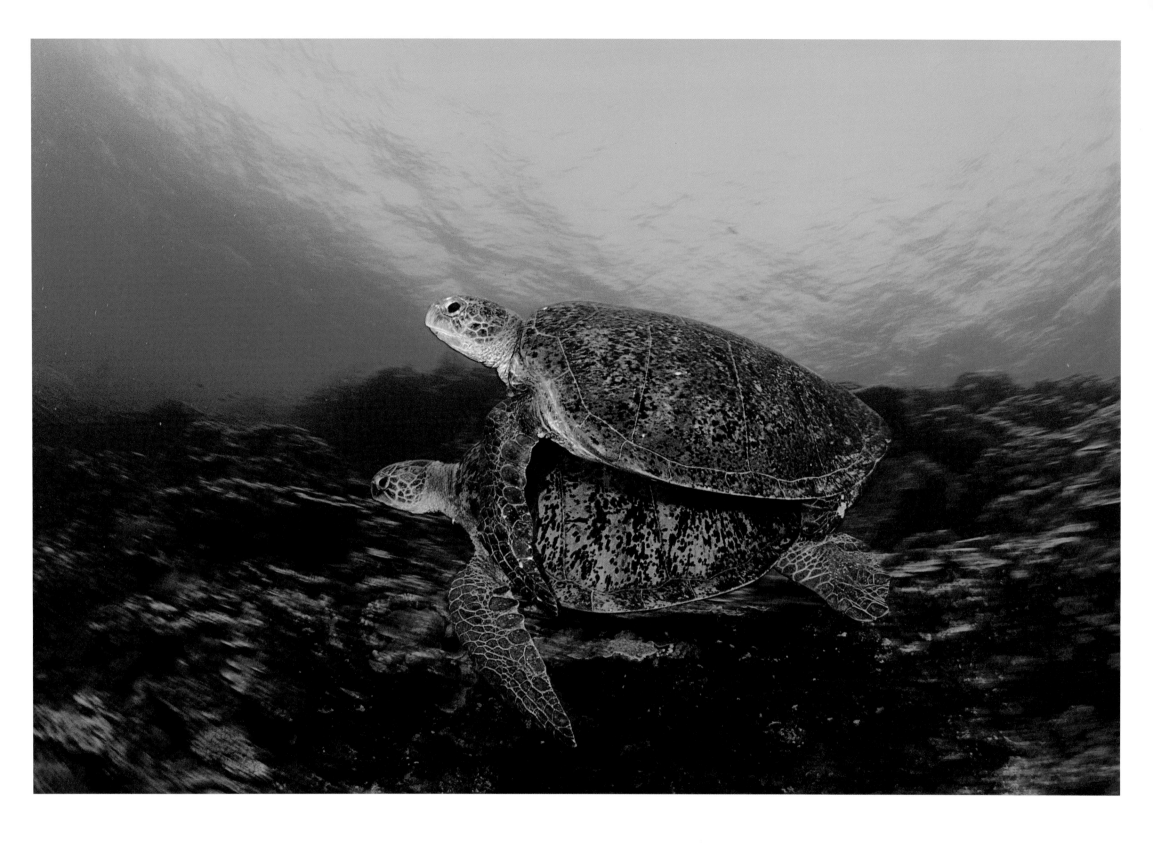

Mating green turtles, Raine Island

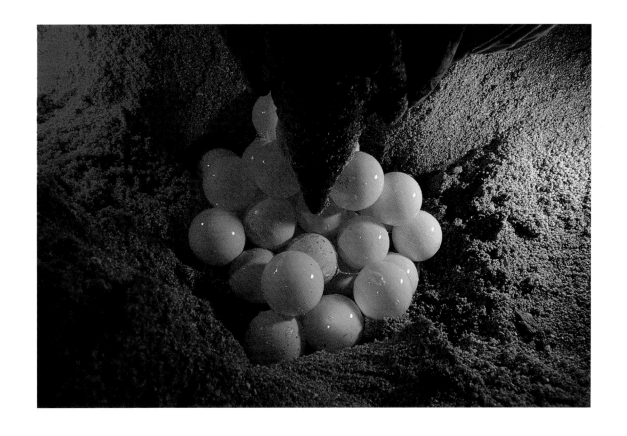

The egg chamber

OPPOSITE: Female green turtle covering nest

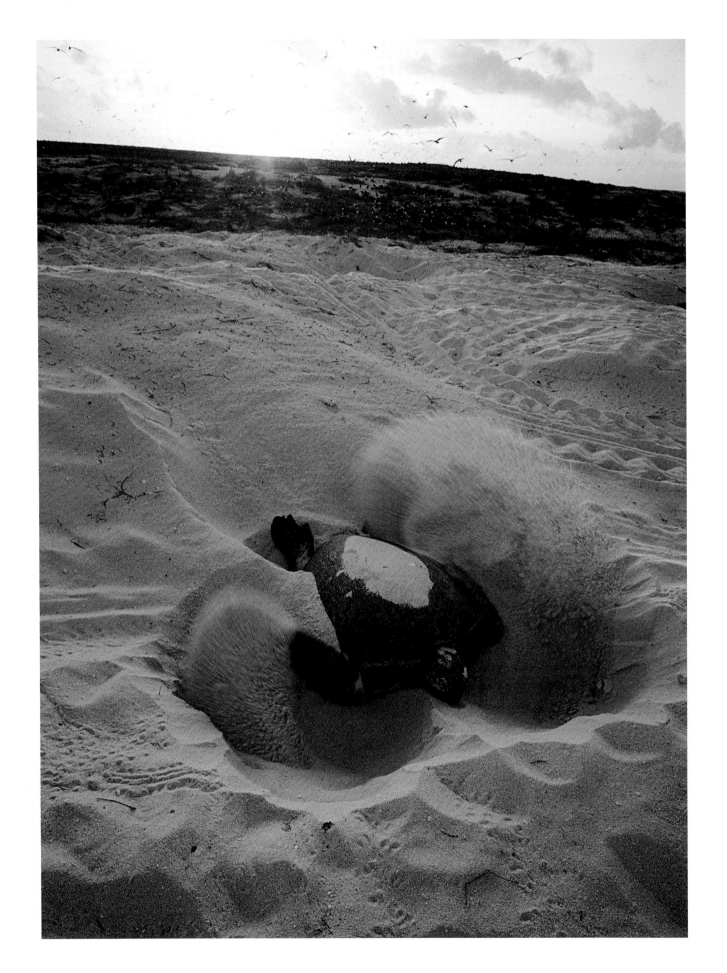

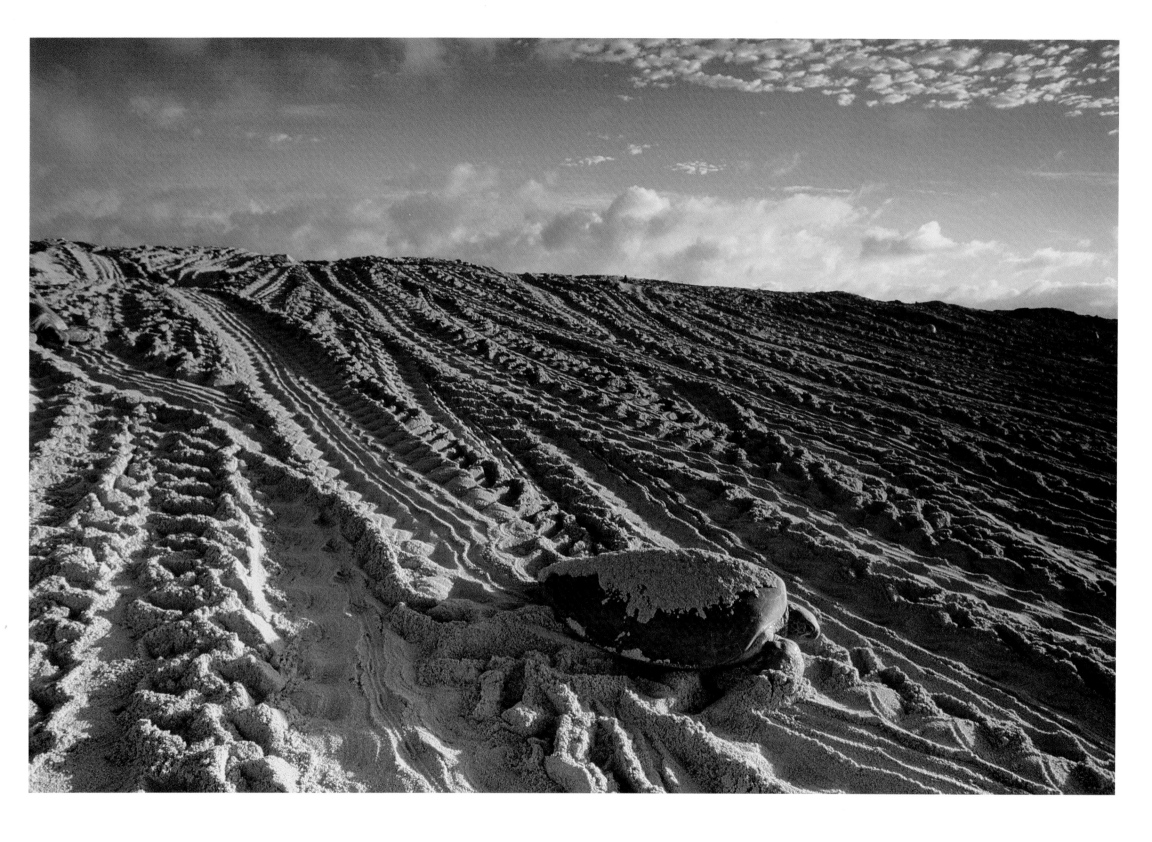

Morning after egg laying, Raine Island

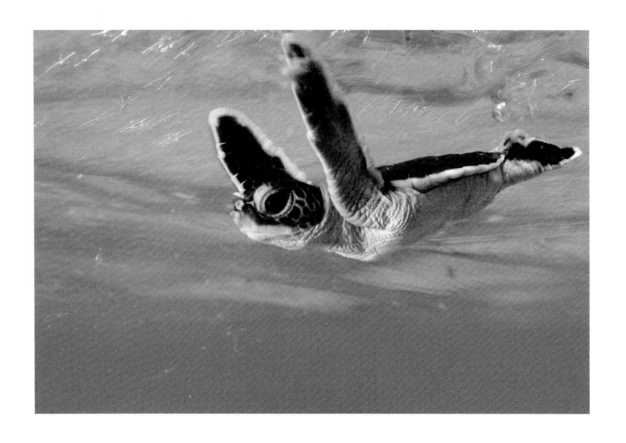

Newly hatched green turtle, Raine Island

Green turtle returning to the open sea, Raine Island

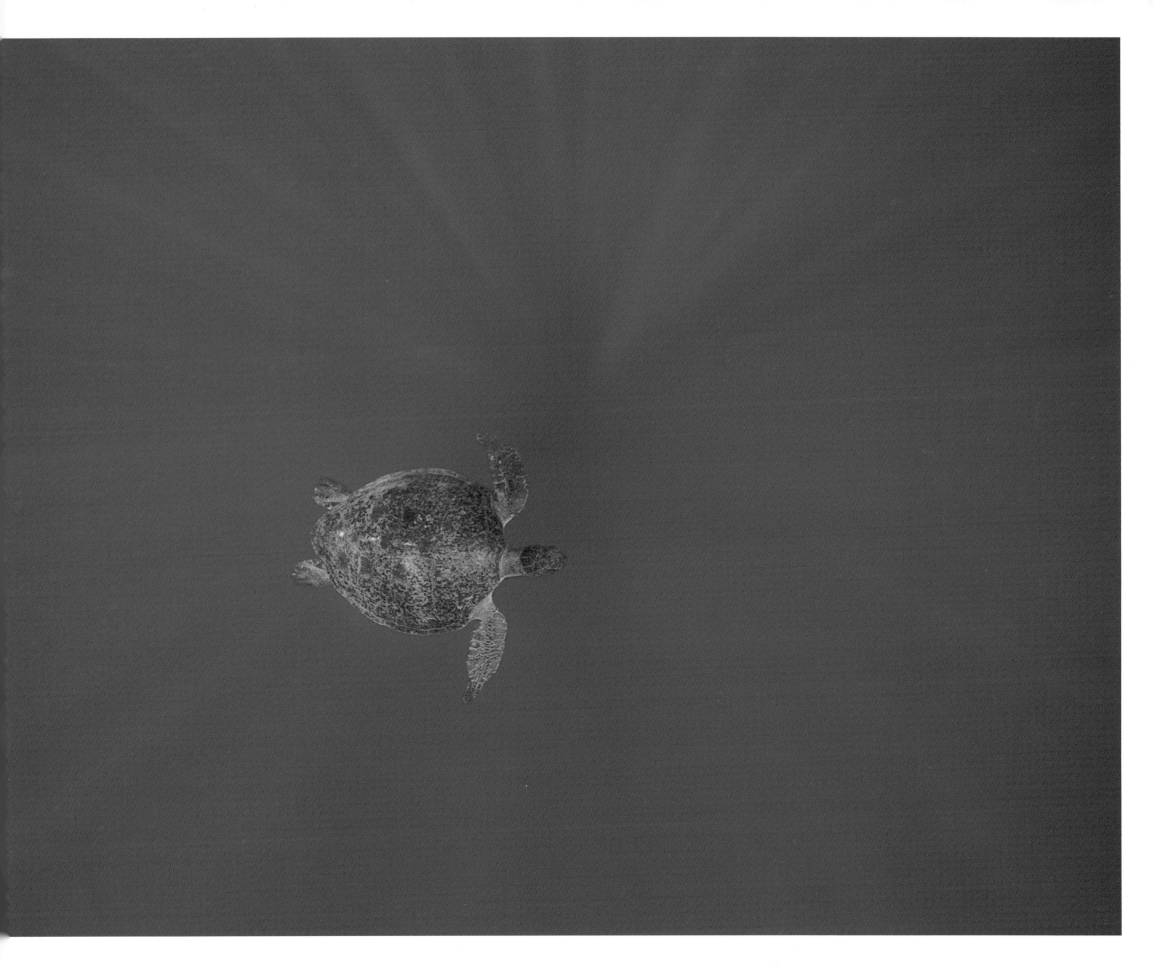

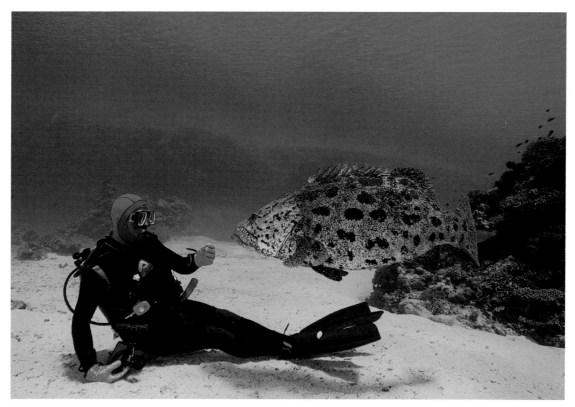
Gary Bell at the Cod Hole

EQUIPMENT

A true understatement: Underwater photography is an equipment-intensive business. Here is why: No matter how fast you are you cannot change film underwater. It is the same with lenses. Therefore, if you want to shoot two rolls of film underwater, you need two underwater camera housings. Everything has to be illuminated in the sea, and every camera housing has to have two strobes. The strobes are attached to the camera housings with strobe arms. The system looks like a spider crab. Other free-hand strobes are used for supplemental lighting.

All of this equipment is maintained in the photo engineering workshop of the National Geographic Society. Kenji Yamaguchi maintains the cameras. Keith Moorehead fabricates the domes and ports of the camera housings. Joe Stancampiano takes my bizarre camera dreams (usually doodles on the back of napkins) and turns them into photographic reality. A camera housing is not a simple aluminum box but a highly complex photo-optical system that must withstand pressure. Joe has modified, built, and rebuilt these intricate systems. He is a wonderful diver and, like me, is prone to *mal de mer*.

CAMERAS: For the photographs in this book, I used the Nikon F4, F5, and N90s cameras in Aqua-vision aquatic IV and V housings, Nexus Pro F4 housings, and Nexus master N90s housings. I also used a Mamiya RZ-67 in an Aquatica RZ housing. I used Nikonos V's with 15mm u/w Nikkor F2.8 lenses and 12mm sea and sea 3.5 lenses.

LENSES: I used the following lenses: Nikkor 15mm 3.5, AFD 16mm fisheye, 18mm 3-5, 20mm AFD 2-8, 24mm AFD 2.8, 28mm 2.8 AFD, 60mm micro-Nikkor AFD 2-8, 105mm micro-Nikkor, and 200mm AFD micro-Nikkor 4.

STROBES: For strobes, I used Sea+ Sea YS 200s with electric-oceanic connectors [E-O] that can be plugged and unplugged underwater. I also used Sea+ Sea YS 120 and YS300 strobes with their normal Nikonos-type connectors, as well as with Aqua-vision water changeable connectors. The Sea+Sea strobes produce a fine clear light. The strobe arms are Aqua-vision ultra-light arms.

FILM: Most of the time I used Fujicrome Velvia ASA50, also Fujicrome Provia F 100 ASA, Fujicrome 400 ASA, and Kodacrome 200ASA. There are some older images made with Kodacrome 64. For the aerial work I used mostly Velvia shot with Nikon F5s and F-100 cameras and a Nikkor 80-200 zoom 2-8 AFD silent-wave lens, as well as 20mm, 24mm, and 28-70mm 2-8 lenses.

ACKNOWLEDGMENTS

For Jennifer

First I wish to thank Gary Bell. I originally met Gary in 1985 at the Heron Island resort, where he was the dive master. Since then, we have worked together on 15 different stories for NATIONAL GEOGRAPHIC magazine as well as two books. Some assignments have been placid, others hair-raising. Gary has been an extraordinary assistant and a strong right arm (left arm also). He has maintained the gear, fixed Nikonos, and watched me destroy my regulators. He has been a friend in the sea and a friend on the even more complicated land. He is a gifted photographer and possesses the tools of patience and vision. Most of all he is a calm center in a stormy sea. Merri Bell keeps Gary safe from harm on land and sea and gives him vision.

I also would like to thank the crew of the *Tusa IV:* Phil Hobbs, owner, Capt. Mark Addington, Duncan Johnson, Keith Mole, Angie Page and Tracey Medway, as well as Capt. Norm Joseph and family, crew of the *Melantre;* Quicksilver Connections company; Hinterland Aviation; Cairns Tiger Moth Flight; pilots Justin Meadows and Tobey Adams, Helireef Helicopters; Whitsunday Air; Heron Island Resort and Research Station; Dr. Peter Harrison; Irvin Rockman; Ben Cropp; the Chadwick family; the Endeavour Foundation; and the crew of the replica *Endeavour.*

At National Geographic Books, I would like to thank Charles Kogod for his picture editing and my editor Becky Lescaze for her extraordinary and spectacular patience and fortitude. Designer David Griffin took a group of underwater pictures and brought them to life.

I would like to thank Jennifer Hayes for her diving assistance and for translating my verbal whirlpools into a real text.

One of the world's largest nonprofit scientific and educational organizations, the National Geographic Society was founded in 1888 "for the increase and diffusion of geographic knowledge." Fulfilling this mission, the Society educates and inspires millions every day through its magazines, books, television programs, videos, maps and atlases, research grants, the National Geographic Bee, teacher workshops, and innovative classroom materials. The Society is supported through membership dues, charitable gifts, and income from the sale of its educational products. This support is vital to National Geographic's mission to increase global understanding and promote conservation of our planet through exploration, research, and education.

For more information, please call 1-800-NGS LINE (647-5463) or write to the following address:
National Geographic Society
1145 17th Street N.W.
Washington, D.C. 20036-4688 U.S.A.

Visit the Society's Web site at www.nationalgeographic.com.

Published by the National Geographic Society

John M. Fahey, Jr. President and Chief Executive Officer
Gilbert M. Grosvenor Chairman of the Board
Nina D. Hoffman Executive Vice President

Prepared by the Book Division

Kevin Mulroy Vice President and Editor-in-Chief
Marianne R. Koszorus Design Director
Leah Bendavid-Val Editorial Director, INSIGHT Books

Staff for this Book

Rebecca Lescaze Editor
Charles Kogod Illustrations Editor
David Griffin Art Director
Michelle R. Harris Researcher
Carl Mehler Director of Maps
Richard S. Wain Production
Meredith C. Wilcox Illustrations Assistant

Library of Congress Cataloging-in-Publication Data

Doubilet, David
 Great barrier reef / David Doubilet.
 p. cm.
 ISBN 0-7922-6475-4
 1. Coral reef animals--Australia--Great Barrier Reef (Qld.)
2. Great Barrier Reef (Qld.)
I. Title.

QL125.D68 2002
508.943--dc21

 2001056224